M000163575

PRESERVING
BRISTOL
Restoring, Reviving and Remembering

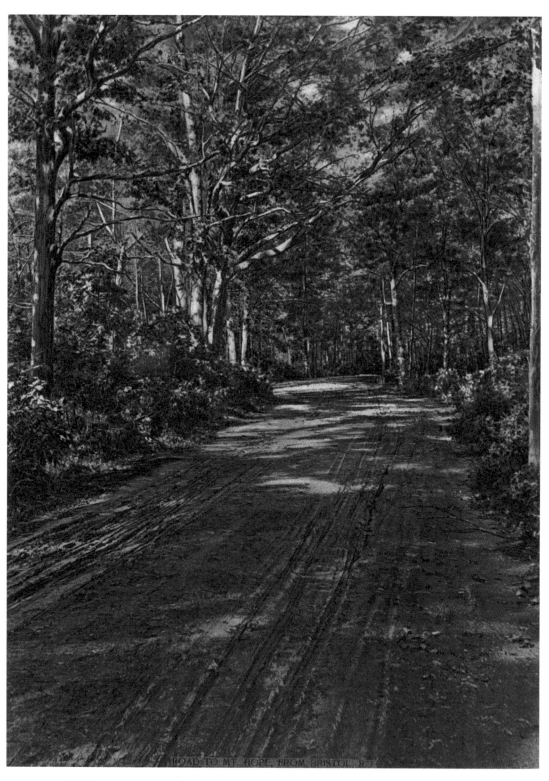

A photogravure image from the February 11, 1899 *Providence Sunday Telegram*, titled, "The Road to Mt. Hope".

PRESERVING
BRISTOL

Restoring, Reviving and Remembering

RICHARD V. SIMPSON

FONTHILL

Fonthill Media LLC
www.fonthillmedia.com
office@fonthillmedia.com

First published 2014

Copyright © Richard V. Simpson 2014

ISBN 978-1-62545-102-6

All rights reserved. No part of this publication may be
reproduced, stored in a retrieval system or transmitted in any
form or by any means, electronic, mechanical, photocopying,
recording or otherwise, without prior permission in writing
from Fonthill Media LLC

Typeset in 10.5pt on 13pt Sabon LT Std
Printed and bound by CPI Group (UK) Ltd, Croydon, CR0 4YY

Contents

Foreword

If a picture is worth a thousand words, as the pundits say, then Richard V. Simpson has illuminated Bristol more than any other historian before him. Wilfred H. Monro in the late nineteenth century and George Howe and Mark DeWolf Howe in the early twentieth wrote delightful books on their hometown, but the prolific Simpson has outdone them. This is his twelfth book with Bristol or a Bristol theme as its subject, and all of his volumes are richly illustrated.

But Simpson is not content with pictures alone. His painstaking research into original sources and his first-hand acquaintance with Bristol's landscape and its physical characteristics allow him to write accurate and informative captions and text to give clarity and depth to his graphic illustrations.

Former U.S. House Speaker "Tip" O'Neill was fond of saying that "All politics is local." If that aphorism can be applied to history, then the contributions of writers such as Simpson are the foundation of our historical knowledge.

This volume's title, Preserving Bristol, is in perfect harmony with its contents. Just as many of the historic structures delineated herein have been saved and restored for posterity by a patriotic and heritage-oriented citizenry, so have the lives and exploits of that citizenry been revived, remembered, and recounted by Richard V. Simpson. His writings on Bristol have made him a town treasure and, by all odds, the foremost historian of Bristol—ever!

(Dr.) Patrick T. Conley
Historian Laureate of Rhode Island

Acknowledgments

My grateful appreciation is extended to Rhode Island historian laureate and author Patrick T. Conley, Ph.D. Pat graciously accepted my invitation to read the manuscript. He offered important facts on the life of Senator William Bradford and other eighteenth and nineteenth-century Bristol luminaries. Dr. Conley also kindly offered other constructive recommendations to make this book the definitive document of the subjects discussed.

Sincere thanks to Edward Castro, a fellow Bristol history enthusiast who read the manuscript and made suggestions helpful in making this history accurate and easily read.

Once again the Herreshoff Marine Museum came to my aid by allowing use of rare circa 1902 archival photographs by Kitty Herreshoff DeWolf.

Sincere thanks to Brigadier General Michael Byrnes, USA (ret) for the Weetamoe Farm history and photo, and the Bishop Mark Anthony DeWolf Howe biography.

Special thanks to Bristol Fire Department historian and author Raymond Castro for his contribution of text concerning the Bristol Poor Farm fire.

A hearty thank you is extended to H. Sanford (Sandy) Town who has entrusted to my care several documents of importance pertaining to Bristol's celebrated history. A wonderfully concise illustrated pamphlet titled *Through the National India Rubber Company's Plant* published in 1918, and a delightful booklet, also abundantly illustrated, concerning the Cranston Worsted Mills, titled *As the Yarn is Spun*, published 1927. Both of these publications aided in writing the essays about these businesses. Sandy also has given for my safekeeping an album of breathtaking photographs of the incredible destruction heaped upon Bristol by the shocking hurricane of 1938. These photographs are the fodder for a future Bristol history.

Unaccredited vintage photos and quoted narrative passages are in the public domain. Unless otherwise credited, contemporary photos are by the author.

Author's Note

In this book, I expand upon previously published events in the town's ancient and recent history. My principal focus is upon many formerly under-reported details of nineteenth-century municipal buildings and historic Bristol homes. In several cases, short biographies of the homes' original occupants are included. I also reflect upon a few of Bristol's long-gone industries, the landed gentry, their farms and commerce. Unfortunately, the limited format of this volume does not allow for discussion of all the town's important buildings.

In conducting research for this publication many sources were studied, but the three most reliable sources referenced are Munro's history *The Story of the Mount Hope Lands* (1880), Bristol's tercentennial publication, *Bristol, Three Hundred Years* (1980), and *Historic and Architectural Resources of Bristol, Rhode Island* (1990). By combining selected passages from each of these books it is possible to compile a reasonably accurate account of the people and their activities, all of which contribute to the distinct and remarkable character of the Town of Bristol, Rhode Island; a history worth preserving.

· · · · ·

Because the DeWolf family has played such an important role in the beginnings and character of Bristol, and their names are prominent in this volume, it is right to give a brief overview of the origin of the family and their business enterprises.

Shortly after the founding of the town in 1680, paramount among Bristol merchants was Simeon Potter, who in his youth, worked as a ship's cooper on West Indies (Caribbean) cruises for molasses and mahogany. By 1744, he was a ship's captain, and sailed as a privateer in the wars of the 1740s and 1750s. By 1756, he had made his fortune and retired from the sea. Later, he invested in slaving ventures, which were undertaken by his son-in-law, Mark Antony D'Wolf. Mark Antony D'Wolf founder of the Bristol branch of the family was born 1726, second son of Charles D'Wolf, in Lyme, Connecticut, or as another source suggests, he was descended from a bastard line of the Dutch deWolffs of New York.

The name D'Wolf is spelled with the French contraction owing to Mark Antony's education in Guadeloupe, French West Indies. Mark Antony married

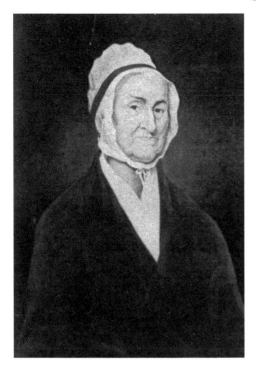

Above left: Abigail Potter the grand matriarch of Bristol's DeWolf family.

Above right: The youthful John DeWolf.

Captain Simeon Potter's daughter Abigail in Bristol in 1744; they had eight sons and seven daughters. Mark Antony died November 9, 1793, insolvent, in a house his sons built for him on Bristol Neck.

Beginning in the 1780s, five of Mark Antony's sons engaged in the slave trade. Of these, the youngest, Livi DeWolf, abandoned the business after one journey, apparently in disgust. Livi spent the balance of his life studying the Bible and growing onions. His brother Charles had no qualms about dealing in the triangle trade. William and John DeWolf, after making money in the slave trade, became respectively an insurer and a farmer.

Charles, eldest of the brothers, was the greediest. It is Charles, of who it is written, was the DeWolf who took pleasure in rolling in his sacks of gold.

John profited from several lucrative years in the trade, after which he retired from the sea to become a farmer. However, he did retain interest in several Bristol ships. He also acted as his brothers' recording and corresponding secretary, and counselor.

William, a competent ship's master, retired from the sea as owner of at least twelve slave ships. He founded a company that insured Bristol ships against the perils of the sea.

The most successful of Mark Antony's sons was James DeWolf, later a United States senator and cotton manufacturer, who made a fortune in carrying and

selling slaves. James DeWolf, a hero of several naval fights against the British, was an ambitious individual. Before he was twenty, he was master of his own ship. He and other members of the family financed and planned eighty-eight journeys to Africa for slaves between 1784 and 1807. In order to benefit from this form of labor all the more, James DeWolf bought a sugar plantation in Cuba—one of the first North Americans to invest in that island after it became legal to do so in 1790.[1]

Down to the present day, there remain in Bristol a great many DeWolfs and others with DeWolf blood flowing in their veins. In Bristol, members of the family spell their name any way that pleases them: D'Wolf, D'Wolfe, deWolfe, and DeWolf. In this text, except when used within a quote, I choose to use the most widely accepted spelling–DeWolf.

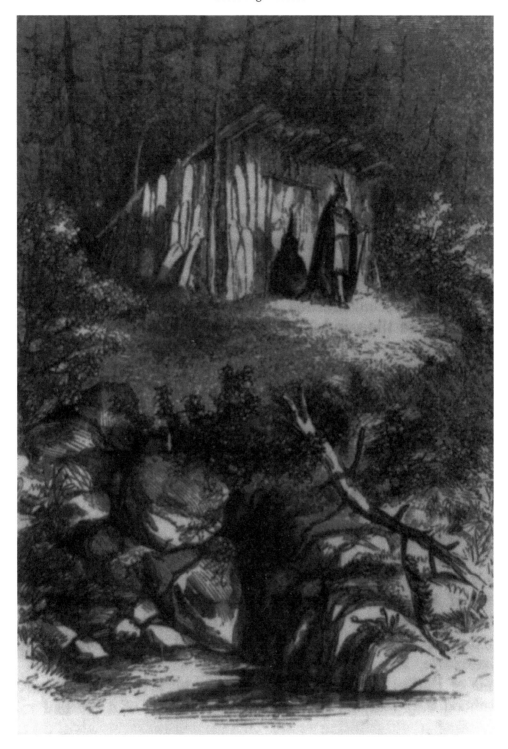

Sachem Massasoit's lodge at Montaup. Engraving from *Harper's Monthly Magazine*, 1857.

Preface

On the eastern shore of Narragansett Bay, commanding an inner harbor, looking over the placid waters to Mount Hope, stands the old Town of Bristol. Its wide streets, arched with stately trees, its spacious common, set apart at its foundation for public use, its fine public buildings, attest the liberality and love of its inhabitants.

Rev. J. Lewis Diman, D.D., Sept. 1880.

Rev. J. Lewis Diman, D.D. (1831-1881). J. Lewis graduated from Brown in 1851. He established himself as a respected Congregational clergyman, and later became a professor of History and Political Economy at Brown.

Montaup / Mount Hope Grant

The Mount Hope Grant of Brown University, a tract of about 600 acres on the shores of Mount Hope Bay in Bristol, is like no other tract of similar size.

Here can be found a number of small worlds all in one neat compact package: sea, seashore, old woods, new woods, open fields, salt marsh, swamps with clear springs and brooks, dry uplands and rocky cliffs. These areas all have their own special plants and animals as well as those that are at home anywhere.

In exploring these small worlds, a good place to start is along the shore in the early morning. Cloudy or bright, there is a certain magic near the sea. On a fair day the sun crosses the horizon sending its full spectrum to the sky, the clouds and the water with its mirrored reflection caught in the calm bay. Here is an ever-changing scene. No two minutes of the day are exactly alike.

Rising up from the shore is a steep gravelly bank from which a number of Indian artifacts have come to light through the ravages of time. It must have been the place where the Indians fixed their nets and made their fishing tools. White quartz fish scrapers and sandstone net sinkers have been found as well as quantities of white quartz chips.

Overlooking the embankment is a red cedar grove, and on a foggy morning as the sun climbs over the mists, it sends long shafts of light penetrating the gloom under the tall dark pyramidal trees, producing quite an eerie effect. This is the place to see the cedar waxwing feeding on the blue "berries" that the red cedar produces. Oddly, they are not berries but miniature cones. Under the cedars is a clear spring lined with mosses and ferns. Once it was the drinking place of the white-tailed deer and the raccoon.

Moving out into an old apple orchard and pasture, one finds that nature is picking up the threads of the pattern she was weaving when the white man interfered. The pioneer trees and shrubs; red cedar, gray birch, wild cherry, high bush blueberry, bay berry and arrowhead viburnum are beginning to give way to the future giants of the forest: the oaks, hickories and red maple.

Beyond in what was once a corn field is all the well-known mid-summer flowers. Daisies, black-eyed Susans, milkweed, thistles, St. Johnswort, Queen Anne's lace, and Deptford pink make an array of color, which attracts the sulphur, painted lady, fritillary and monarch butterflies as well as bees. A little later toward fall, asters and goldenrod replace the summer flowers in varying sizes and shades.

The oaks, hickories, and yellow birch give way to the beech. This admirable tree is attractive at any season of the year. Its smooth, silvery branches stand out in the winter, pointed buds in the spring, and healthy symmetrical green leaves in summer turn to a rich tan in the fall.

On the other side of the wood, there is a high rocky cliff. Oaks grow here out of the rock by sheer determination. Among the crevices mosses and lichens are as much at home as are the native columbine and saxifrage, the latter name meaning "rockbreaker". Tumbling over the edges of the cliffs is a rich carpet of common polybody, one of our few evergreen ferns.

A few hundred yards below this cliff is a swamp made famous through an Indian's lack of fortune! Metacomet also known as King Philip, the great native sachem, met an inglorious end here, thus calling a halt to the strife between the white man and the Indians in southeastern New England.

A general lack of respect prevails toward the land that has been lent to us for a fleeting second in the long eons of time. Many of these beautiful natural areas may become just a memory we will describe to our grandchildren.[2]

Preserving Mount Hope

Rudolf F. Haffenreffer II amassed a very large collection of artifacts associated with North America's indigenous people, which he housed in his King Philip Museum, a rambling building that he built beneath the crown of Mount Hope.

In the mid-1950s, Haffenreffer's heirs deeded about 350 acres of the original farm, including historic Mount Hope to Brown University. This gift to Brown is referred to as, Mount Hope Grant.

The museum, along with the extensive collection of Native American relics, which later became the Haffenreffer Museum of Anthropology, is on the property donated to Brown University; it is part of Brown's Department of Anthropology.

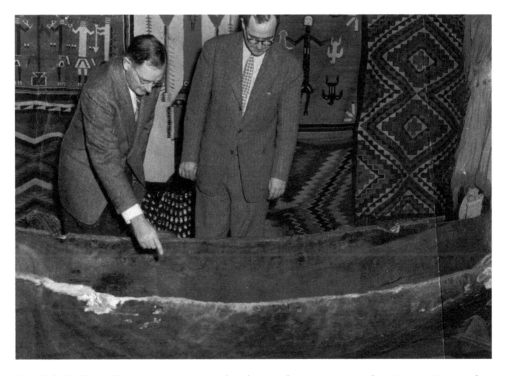

Rudolph Haffenreffer is pointing out a detail on a dugout canoe at his Mount Hope Indian Museum. *Phoenix Photo*

In June 1988, the Bristol Town Council, fearing a subdivision of Mount Hope, floated a plan to approach Brown University with a proposal to purchase a 50-acre tract west of Mount Hope and south of Tower Street. The parcel includes land surrounding King Philip's spring and a beach parcel.

Director of Community Development Gerhard Oswald, described the options the town could consider for buying part of the Brown University land between Metacom Avenue and Mount Hope Bay. Town officials' desired as much shoreline as possible, including Church Cove the indentation at the south end of the property; the town also proposed buying a parcel of about 20 acres at the top of Mount Hope which had been part of the NIKE missile site. A conservation area of 48 acres, which is at the southernmost tip of the property, may someday be available to buy because deed restrictions preclude development.

Ultimately, town officials agreed to try for as much of the university's total of approximately 350 acres as the town could get. The town wrote a proposal to the state for funds from the open space and recreation bond approved by voters. The proposal bore no fruit.

According to the Pokanoket

Speaking in February 1995, Don Weeden, Chairman of the Council of Seven of the Royal House of Pokanoket, a tribe that is scattered throughout eastern Rhode Island and southeastern Massachusetts, remembers the story of the creation.

Weeden said that after the creation of all things, "three messengers were sent by the Creator with gifts to us, the Pokanokets, at Montaup [Mount Hope], the tribe's sacred land, which is the lookout of Pokanoket. Each of the maidens brought a gift, because we were pleasing in the sight of the Creator. They brought beans, squash, and corn."

Weeden is a walking encyclopedia of information about his tribe, historically known as the ruling tribe of the Wampanoag nation of New England. He claims he is descended from Ousamequin–the first Massasoit, or Great Leader who befriended the Pilgrims in 1620.

It is estimated by Weeden that there are about 700 Pokanokets in the region who are aware of their heritage and possibly many more who do not know of it. But to be a Pokanoket is a "spiritual" concept, he explained. It is a way of life that entails love and living within the boundaries established by Mother Nature–not taking more than is needed.

Until deposed as leader of the tribe, Weeden worked long hours as an unsalaried administrator for the council and his people in his office on the first floor of Richard Alegria's King Philip Inn on Metacom Avenue. In this cramped office, pieces of his heritage surround him. On the wall is a leather banner with the rising silver star of the Wampanoag Nation painted on it. Beneath this are the seven "crescents" of the Pokanokets. Each one is a different color, and together they look like a rainbow. Each individual crescent stands for an aspect of man's

W. G. Lescomb's *c.* 1890 stereo view photo of King Philip's spring at the east base of Mount Hope.

relationship to God and nature. Below the crescents is a small deer hoof, Weeden's own symbol.

Moving into the twenty-first century, the Council of Seven has drawn a constitution and incorporated. The Pokanokets are at a critical moment in their history, they are seeking federal recognition.[3]

Introduction

The undoubted interest of England is Trade, since it is that alone which can make us either Rich or Safe ... and without Trade we could have neither sea-men nor Ships.

Anonymous pamphleteer, 1672.

This English ideal of ships, trade, and wealth was also the goal of the four prosperous Boston merchants who purchased the Mount Hope Lands, and founded a plantation based on sound business principals the singular objective of which was to accumulate wealth.

Originally part of Plymouth Colony, Bristol's harbor was the most important seaport of the colony. Few realize that Bristol's harbor was once the fourth busiest seaport in the country. Its harbor is deep and until the twentieth-century accommodated deep-hulled merchant and excursion vessels.

After the death of the Wampanoag Sachem Metacomet (third son of the Great Sachem Massasoit) called King Philip by the English, in the marsh near his Mount Hope throne on August 12, 1676, Mount Hope and its surrounding environs became tempting territory to prospective settlers. The area, containing some 7,000 acres originally granted to Plymouth Colony, was now coveted by the colonies of Massachusetts Bay and Rhode Island. On January 12, 1680, King Charles II confirmed the claim of Plymouth Colony.

In September 1680, the land called Mount Hope Neck and Poppasquash Neck was purchased for £1,100 by four Boston merchants who vigorously began developing a town and inviting settlers to populate it.

Within a decade of the town's founding in 1680, a modest ship building industry started; one of the earliest recorded ventures occurred in 1686 when Judge Nathaniel Byfield, one of the town's original four proprietors, shipped horses and onions to the West Indies Dutch Guiana Colony aboard his sloop the *Bristol Merchant*. This was Bristol's first sloop, it was commissioned by Byfield thus essentially establishing Bristol's first shipyard. At the early date of 1690, fifteen vessels were owned by town residents engaged in foreign commerce. Soon after settlement, Bristol's farm crops and livestock were being shipped out of the harbor. In 1696 the Bristol-built merchant ships the *Grampus* and the *Dolphin* were launched.

The town was planned upon a far more liberal scale than any other settlement made in New England up to that time.

The so-called Grand Articles, a form of "constitution" was an unusual document for the times; it was signed by the eighteen original settlers. The "Articles" spelled out the arrangement and requirements of the town and its buildings. Paramount in the document was the plan for the town's three principal streets: Thames, Hope, and High Streets, running parallel with the waterfront; widths and lengths of the streets were specified. It was further required that "all houses should be two stories high, with not less than two good rooms on a floor."

The town's major north to south roads, Metacom Avenue, formerly Back Road (Rt. 136), and Hope Street which becomes Ferry Road on its southern extremity (Rt. 114), are the lengthwise divisions of the town. These two streets cut Bristol into three sections, each section having an impact of the past and present land development. The original platting of the town laid out the compact part of town and some small farms in the center section, moderate-sized farms in the western and eastern sections, and large parcels in the southeast. This pattern of east-west property lines which run between the major north-south highways still exists. From many locations along these roads the water of Bristol Harbor is visible, stone walls, minor roads, and the perimeters of modern subdivisions represent the location of land divisions dating from the town's origin.

The compact part of Bristol is located on the west side of Bristol Neck, facing the harbor. This part of town is laid out as a grid with wide streets meeting at right angles to form somewhat square blocks. This pattern dates from 1680 and is still clearly in evidence. The streets in this area are densely developed and lined with rows of houses dating principally from the eighteenth and nineteenth centuries. The compact part of town has a rich variety of historic buildings and, at the same time, a remarkable image of unity that is evident because of the regular and continuous alignment of structures set close to the street line, the use of wood as the principal building material, and the repetition of gable and shallow hip roof treatments—all this visual excitement brings joy to the eye of the perceptive viewer.

During the Revolutionary War, an incursion by English and Hessian troops in 1778 resulted in the destruction of the majority of Bristol's original buildings. Because of the destruction Bristol is left with an unusually consistent collection of houses constructed in the ensuing period between 1780 and 1820. The oldest building is the 1680 Deacon Nathaniel Bosworth House; also known as Silver Creek. Exactly why this large dwelling was left unscathed by the invader's torch is lost to history. It was in this building that the first Congregational worship services were held, Deacon Bosworth presiding. This house standing just north of the Town Bridge, that crosses the Silver Creek tidal pond, has seen many changes in interior alterations, additions of various wings, and a porch with Greek columns, now removed.

The citizens of the Town of Bristol, Rhode Island are justifiably proud of the town's architectural heritage. To a great measure, Bristol's pride is in its legacy of hundreds of restored Federal-era homes; classic gems generally preserved as originally built for future generations to admire. In all of the state of Rhode Island there is no finer cluster of late-eighteenth and early-nineteenth-century structures than in Bristol's well-defined historic district. So enamored are Bristolians of

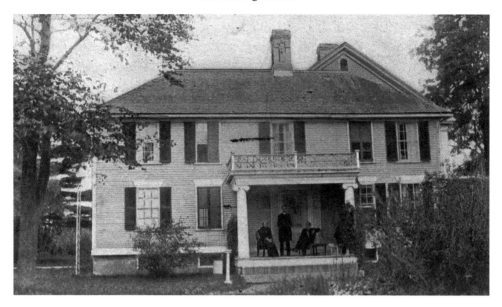

Visible in this *c.* 1903 photo are members of the Perry family lounging on the added Greek Revival porch (now removed). Prominent members of the Perry family include: James DeWolf Perry, (a descendant of Captain Christopher Raymond Perry), Commodores Oliver Hazard Perry, and Matthew C. Perry, and Senators William Bradford, and James De Wolf. DeWolf was the great grandson of Lieutenant Benjamin Bourne who served in the American Revolution.

their architectural heritage they have preserved the best and the mediocre as time capsules of that by-gone era.

The elegance and grandeur of structures brought forth from the pencil of Russell Warren that remain for our inspection and admiration today, would not have been possible without Bristol's great wealth—the profits of three highly remunerative enterprises known respectively as ship building, privateering and slave-trading.

The majority of the town's beautiful antique residences and public buildings are to be found along Hope and High Streets, and a few nineteenth-century homes remain on Thames Street. In most instances, the attractive doorways for which the town is famous have been retained along with certain curious details of windows and cornices. The interiors of these homes are generally restrained and without overly-zealous decorative mouldings. However, it might be fair to say that some interiors are rather grand so far as they still exhibit woodwork of the original period. Staircases, for instance, while delicate and tasteful in design, usually have small square balusters with a delicately turned newel or a mahogany railing wound into a beautifully proportioned scroll. Crown mouldings, door and window casings, and baseboards are equally restrained with only delicately moulded shallow relief.

Unfortunately, not all of the town's early dwellings and commercial blocks have faired well from the "kiss of time." As you will see by studying Kitty Herreshoff DeWolf's 1902 photographs, many residences are stripped of some of their original architectural finery; cornices, rails, brackets, balustrades and so on. During eras of affluence, many owners of early homes endeavored to "modernize" certain features of

their property. Many of the original wooden mantels have been removed in favor of the more imposing marble substitutes that became fashionable. Most all of the older homes' interiors have suffered this fate, more or less, along with some of the exteriors.

One handsome nineteenth-century commercial building, the so-called Sparks' Block, on the corner of Hope and State Streets was razed and replaced by a modern cement-slab bank building.[4]

On the west side of Thames Street between State and Bradford Streets stands a long stone building, which is intimately linked with one of Bristol's most notorious, wealthy and covetous citizens, Captain James DeWolf. This granite warehouse was built in 1818 by the DeWolf brothers James and William, to store merchandise brought home in their many square-rigged cargo carriers. The stone of the building came mostly from Africa and the West Indies, carried as ballast in their ships returning with light cargoes. Later, during the late 1800s through the last decade of the 1900s, this old stone warehouse continued in use by new owners, the Paull, Wardwell, and O'Connell businesses, for stocking coal, lumber storage and sundry building supplies. Now, the old stone building is fully restored; it is an upscale restaurant and bar called DeWolf Tavern.

The casual historian thumbing through many of the old Bristol pictorials will notice a number of waterfront commercial buildings which formed the center of Bristol's thriving commerce and trade neighborhood. This former industrial area contained a lumber yard, wharves, the historic Bank of Bristol (1797), the DeWolf Rum Distillery (1800), warehouses, a gas house, and mountains of coal in open storage bins. Many of these circa 1797–1825 structures are now revitalized to find new functions with their façades preserved the way they looked at the dawn of the twentieth-century.

Bristol Harbor Inn is the central feature of the newly restored waterfront complex called Thames Street Landing. The reconstruction and rehabilitation of these buildings was completed in 2001. Bristol Harbor Inn is the only waterfront hotel on Rhode Island's East Bay.

At the first-decade of the twenty-first century, Bristol is in the midst of a remarkable transformation. The rubber plants and cotton mills are gone. The old National India Rubber Company buildings where once thousands of people earned their living, now serve as apartments for Bristol's low-income elderly. The cotton thread mills are transformed into up-scale waterfront living spaces for the well-to-do—the nouveau "Great Folks". The furrowed and worn face of the former run-down Thames Street is once again brightly dressed in its former nineteenth-century finery.

There are few towns in America that surpass Bristol in the artistic excellence of its many old houses, and the number of these structures is so large in proportion to the size of the town that they dominate its character. So it is that this Town of Bristol built its everlasting legacy to all future citizens and strangers to enjoy the beauty and rarity of its Colonial and Federal-era architecture.

Areas and periods under discussion

In this volume, it is not my intention to focus on one particular period of architecture. Not only have I selected architecturally noteworthy structures from Federal to early twentieth-century for discussion, but also buildings that have played a significant role in the history and development of Bristol. In some cases, it is difficult to separate a building's original owner or current resident from the actual wood and brick. So, included along with details of the structure, you will be occasionally regaled with short biographies of owners-in-residence–historical figures that have left their mark on this grand old town.

Every town that planted its roots along the New England coast had a scoundrel who kept his fellow townsmen buzzing with shocked delight or an equal amount of annoyance. Bristol can claim several who knew no standards but their own.

Captain Simeon Potter, Bristol's most notorious sea captain, was a conspicuous figure in town and one of the most influential men in the Colony; a dashing willful rogue, daring and clever, he sailed the Caribbean raiding settlements, taking his plunder back to Bristol. So successful was Potter at privateering he retired at an early age with a fortune estimated at a quarter of a million dollars—equal to many millions in twenty-first century dollars.

Disguised as Indians, Potter and others from Bristol and Providence boarded His Majesty's revenue ship the *Gaspee* destroying the ship's papers, removing valuables, imprisoning her captain and crew and put a match to the vessel burning her to the waterline. This rebellious act, predating the notorious "Boston Tea Party," ignited the fires of revolution.

When the HMS *Rose,* flagship of the British fleet stationed in Newport came to Bristol in October 1775, firing upon the town, Potter calmed the British with an offer of forty sheep.

Legends abounded of Potter's many daring deeds, albeit some belonging to other men, he accepted as added jewels to the tarnished crown that he wore with ease until he went to his eternal reward in 1806.

Long before the Revolution, the town was noted for its development of a peculiar local wit. There is a story told that Sammy Usher, a town character, when asked by a Brown University visitor to Bristol, "Mr. Usher, sir, I hear that Bristol's claims to fame are three—girls, geese, and onions—what do you do with them all, pray tell?" Unperturbed, Sammy said with great self-confidence, "Oh, sir, we marry all our girls as soon as we are able. We ship our onions down Cuba way and send our geese to college."

The town developed a language of its own and local doggerel by the yard, and stories by their many telling grown to quite a yarn. Half-truths lent an air of logic to the rhyme:

> Down town gentlemen, Uptown shacks,
> Goree niggers and Poppasquash rats.

And this well known ditty:

> In fourteen hundred ninety-two Columbus sailed the ocean blue.
> In seventeen hundred eighty-one, I saw General Washington.

Bristol's sea captains, through their trading voyages to Africa, the colonial islands of the Caribbean, and northern and southern Europe became extremely wealthy as did the several families who owned the ships; the firm of Bourn & Marshall owned 42 trading vessels. Unlike other New England coastal towns engaged in marine-borne trade, Bristol's ship owners never abandoned privateering, smuggling or slaving—they found ways to dodge the Federal anti-slavery laws. The success of these voyages stimulated the local economy by establishing all industries supportive of the town's maritime commerce. Every enterprise relative to a bustling seaport flourished.

The town's wealthy barons of industry and trade were, in fact, the ruling mercantile elite. It was during this period of "trickle down" prosperity that citizens began referring to the aristocratic gentry as "The Great Folks;" a description still used as a back-handed complement to some of today's self-aggrandizing, politically connected, and privileged Bristolians.

These prosperous elite, in their role as the ruling class, needed a way to flaunt their accomplishments. Certainly, the most flamboyant way was by building stately homes in a grand style to proclaim their social importance to the common folk.

Fortunately, at the time a young housewright named Russell Warren (1783–1860), had moved to Bristol with his father and brother in order to become involved in the building boom occurring in the town. Russell Warren gave the town chaste architecture in the Federal, and Greek Revival styles, most examples of which are still seen and admired.

Ministers, pastors, and preachers from several diverse Protestant pulpits delivered the precepts of religion in Bristol. First and foremost the Congregationalists came, then the Episcopalians, the Baptists, and the Methodists. The Methodists' built an imposing edifice on State Street in 1832; after 83-years of service, the building was destroyed by the surprise hurricane of 1938, which ended the Methodists' Bristol ministry.

In the mid-1860s French and Irish Catholics came looking for a place to build their church so the Faithful need not make the long, dusty trip to Warren to attend Mass. Jews came later, and stayed to become part of the mix.

Bristol folks worshiped as they pleased, or did not worship if that pleased them. Over the years, itinerate evangelical preachers set up their tents, preaching fire and brimstone, and the evils of demon rum. The crusades against strong drink did not fare well in Bristol; always a hard drinking town, several distilleries were operating very profitably within shouting distance of the abstinence crusading preachers' pulpits.

Pity the poor and humble black slave said some chest-pounding churchgoers. Even some of the captains immersed in the trade went to church begging God to wipe away their fearsome dreams of the horrors of the traffic—after all slaves are human. However, most times, this was quite easily forgotten, except by the slaves themselves. In Bristol, household and field slaves who did not live in or close by their master's house, lived apart in a shanty-town, up Crooked Lane, (now Bay View Avenue) called Goree—a tract set aside for them to live.

Along the waterfront, in what we now call the Historic District, we can trace the development of this manufacturing quarter from the south line of the Namquit Mill, to the far south of the Richmond Manufacturing Co., the so-called

"Red Mill" on Thames Street south of the foot of Bradford Street. The success of the Cranston Worsted Mill encouraged the building of additional production space. The additional structures eventually spanned the length of Thames Street, bounded by Church Street and Constitution Street. The complex now houses the Robin Rug Division of the Bristol Yarn Corporation.

Charles B. Rockwell, another civic benefactor, brought his Cranston Worsted Mill to town in 1866; this venture became the Collins & Aikman Corp., an enterprise that firmly established the basis for high quality woven cloth made by skilled Bristol hands.

Familiar family names in a town are the milestones of eras and industry. The Herreshoff brothers designed boats that started the nation sailing in sleek and speedy pleasure craft contrasting the trading sloops and coasting vessels of an earlier century. Dr. Ramon Guiteras made a presentation to the town of the magnificent school building with the Greek temple façade facing Bristol Harbor; Col. Samuel P. Colt, the town's most generous benefactor employed hundreds of Bristol citizens at his National India Rubber Company.

Other recognizable names in Bristol's formable history are: Bosworth, Bradford, Church, Coggeshall, DeWolf, Diman, Drury, Gladding, Gorham, Haffenreffer, Hopkins, Howe, Leahy, Marshall, Munro, Pearse, Reynolds, Rockwell, Usher, Wardwell, and Warren, some old, from the foundation of the town; some newer, from the town's middle years; and some very new, from the early-to-mid twentieth century. Every decade many more are added to become part of Bristol's richly patterned fabric, and after fifty years or so, they too become an integral part of the town's celebrated story.

The town's most notorious privateer and slave-trader Captain Jim DeWolf once owned Hog Island.[5] At his death in 1837, he left it to his son-in-law Ray Perry. Defining it as, "… that well-known island called Hog, hereafter to be called Perry." For a few years one could find it marked on nautical charts as "Hog or Perry Island." The name never took hold however, because behind his back irreverent Bristolians called Lieutenant-Commodore Raymond H. J. Perry, USN, "Commodore Hog," and one local wag named his hog "Commodore Perry."

Speaking of his home town, Bishop Mark Antony DeWolf Howe (1808–1895) said, "The villagers of Bristol, having little intercourse with the outside world, became in many respects a peculiar people, and of these, the few who differed from their neighbors were decidedly eccentric."

Town biographer George Howe once wrote of his hometown, "The Bristol character was a perpetual battle between conscience and cupidity. The old-timers were generous and skinflint, irreverent, pious and scandalous, antlike for work and catlike for fighting. They loved sport and laughter, and they never took themselves too seriously."

Bristol, Rhode Island, the shire town of the smallest county in the smallest state, nestles on a double-pronged peninsula shaped like a lobster claw that pokes into Narragansett Bay. The town, attached to the rest of the world by a narrow two-mile strip called The Neck, developed a singular personality because of its isolation; now she offers herself to be admired as the little town with an historic past and a bright and promising future.[6]

Bristol Train of Artillery

Excluding religious institutions, and education, the Bristol Train of Artillery is the oldest organization in Bristol, Rhode Island. The BTA has sustained an uninterrupted existence since February 12, 1776, the date of establishment by receipt of its charter.

The BTA has sent members into every war in which the country has fought since the War for Independence. It has been called upon to assist in suppressing riots, it has performed police duties, it has assisted as honor guards for presidents and other distinguished Bristol guests, and it has supported countless civic and patriotic celebrations at home and in other cities and towns cultivating good will everywhere.

Bristol Township

When the Mount Hope Lands were settled in 1680, it was a colonial outpost in the wilderness under the jurisdiction of Plymouth Colony. Bristol became a township when its boundary lines were incorporated in 1746 and became a part of Rhode Island Colony.

At a town meeting on September 22, 1685, it was determined that a self defense corps. should be formed. Proprietor John Walley was named a Major and Nathaniel Byfield was commissioned a colonel in the newly formed militia. At the same meeting the town ordered a rate to be made of £40 to be raised in two months to buy gun powder, lead, flints, muskets, drums and colors.

Stephen Burton, Sergeant John Cary, Captain Benjamin Church, Colonel Nathaniel Byfield and Deacon Bosworth were chosen as a committee to join the commissioned officers of the town in ordering concerns relating to militia affairs.

The first training day was August 9, 1688; ten male citizens took the oath of fidelity and drilled that day.

On July 3, 1690, at a town meeting John Sassin and Sergeant William Throop meet with the commissioned officers to consider what need be done for the preservation of the town in case of an assault by an enemy by land or sea.

At a March 23, 1692, it was voted that Stephen Burton, Mr. Blagrove and Captain Gallop meet with the military offices to inspect and look into the condition of the town in respect to arms and ammunition. Each settler owned the necessary arms without which no house hold was complete. These weapons included a pike, musket, bayonet, two-edged sword, rapier, and a cutlass.

By 1695, the town's permanent population numbered 375 souls, this number including freemen, indentured servants, and Negro and Indian slaves. During these early decades everyone was known to one another in the community, and known rather intimately. Certainly, there was a need of a considerable measure of cooperation in all things for the common good, including defense.

State Chartered Militias

By 1714, there existed various and scattered military corps that were formed into the First and Second Regiments of the Militia of Rhode Island. These regiments existed for the next sixteen years.

The first independent chartered command was organized in 1719 under the name of the Providence Troop of Morse. By 1730 the Second regiment was composed of twenty-three companies; the volunteers from Bristol were part of the Second Regiment.

By 1760, each of Rhode Island's five counties had a regiment. The Bristol County regimental commander was Colonel Thomas Greene. The county regiment formation continued for fourteen years, without change, until the rumbling of the impending revolution aroused the people to much concern that war clouds are on the horizon.

Concord and Lexington

Many of the military companies marched to Boston when news of Lexington reached Rhode Island Colony. The strength of the Rhode Island forces in Boston was 1700 men; the Rhode Island contingent was led by Brig. Gen. Nathaniel Greene.

Six days after the battles at Concord and Lexington, on April 25, 1775, the town of Bristol voted that a watch should be set and that, "… all men, from the age of sixteen to sixty, shall be liable to attend upon said watch."

The town alarm post was located on the south side of State Street, between High and Hope streets, the site where the BTA was formally instituted ten months later.

On February 12, 1776, the Train of Artillery in the Town of Bristol was instituted at a town meeting. The militia company now had a formal name for the first time.

The citizens elected Robert Jolls as captain, and Samuel Reed as lieutenant. Captain Jolls served as commanding officer for three months. He was replaced by Captain Jeremiah Ingraham who also served for a period of three months. In August 1776, Captain William Throop was elected commanding officer, holding that office until April 1784.

The BTA built and manned two gun batteries. One located at Poppasquash with 6 artillery pieces, each cannon being an 18 pounder. The second battery was located on Bristol's southwest shore facing Hog Island. This battery consisted of eight pieces; each cannon being an 18 pounder.

On May 4, 1776, the Rhode Island General Assembly formally renounced allegiance to Great Britain; on July 18, 1776, the Declaration of Independence was formally approved by the Assembly. From this date forward, the style and title of our government was changed to be forever, the State of Rhode Island and Providence Plantations.

Source: *History of the Bristol Train of Artillery, R.I.M.*, by Brig. Gen. Raymond Thomas, 1976.

Chapter 1

Founders and First Settlers

We know the four men who originally signed the Grand Deed of the Plymouth Colony and purchased the Mount Hope Lands had acquired their fortunes as merchants; they are John Walley, Stephen Burton, Nathaniel Oliver, and Nathaniel Byfield. Soon after purchase, Nathaniel Oliver transferred his share of the purchase to Nathan Hayman. Although not widely known as a Proprietor, Hayman is named in the records of the town's first meeting as an original Proprietor.

The four proprietors had the same option as every potential purchaser to inspect the tract before committing to buy. Thus, they must have been reasonably sure of the success of their enterprise before paying the £1,100 purchase price.

In this chapter we will investigate the origins and the manner of men these were who had the vision and ambition to set about founding the Town of Bristol in the wilderness of the Mount Hope Lands.

John Walley

The Honorable John Walley was born 1642 or 1644, in London, England and died in Boston, Massachusetts on January 11, 1712. His father was the Rev. Thomas Walley, rector of St. Mary's White Chapel, London. John came to Boston before his father, who arrived May 24, 1663 on the ship *Society*. He married in Boston or Barnstable, to Sarah, whose maiden name is unknown. John obtained the rank of major in the Ancient and Honorable Artillery Company in Boston in 1671, and for many years was a member of the Council there and Judge of the Superior Court. His signature is the first on the Grand deed of August 27, 1680 when he purchased an eighth part of the Mount Hope Lands.

John was living in Bristol in 1684 when he was Representative to the General Court of Plymouth Colony. The 1689 census of Bristol lists Major Walley as living there with a wife, five children, and four servants. In 1690, he commanded the land forces during Sir William Phip's unsuccessful expedition against Canada.

As a merchant, he earned a fortune; in his old age, he developed a painful disease that caused him to return to Boston to live, where he died. The will of Major John Walley named his son John as executor; two unmarried daughters, Elizabeth and

Lydia were each left £1,500, and daughter Sarah, widow of Charles Chauncey with her four children, Charles, Mary, Isaac, and Walley received a share.

Stephen Burton

Stephen Burton's birth date and place of birth is unknown, he died on July 22, 1693. He was the best educated of the four proprietors; it is said he attended Oxford. He signed the Grand Deed on August 27, 1680, and purchased an eighth part of the Mount Hope Lands, and he was the first recording officer of the County as Clerk of the Peace, and he was a representative of Bristol to the Plymouth General Court in 1685, '86, '89, '90, and '92. He built a house in Bristol on Burton Street, which the British burned in 1778.

Stephen was a merchant in Boston, Massachusetts where he married Abigail Brenton on February 9, 1673. Abigail was daughter of William and Martha Brenton of Boston and Newport, Rhode Island; she was buried in Bristol on March 30, 1684. William Brenton was Governor from 1666–1668.

Burton married again on September 4, 1684 to Elizabeth Winslow, daughter of Governor Josiah and Penelope Winslow of Marshfield. Josiah was the only surviving son of Governor Edward Winslow of Plymouth Colony who came to North America on the *Mayflower* in 1620.

Stephen Burton died intestate and four deeds, two in Bristol County, and two in Middlesex County are listed in *Mayflower Fame in Progress, Edward Winslow (p. 3-4), identify his heirs.*

Nathaniel Oliver

Nathaniel Oliver, born in Boston, Massachusetts on March 8, 1652, died there on April 15, 1704; he was the son of Peter and Sarah (Negate) Oliver. Nathaniel married in Boston on January 3, 1677 to Elizabeth Brattle daughter of Thomas and Elizabeth Tying Brattle of Boston.

Nathaniel, a wealthy merchant in Boston was on the Committee of Safety in 1689 after Governor Andros was overthrown, and he became a freeman in 1690. Although he signed the Articles of the Grand Deed as a proprietor and purchased an eighth part of the Mount Hope Lands, he never settled in Bristol. In 1687, he gave a bell to the Bristol Congregational Church, which was founded in 1684. His interest in the town was great enough; however soon after his investment, he sold his share to Captain Nathan Hayman. Captain Hayman replaced him as one of the four proprietors before the first town meeting on September 1, 1681.

Captain Nathan Hayman

The name of Nathan Hayman appears in the records of the first town meeting as one of the four proprietors. However Wilfred H. Munro lists N. Byfield, J. Walley, N. Oliver, and S. Burton as the first four signers of the Articles on August 27, 1680, each of whom purchased an eighth part of the Mount Hope Lands. Munro says, at the first town meeting on September 1, 1681 the citizens were admitted by Walley, Byfield, Burton and Nathan Hayman—the four proprietors. Captain Hayman had replaced Nathaniel Oliver as one of the four proprietors before the first town meeting.

Nathan Hayman probably came from England with his father, the Major John Hayman, a rope maker, who was in Boston in 1662 and became a freeman there in 1668. John's greeting was Mister and Major. Nathan lived in Charlestown, Massachusetts and married, March 11, 1673/74 to Elizabeth Allen of Boston, daughter of Captain John and Sarah Allen.

Captain Hayman was a well-to-do sea captain and merchant of Boston. At the time of his death, he was still part-owner of several ships. He lived in Charlestown until he moved to Bristol, where he signed the Oath of Fidelity on August 9, 1686. He is listed in the 1689 census of Bristol with a wife, six children, and two servants.

Nathan died in Bristol, July 27, 1689, at the tender age of 38, and his widow married Nathaniel Blagrove Esq. at Bristol January 18, 1690. The inventory of his estate taken February 3, 1689 included among other things two-house lots by Gladding's lot, three lots by John Smith's lot, two-thirds of the Brigantine *John and Mary*, one-sixth of the ketch *Betty*, one-quarter of the *Pink Katharine* and one-sixteenth of the ship *Michael*. He was called mariner when the receipts of his estate were signed and dated May 25, 1696 by: Nathan Hayman, Jr., mariner, for a double portion; Thomas Church for his wife Sarah, daughter of Nathan Hayman; John Hayman; Rev. William Brattle for the share of his wife (unnamed), daughter of Nathan Hayman; Mary Hayman, daughter and Grace Hayman, daughter.

Nathaniel Byfield

The Honorable Nathaniel Byfield was born 1653 at Long Ditton in the county of Surrey, England, son of Rev. Richard Byfield, and he was the only person of this surname listed in early New England records. He died in Boston, Massachusetts June 6, 1733 in his eightieth year. He was in Boston by 1674 and married Deborah Clark daughter of Captain Thomas Clark a merchant of Boston, she died in 1717. He married his second wife Sarah Leverett on April 18, 1718; she was the daughter of Governor John Leverett of Boston. Byfield had no issue by his second wife.

Nathaniel was a member of the ancient and Honorable Artillery Company in Boston, 1679. He signed the Articles on August 27, 1680 to purchase an eighth

part of the Mount Hope Lands (Munro, p. 96), and built one of the earliest homes in Bristol, on Byfield Street. Soon, he acquired almost all of the land on Poppasquash Neck where he built his homestead. The town rented the house on Byfield Street for public use; its first tenant was the first Congregational minister the Rev. Benjamin Woodbridge.

Byfield was a Representative from Bristol in 1689 to the General Court of Plymouth Colony, and again in 1693 when he was Speaker, and in 1694 in the General court of Massachusetts. He also served as Judge of Probate and Common Pleas for the new Bristol County and later was a judge in Suffolk County, Massachusetts, after returning to Boston to live. There is no birth, death or burial records for any Byfield in the vital records of Bristol, but under the members of the Congregational Church of Bristol are given the names of Nathaniel Byfield and his wife Deborah. The 1689 census of Bristol lists him as Captain Nathaniel Byfield, living there with a wife, two children, and ten servants.

Captain John Gorham

At the early date of 1669, long before the death of King Philip, the General Court of Plymouth Colony granted to Captain John Gorham 100 acres of land in the Mount Hope Lands, which one day would become the town of Bristol, only if he could purchase the land from the Indians.

He made the purchase and he built a simple dwelling north of what is now the North Burying Ground on the west side of the Hope Street. Gorman is, in fact, the first white to settle in Bristol, although he did not stay for an extended period.

John "from Barnstable" was a descendent of *Mayflower* passengers John and Elizabeth (Tilley) Howland he achieved the rank of Captain as a member of the Second Company of the Plymouth Regiment in the Narragansett Campaign in King Philip's War. He removed from Plymouth to Marshfield, then to Yarmouth and later to Barnstable. He died of a fever at Swansea while still on service in the war.

Colonel Benjamin Church[7]

Benjamin Church was born c. 1639 in at Duxbury, in Plymouth Colony and died January 1717/18 in Little Compton, in his 78th year. Benjamin was the son of Richard and Elizabeth (Warren) Church. Elizabeth was the daughter Richard Warren of the *Mayflower* passengers; thus, all of Benjamin Church's descendants have a *Mayflower* line.

Benjamin first settled at Little Compton in 1675, and became a captain of the Plymouth Colony's Army in King Philip's War. After the war, he moved his family to Bristol where he is listed in the 1686/87 census as living with his wife, six children, and three servants. As an honored and respected elector of the village, on

September 14, 1680, he signed and sealed the "Grand Articles" for the settlement of the Mount Hope Neck and Poppasquash Neck. On July 7, 1681, the Plymouth Court authorized Church to "cutt and cleare" a more direct way from Mount Hope to Boston. The first proprietors of Mount Hope, 76 in member, Captain Benjamin Church heading the list, meeting in concert on September 1, 1681, decided that the name of the new town should be Bristol.

Church's accolades continued with added honors and responsibilities. In May 1682, he was chosen deputy to represent Bristol in the Colonial Court, at which time he was also chosen first selectman of the town, positions he held during his residence at Bristol. In July 1682, he was commissioned a magistrate authorized to solemnize marriages. He was one of the original eight founders of the First Congregational Church of Bristol.

Church continued living with his family in Bristol until 1705, when he returned to his original homestead farm in Little Compton.

Thrown from his horse when returning from a visit with his sister on January 16, 1718, he was severely injured, precipitating his death about twelve hours later. He is buried in the Little Compton Commons Cemetery.

Doctor Isaac Waldron

Dr Isaac Waldron of Boston, signed with the Proprietors for a sixteenth part of the Mount Hope Lands, however he died in 1683 before the time had expired within which he was to settle in Bristol with his family. He was present as a citizen at the first town meeting in September 1681, as was his brother George.

Captain Timothy Clark(e)

Captain Clark was a mariner, son of the honored navigator Jonas Clark. Timothy signed with the Proprietors of August 27, 1680 for a thirty-second part of the Mount Hope lands. The 1689 census listed him there as head of a household consisting of a wife, five children and two servants.

He returned to Boston and became an important man there, as a constable in 1693, a representative in 1700 and a selectman for some years. He died on June 15, 1737.

William Ingraham, Sr.

Ingraham of Swansea, a cooper by trade, acted as the attorney for the settlers of Bristol. He signed with the Proprietors on August 27, 1680 for a thirty-second part of the Mount Hope Lands. The General Court ratified and confirmed the deed to this land on September 29, 1680.

The Honorable Colonel Nathaniel Paine, Jr.

Nathaniel Paine, Jr. was born October 18, 1661 in Rehoboth, Massachusetts and died in Bristol in 1723 or 1724. He signed the articles on August 27, 1680 to purchase a thirty-second part of the Mount Hope Lands. He moved from Swansea and succeeded Nathaniel Byfield as Judge of Bristol's Probate Court. The 1689 census listed Nathaniel Paine, Jr., with a wife, four children, and two servants.

Captain Nathaniel Reynolds

Nathaniel Reynolds was born *c.* 1627 in England and died "suddenly," in Bristol July 10, 1708.

He was a captain during King Philip's War; he held the rank of lieutenant in command of the garrison at Chelmsford, Massachusetts in the fall and winter of 1675/76.

Nathaniel signed with the Proprietors for a thirty-second part of the Mount Hope Lands on August 27, 1680; he was one of Bristol's original settlers and he was one of the founders of the Bristol Congregational Church. His elected town posts include grand juryman, sealer of leather and a Bristol selectman.

Deacon Nathaniel Bosworth, Sr.

Born September 4, 1617 in England, Nathaniel Bosworth, Sr., came to North America, with his father, Edward, in 1634 on the ship *Elizabeth and Doris*. He died in Bristol August 31, 1690.

He was a cooper, fisherman and Deacon of the Church of Christ at Hull, Massachusetts, where he and his wife Bridget had nine children. In 1683, he left three of his sons in Hull, and moved to Bristol with his wife and daughters and three unmarried sons.

He bought two-thirds of a thirty-second part of the Mount Hope Lands from the Proprietors, where in the1680s he built the town's first frame house on his land on the east side of Hope Street, just north of the town bridge crossing Silver Creek.

Nathaniel became a prominent man in town; he was the first deacon of the First Congregational Church in Bristol. The 1680 census lists him with a wife, two children, and two grandchildren.

Chapter 2

May 25, 1778

In the public record there remain a paucity of facts concerning the British and Hessian incursion into Warren and Bristol. Using the few facts extant, I have cobbled together a likely scenario of the happenings of the day. The principle characters in my narrative are a pair of fictitious young militiamen: Billy Haskins and Gallant Pony.

Five-thirty o'clock post meridian, earthwork at Bristol Ferry.

In the short time remaining before His Majesty's armed forces appear rounding yonder bend in Ferry Road, I will endeavor to record the happenings of this day as they unfolded for my companion and me.

The serenity of this Monday morning May 25, 1778, was shattered when the town alarm sounded from the Congregational Church.

Within minutes of the sounding of the alarm, the Bristol Militia and Captain Pearse's artillery company numbering three hundred men and boys drew up on the State Street side of town common near the rear of the courthouse.

Our military forces under command of Colonel Nathaniel Cary consists of rugged farm hands as well as rough sailor boys, combative village merchants, twelve or so negro slaves, a Wampanoag Indian boy called Gallant Pony and me, Billy Haskins, a man of twenty years of age. Together, in orderly ranks we awaited our officers' orders.

A dispatch rider from the neighboring village of Warren brought news that a troop of 500 British and Hessian soldiers had landed on the west shore of Bristol at a farm between Poppasquash and Warren. The troop was divided into two parties, and marched about 3 miles through the heart of Warren to the Kickamuet River and destroyed two American row galleys—the *Washington* and the *Firefly*—and a great number of scows loaded with munitions destined for an expedition against British ships in Newport Harbor.

To the distress of Colonel Cary and Captain Pearse, the informant said that the British, in a destructive mood had blown up the powder magazine, disabled several pieces of artillery they found and set fire to the Baptist church and parsonage as they regrouped marching south through Warren by means of Main Road to Bristol.

Fearing the aspect of meeting the stronger enemy head-on at Town Bridge at Silver Creek, the American commanders thought it the better choice to harass the opposing forces, Indian-style, from the woods and behind stone fences. Rightfully, they reckoned the enemy would march single file or two abreast at the narrow section of Ferry Road endeavoring to reach the armada of rowboats waiting to ferry them across Mount Hope Bay at the narrow divide that separates Bristol from Aquidneck Island and Newport.

Before marching his Bristol troops out of the village to take their places of ambush on Ferry Road, Colonel Cary took Gallant Pony and me aside. We, being among the youngest and fleetest of foot were ordered to find Colonel William Barton, headquartered in Warren, and inform him of Bristol's dilemma. A note was thrust into my hand addressed to the Colonel informing him of Colonel Cary's plan and invoking him to join the Bristol militia with as many men-at-arms as he can muster.

In Bristol, no one knew that Colonel Barton upon learning of the British invasion of his hometown hurriedly rode to Providence to confer with General John Sullivan about the events currently unfolding.

Then, galloping back to Warren, accompanied by a few dozen horsemen from Providence and gathering recruits in Barrington and other places, Colonel Barton and his brave little army came to the outskirts of the village. He found the enemy in possession of the place, preparing to burn and pillage. When the Americans began pouring into the streets and fields following Barton, the British, thinking that a very large force of soldiers was attacking from their rear, began to retreat toward Bristol.

It was then that the rider was sent off with the news that sounded the Bristol alarm.

Gallant Pony and I started at a quick jog to Warren, a scant five-miles north, in search of Colonel Barton.

Until we reached Frog Hollow, near the dividing line between the villages, we stayed our course on Main Road, the primary highway of the county. Because of concern of running headlong into enemy scouts, who were surely a mile in advance of the principal force, we chose to use the logging trail.

The trail, rarely used for commerce, is normally free of traffic as it is east of and generally parallel to Main Road. The logging trail, meanders through the wood lots and farms of the two towns.

My Wampanoag companion is apprenticed to Bristol's smithy Aaron Prew, he is a praying Indian with the Christian name Peter, but he favors using his tribal name Gallant Pony. In his demeanor, he is quick in the ways of the white man and clever, hardworking, fearless and friendly.

Gallant Pony's glistening reddish-bronze skin, taught over his muscular frame defies his 17 years. He is an unusual sight for these times because 100 years after King Philip's War, very few Wampanoags live in Bristol. After the War, the remnants of the once mighty nation fled their Mount Hope lands, west to Connecticut and New York.

He wears his hair in that peculiar fashion that the young men of his race prefer. His head, except for a very long braided pigtail that hangs off to the right side, is clean shaved. These adolescent braves, when playing their favorite chasing game, taunt their fellows by challenging them to catch them by their pigtail.

His dress is an interesting mix of English and Indian. On his lower extremities, his traditional long deerskin stockings are held up by means of a rawhide thong looped over a waistband; he wears short leather britches to cover his private parts. On his feet are old English riding boots decorated with carved pieces of clamshell and hammered brass discs. Around his neck hangs a decorative chain he fashioned from English copper coins; his medicine pouch of precious objects hangs from his neck.

On special military outings such as this, Gallant Pony decorates his pigtail with a turkey feather and paints his chest, forearms, and face with black and ochre vegetable colorings. His weapons consist of a short, stout steel blade fashioned at his anvil; a slingshot carved from oak and a leather pouch filled with round, ocean-washed stones as ammunition.

My arms consist of a loaded pistol thrust into my waistband, buccaneer-style. With a powder horn and pouch of shot slung across my chest I look every-inch a menacing pirate.

On my head is a sailor's knitted cap from under which my short English-style hair-braid protrudes. Gallant Pony thinks it amusing to grab my braid and yank me off balance when I least expect it, making me fall hard to the ground on my behind.

Gaining access to the logging trail, we hack a narrow path through the thicket of brambles and wild grape vines that form the hedgerow. The trail passes through thinned stands of towering elms and chestnut, and ancient silver and sugar maple trees that border the cleared plantations of widely spaced farmsteads.

Quickly, but with stealth we approach the outskirts of Warren where the logging trail sweeps west closely paralleling Main Road. Musket shots and the voices of the enemy can be heard. The British had indeed sent scouts ahead.

Unceremoniously, a yank on my pigtail pulls me off balance and I fall backward to the ground. Before registering my displeasure at the unwelcome prank, I see a flash and hear the discharge of a musket. A shot zips past where I had stood and lodges harmlessly in a nearby tree.

With equal speed, and with the accuracy of much practice, Gallant Pony aims and fires his slingshot. The pellet strikes the Prussian soldier square in his forehead rendering him unconscious. Swiftly, Gallant Pony runs to the fallen man and with lengths of rawhide bind his hands and feet.

Joining Gallant Pony by the side of our prisoner, we disarm him. I take his musket and sling his pouch of cartridges and shot over my shoulder. My companion takes his saber and scabbard and straps it around his waist.

Encouraged by the success of our first taste of combat, we continue our journey in search of Colonel Barton.

The closer we press forward to Warren Center the louder the sounds of soldiers barking orders, the firing of muskets and the shouts of citizens begging to be left

in peace fill our ears. The sulfuric smell of gunpowder and burning buildings thickens the air.

As we advance into a particularly dense section of the woods, we spy the unnatural color red among the emerging green. Silently proceeding to the strangely out of place color, to our surprise we see a red coated enemy drummer boy of about ten or eleven years of age, sitting in the crotch of a fallen tree with his britches down around his ankles relieving himself.

Stifling a laugh at the unexpected sight, we creep as close as possible without being heard. Then, in my most adult-sounding voice, I shout, "Secure yourself lad, you're surrounded."

Sensing the humor in the situation, Gallant Pony runs toward the boy wielding his newly acquired saber in the air, whooping, what the boy must have thought to be a killing war cry. To the uninitiated of his gentle manner, Gallant Pony is a fearsome sight with his shaved head and painted body. The boy faints from fright at his first encounter with a "wild" Indian.

Within moments, the boy regains consciousness; he is visibly shaking as he looks into the faces of his captors. I offer him a swallow of water from his own canteen.

Retrieving the canteen, I beseech him, "Pray lad, draw up your britches."

"Are you rebel soldiers?" he asks in a trembling childish voice as he wiggles into his britches and makes them fast.

"We are American Militiamen from Bristol on a mission of rescue," I inform the boy.

With a stern tone in my voice, I interrogate the frightened young Englishman, "What mission is it that brings such a large contingent of His Majesty's Army to rain havoc on peaceful Bristol and Warren? Exactly what does your mission entail?"

"To destroy rebel munitions, Sir." Without hesitation, the lad tells of the destruction of the American scows laden with ammunition in the Kickamuet River.

"We have completed our mission, Sir," he blurts. Adding, "We are now retreating to Bristol Ferry where transportation awaits to return us to Newport."

Our capture of the British drummer boy proves to be a most fortunate event. A devious plan is hatched in my head. It is my plan that we three regain Main Road and countermarch north to Warren Center, less than one mile distant, against the south marching British. We two scruffy-looking irregulars, carrying British arms with the red coated drummer leading the way, should be no cause for alarm among the passing red coated regiment.

We hack our way through twenty yards of thicket and take to Main Road just as the central body of British troops begin passing us in disorderly array looking to the right and to the left with muskets at the ready.

As planned, we form a single file with our drummer boy leading the way, I behind him with Gallant Pony close behind. Some soldiers look curiously at us marching in the opposite direction to that of the column interspersed with

civilians taken as hostages and several horse drawn farm wagons carrying what I assume to be looted goods.

A captain, thinking us Tory loyalists is interested for what reason we are returning to the village center challenges us. I salute smartly and say, "Sir, our sergeant has ordered us back to the scene of action to prod along any stragglers and to assess casualties."

The captain waves us on our way and commands, "Be quick about it then, this is not a holiday." He adds in a stern voice, "Smartly now, quick step!"

Obeying the enemy officer's command, we take off in a sprightly jog.

As we proceed to the rear of the retreating British and Hessians their ranks become thinner. Occasionally, we encounter stragglers in groups of twos and threes some obviously weary and others with minor wounds. We bid them to catch up with the main column lest they be taken prisoner by the rebels.

With the last of the enemy to our rear, the streets are clear except for clusters of citizens, men and women, who have left the security of their homes to form water brigades in their attempts to extinguish the fires.

A group of five women brandishing pitchforks and pikes surround us and demand to know our business. I explain that we are Bristol Militiamen carrying an urgent message to Colonel Barton, and that the boy is our prisoner. To further prove our sincerity, I hand the boy over to the women to keep as a hostage.

Secure in our friendly intentions, the women inform us that Colonel Barton is holding council with his officers near the burned out shell of the armory a mere quarter mile down the road. With all haste we proceed to the armory to complete our mission.

Colonel William Barton, a hatter by trade, who makes his home in Warren is much respected by his men and is a great favorite of the citizens in this area. He is honored for his social qualities, his manners, his constant good humor, and his patriotic zeal. It is said that he has an inexhaustible store of humorous anecdotes and bawdy stories.

Colonel Barton had distinguished himself in July last year by capturing British General Richard Prescott.

In June a man named Coffin escaped from Aquidneck Island and sought Colonel Barton at his Tiverton headquarters. Coffin brought intelligence that General Prescott, commanding officer of the British forces on the island, was quartered with relatively light security at Mr. Overing's farm in Portsmouth. Upon learning this, Colonel Barton conceived his daring plan to capture General Prescott.

To confound the many Royalists extant who act as British spies, Barton's expedition to capture Prescott took a roundabout trip through Mount Hope Bay and consumed several days recruiting a force of forty volunteers, all sworn to secrecy. He stopped in Bristol to perfect details and at Warren to see his family. He finally rendezvoused with his party of rangers at Warwick Neck.

On July 9th, one year after the signing of the Declaration, the party launched its attack from the west side of Narragansett Bay. With muffled oars Barton's Raiders silently approached the island going ashore at a point not far distant from Overing's house.

In the hushed solitude of his bedroom, General Prescott was rudely aroused from his quiet reading by Barton himself. He was informed, in a gentlemanly fashion, that he was now the Colonel's prisoner.

Barton's men, however, were not as courteous. With insolence they jostled Prescott, clothed only in his nightshirt, outside into the night. He was hustled through stubby cornfield and pushed into an awaiting boat. The General was soon successfully transported to the Warwick shore where he was imprisoned in a nearby house.

As Gallant Pony and I approach the armory, we can hear the buzz and hurrying of the soldiers gathering around the place. Standing on a coarsely constructed platform, above the mud, the Colonel appears to be consulting with his officers. We push and enter the throng of men pressing close to hear any inspiring words from their leader. I try to make my presence known by shouting the Colonel's name. This only succeeds in raising three boisterous cheers for him.

With vigor, I inch my way to the front of the platform where I manage to gain the attention of a captain.

"Sir, I bring an urgent message from Bristol, from Colonel Cary to be placed in the hand of Colonel Barton," I exclaim while waving the document for the officer to see.

"Come up here and deliver it then," he says with a wave of his hand, and adds with a snarl of blind prejudice, "is that Indian boy with you?"

"Aye, Sir," I reply, stepping briskly onto the platform.

The captain grumpily gestures for Gallant Pony to mount the platform.

"Then you come too," he shouts, waving his hand. He leads us to Colonel Barton and introduces me as a courier of salutations from Colonel Cary.

Coming to attention in front of my heroic compatriot, I salute and address him, "Sir, may I present this entreaty from my commanding officer Colonel Cary of Bristol?"

Colonel Barton returns my salute and retrieves the paper from my hand. He inspects the unbroken seal, assuring himself that Colonel Cary undeniably originated the message. Perusing the hurriedly but neatly written message the Colonel nods agreeably and when finished hands the paper to his captain who shares it with the other officers.

Addressing Gallant Pony and me, Colonel Barton says, "Your Colonel Cary is a prudent commander. He chose his offensive position wisely."

He then adds, "Colonel Cary informs me that I may have complete confidence in you two men to act as guides in leading us on the most expeditious avenue to Bristol Ferry. What say you?"

"Sir," I reply, "that would be via the old logging trail; the very road by which we came here so quickly."

Upon hearing this, Colonel Barton concurs with my opinion; he is very knowledgeable with all the highways and paths in the county.

He queries my reckoning of how far distant the enemy may now be from where we stand.

I reply that the speed of the soldier's progress is governed by the slowest among them and that being wounded and civilians not accustomed to a forced march, their progress is indeed slow. Judging the amount of time elapsed since we saw the end of the enemy column, I reckoned the head of the column must now be approaching Frog Hollow, about two and one half miles from this place.

The Colonel appears pleased by this bit of information. Before turning to his officers to lay plans for our journey to Bristol Ferry, he bids us to procure a horse for ourselves, in his name, and to wait nearby for his command to march.

Most of Colonel Barton's hundred-eighty or so men are on horseback; the ones without horses ride double, the same as Gallant Pony and me. By riding, rather than marching on the logging trail, we will pass the British just about the time they are crossing Silver Creek into Bristol.

Our leader's strategy is quite brilliant. The second rider on the double rider horse is a marksman. It is his plan for additional marksmen to dismount at measured distances, as we pass the enemy, hide undercover of the hedgerow and endeavor to wound or perhaps kill soldiers while avoiding injury to the captured civilians. Each marksman, after discharging his weapon, will proceed south where he would then choose another protected position and fire upon the enemy as they pass. This, in effect, will necessitate the enemy to break ranks and take defensive action, slowing their progress, thus allowing Colonel Barton and his horsemen to proceed to Bristol Ferry unmolested.

We execute the plan flawlessly. When we join Colonel Cary's men, who have thrown up rude walls of earth from which to take cover on both sides of Ferry Road, our strength is about five hundred muskets.

Now, in silence, we await the enemy to traverse our gauntlet.

Thirty minutes post meridian. Bristol, June 4, 1778.

Seven days have passed since the American and British encounter at Bristol Ferry. During the ensuing week citizens have pieced together many of the events of the previous Monday to which we were not privy at the time.

The rider who brought the news to the American officers had grossly exaggerated the number of the attacking forces. To our chagrin we also learned British Colonel Campbell's orders directed him not to attempt a forced entrance into Bristol if he should find opposing American Militia. Rather, he should attempt to avoid a confrontation and depart the area by way of Poppasquash Point.

As the soldiers marched south along Main Road, small squads were sent out, east and west, to visit the farmhouses, which stood back from the road. These forays resulted in many farmers being taken prisoner.

Upon entering Bristol, the troops approached the house of Squire Joseph Reynolds. All of the Reynolds family, with the exception of Mr. Reynolds, had fled the house and taken refuge in a building that stood a considerable distance from the main house. The officer in charge of the detachment that visited this building was very gentlemanly in his deportment, and did not allow his men to molest in

American Revolutionary War re-enactors in British and Hessian uniforms commemorating the May 1775 British march through Bristol in May 1976. The man on crutches represents Mr. Joseph Reynolds. *Author's photo*

Two hundred uniformed actors were bussed to Bristol, walked the length of Hope Street, harassing and taking prisoners of citizens in period clothes. *Author's photo*

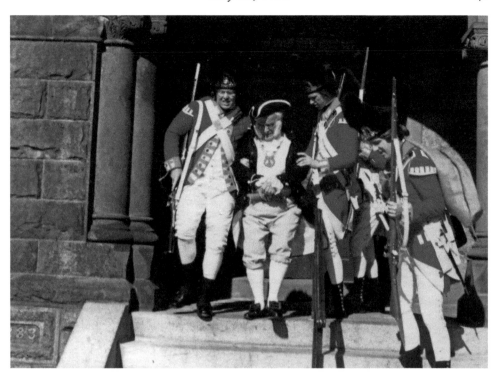

A detachment of "soldiers" take Town Crier James Rielly prisoner. *Author's photo*

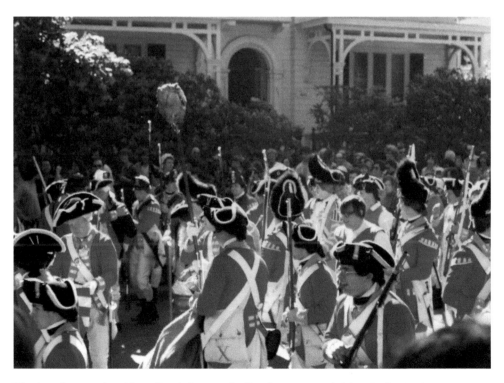

The invaders revel as "Loyalists" cheer and offer them mugs of cider. *Author's photo*

any way those who had taken refuge there. Among the people hiding was a Negro slave, named Cato, whose explosive nature was so inflamed by the excitement that it was only with great difficulty of will that he was prevented from discharging his musket into the backs of the soldiers as they returned to the main body.

Mr. Reynolds did not fare as well. Notwithstanding the fact that he was suffering from a severe attack of rheumatism, the commanding officer forced him to leave his sickroom and accompany the troops to Newport. He returned not many days later, having been exchanged for the British drummer-boy we left in company of women in Warren.

The invader's torch was first put to the home of the Reverend John Burt. With two barns that stood nearby, the house was completely consumed. The British authorities knew of Parson Burt because he was most zealous in his denunciations, from his pulpit, of the course pursued by the English.

South of Parson Bart's house, was burned were the dwellings of Dr. Richmond; this house, and the house of Dr. Aaron Bourne burned. In the possession of Doctor Bourne was a large amount of Continental paper money. When the approach of the British troops was announced by the alarm, the family fearing robbery hid the money in the garret tucking the notes behind the rafters. I cannot imagine the consternation of the family when their home was set ablaze.

A small group of royalists had prepared a cask of punch with which to welcome their friends. However, the troops had stern business before them as they marched to Bristol Ferry, and a well-directed kick from an officer's boot sent the liquor into the street.

The home of Mrs. Woodbury was the next dwelling to receive the attention of the British, which stood on the west side of Hope Street. This too was set on fire. No water was available, but the women of the house came to its rescue. Splashing large pails of milk upon the flames, they succeeded in saving the building.

In all, about thirty buildings were destroyed: the Episcopal Church, nineteen dwellings, and the balance being smaller outbuildings and barns.

By the time the retreating column reached Ferry Road, the Americans had rallied, and we began to attack from our defensive positions. The platoon of prisoners was therefore forced to march mingled with the soldiers to protect them. This unchivalrous use of civilians to shield the enemy from our fire no doubt saved many a British and German life.

The British loss in this skirmish has not been officially established, but we assume it to be considerable because much blood was found on the road where the exchange of fire took place.

For his effort, Colonel Barton was wounded in his thigh and carried to Providence on a litter where he is now recovering.

Chapter 3

Historic Bristol Homes

During the century encompassing 1800 to 1900, Bristol became characterized as the town it is today by the buildings constructed during this period. Bristol is perceived as a colonial and early nineteenth-century town, it is however, to a far greater extent the product of its industrial period than its earlier colonial and federal years. The architectural legacy of the nineteenth and early twentieth centuries is remarkable; the houses, factories, churches, public and commercial buildings remain to document this important stage of Bristol's development.

The middle decades of the nineteenth century evidence the beginnings of these changes, as the new interest in the picturesque and the romantic led to a series of revivals of ancient, medieval, and renaissance styles. The first and most popular of these was the Greek Revival.

Greek Revival houses appeared first in Bristol in the 1830s and dominated Bristol building into the 1870s, long after the style had gone out of fashion elsewhere. Such houses were inspired by publications describing archeological excavations of Greek sites in the eighteenth and early nineteenth centuries and by American sympathy for Greece's struggle for independence in the 1820s. Greek Revival houses are, for the most part, rectangular boxy forms, with gable roofs often turned gable end to the street, and they are characterized by classical detailing–columns, pilasters, and entablatures–heavier, plainer, and more monumental in feeling than earlier federal detailing.[8]

Deacon Nathaniel Bosworth House/Silver Creek (1680–83 *et seq.*), 814 Hope Street

Local legend tells us that Deacon Nathaniel Bosworth, one of the original settlers in the Mount Hope Lands, with a fond memory of the stream that ran through his family's property in England, named his new house on the edge of a salt tidal pond adjacent to Bristol Harbor, Silver Creek.

The house stands at the "gateway" to the town's historic center just north of the old town bridge on the east side of the main road; supposedly the first house erected within the limits of Bristol. The reason Bosworth's house escaped the British torch in 1778 is unknown.

For more than three and one-quarter centuries this colonial-era mansion has seen many owners and many changes. When Bosworth began building in 1680 (or 1683), only the southwest portion was built by him. Successive owners have made the additions, which are seen today; they have strengthened the old manse to preserve its architectural peculiarities, which has withstood the fierce tropical gales that have whipped it over three centuries. The probable reason for the strength of the structure is the durability of the century-old oak trees harvested from the land on which the house is built—used as framing and other structural supports.

When Wilfred Munro wrote about the house in 1880, he said, "The southwest room remains almost as it was when, in 1680, the people of the little settlement gathered within its walls for their first religious service." It must be remembered at the time, Bristol was part of Plymouth Colony and subject to its laws concerning religious service. Every settlement within Plymouth's dominion was subject to establishing a place for Congregational worship and funding the support of a minister. Deacon Bosworth conducted religious services here before the First Congregational Meeting House was built on the Town Common in 1684.

Shearjashub Bourne, a tavern keeper and lawyer of some distinction, settled in Bristol in 1745; in 1750 he bought the Bosworth House. Bourne's wife was Ruth Bosworth, Deacon Bosworth's daughter; she had inherited part of her father's estate. When Captain James Wallace, commander of the HMS *Rose*, bombarded the town in 1775, the Bournes were occupying the house.

Benjamin Bourne, grandson of Shearjashub and Ruth, was Quartermaster General of Second Rhode Island Regiment in 1776, a member of the Rhode Island

Kitty Herreshoff DeWolf's *c.* 1910 photo of the Bosworth-Perry house.

General Assembly, a United States Congressman from 1790 to 1796, and a U.S. District Court Judge from 1801 until his death in 1808.

In 1836 Julia Sophia Jones, Bourne's granddaughter, married James DeWolf Perry, a grandson of Senator (Captain Jim) James DeWolf. The Perrys continued farming on the thirty-acre parcel bordering the tidal pool outflow of Silver Creek.

The northwest elevation of the house was constructed in 1863. At some time during the mid-nineteenth century, a Greek Revival style porch was added to the south side facing the gardens, which is now removed.

After Julia Perry's death, the property was divided amongst her five sons; the youngest, William Wallace, occupied the house until after the horrific 1938 hurricane. In the 1940s the house came under the joint ownership of William Perry, his nephew Bishop James DeWolf Perry, and the Bishop's son, DeWolf Perry. The Perry family owned Silver Creek until 1957 when Alfred Rego, Sr., Consul for the Dominican Republic acquired the property.

Rego subsequently converted the house to five rental units and in the mid-1960s subdivided the land thereby destroying the much admired Victorian-era gardens. Land to the south, abutting the salt tidal pool was purchased by attorney and Bristol Probate Judge Raymond A. (RAT) Thomas. Thomas leased the land to the Cumberland Farm convenience store and gas station.

After a destructive fire at the convenience store in the mid-1990s, the town refused to grant a license to rebuild the store and gas station. After months of negotiations and threats of law suits, the public outcry against Cumberland Farms was overwhelming; fearing a backlash against their other stores, the petitioner

The Deacon Bosworth house and the Thomas Park at Silver Creek Victorian garden and nature trail. *Author's March 2007 photo.*

backed down and Thomas sold the property to the town for the rehabilitation of the wet lands and building a nature trail called Thomas Park.

Late in November 2007, plans for development of Thomas Park and replanting Julia Sophia Perry's Victorian garden were announced. Bristol Parks and Recreation Director Walter Burke said the town had received $180,000 in grants for improving this prime location. He said the focus will be on the plants and wildlife abundant in the area. His vision is of rustic paths through the lush, rich wooded areas and along Silver Creek, with small areas for picnicking, and all of it brimming with butterflies, hummingbirds and other wildlife.

Gary Watros, president of the Bristol Garden Club brought forth several ideas for the park's renovation that tie into its history. Because Mrs. Perry, who during the 1800s lived in the old manse, was an avid gardener, Watros floated the idea of an old English-style garden at the park dedicated to Mrs. Perry.

Munro relates an amusing anecdote told by Julia Perry:

> ... the tradition that several cannon balls, shot from the British vessels during the bombardment, had pierced the walls of the old building and lodged between the ceiling and the floor of the second story. Incredulous listeners had smiled with poorly concealed disbelief whenever the tale was told, but the faith of its narrator never wavered. In 1863 the ceiling of the great parlor was torn down to make some necessary repairs, and Mrs. Perry was sarcastically invited to find the cannon balls. Scarcely had she entered the room when down fell several large sized grapeshot almost at her feet, and the voice of skepticism was hushed.

King Philip House (1680? *Et seq.*), 2 Pokanoket Place

The King Philip House, the subject of on-going professional research concerning its origin, was built in three stages.

Although town records indicate a first stage construction in 1680—just after King Philip was killed near the site—there is no documentation as yet discovered for such an early date. More likely, the original structure was built as an eighteenth century farmhouse (now the central portion of the building), then received its imposing colonnaded three-level addition in the late nineteenth century when the structure served as a hotel. In 1912, when the well-known Haffenreffer family occupied the house as their summer residence, the final section was built—perhaps as servants' quarters.

This historic house derives its name from its proximity to the so-called King Philip's Chair, located less than one hundred yards from the house's front door and just beyond the property's present boundaries. The chair, a natural depression in a large quartz outcrop, is said to be the "throne" where Chief Sachem Massasoit and his son Metacomet (King Philip) held tribal councils for their Pokanokets, the dominant sub-tribe of the Wampanoag nation. This particular geographical place is described by Thomas W. Bucknell, a leading Rhode Island historian, as the most important Native American geological site in New England.

The historic King Philip House. In the early 1900s this antique dwelling became the summer residence of Rudolph Haffenreffer.

King Philip House sits half-way up the eastern side of the two-hundred foot slope of Mount Hope, from which residents may enjoy a panoramic view of Mount Hope Bay northeasterly to the City of Fall River. The house is nestled in a woodland preserve of more than five hundred acres that contain abundant wildlife including; deer, coyotes, foxes, and varied bird life including wild turkeys.

The land on which the house is built, and the house itself, has passed through an array of prominent owners. Prior to 1676, Massasoit (friend of the Plymouth Pilgrims) and his sons Wamsutta (Alexander), and Metacomet (Philip) presided here. In 1680, it became the domain of Judge Nathaniel Byfield, the most important of Bristol's four original proprietors. Byfield sold the land in 1702 to Henry Mackintosh, a founder of St. Michael's Church. The land descended to Isaac Royall, Jr., in 1744 by virtue of his marriage to Mackintosh's granddaughter and heiress, Elizabeth. During the American Revolution the property was confiscated from Royall, an appropriately-named Tory. Former Lieutenant Governor and U.S. Senator William Bradford acquired the house and more than 368 acres surrounding it at the war's end in 1783 from Nathan Milles of Warren who owned it briefly.

The Bradfords, who added additional property to their Bristol holdings, lived in the magnificent home facing present-day Metacom Avenue (the so-called Governor Bradford House), built by Royall in 1745. There is reason to believe the Bradfords rented the easterly portion of their large estate, including King Philip House, to tenant farmers.

Samuel Church, a Taunton Massachusetts businessman, acquired the entire property from Senator Bradford's son, John, in 1837 and operated a model farm on a portion of its spacious grounds.

Shortly after the Civil War, the Church family cleared the eastern slope of Mount Hope and developed a summer amusement park easily accessible from the bustling industrial City of Fall River, Massachusetts. An 1881 engraving of the site appears in W. H. Munro's *Picturesque Rhode Island* Massasoit Amusement Park.

During the 1890s the large colonnaded three-story east wing was added to the original farmhouse, and the enlarged structure became an inn and tavern to serve visitors to the newly-incorporated (1897) Mount Hope Amusement Park.

In 1903, Rudolph Haffenreffer, Jr., a prominent and wealthy Fall River brewer, purchased the failing sixty-nine acre park, which he tried to revive. The acquisition included the King Philip House hotel, the King Philip chair, and several other park buildings, which he later used for his famed King Philip Museum of Native American anthropology. Having become enamored of Bristol, Haffenreffer, in 1912, acquired a much larger parcel that extended his Mount Hope property to Metacom Avenue and the Bradford House with its outbuildings.

From 1912 until Haffenreffer completed the renovation of the Bradford House, he used the King Philip House as his primary summer residence. There he could enjoy panoramic views of his home city from the house's spacious veranda, and he could walk the short distance from the house to his evolving museum.

During his tenancy, probably around 1912, Haffenreffer added a two-story elevation to the rear of the building. It contained a spacious kitchen on the first level with servants' quarters above it. This final expansion of the colonial farmhouse brought the number of rooms to sixteen plus four baths.

After Rudolf's death in October, 1954 at the age of eighty, his wife Maude and his sons, Carl and Rudolf III, donated, in several separate gifts from 1955 to 1958, approximately four hundred and fifty acres to Brown University including the museum and the King Philip House, but excepting about one hundred twenty acres that included the Bradford House. The Haffenreffers owned the Bradford House and its environs until 1999 when the family sold that parcel, which is on the National Register of Historic Places, to the Bristol-based non-profit Mount Hope Farm Trust.

In 1960, shortly after the Haffenreffer grant to Brown, the university carved out the two acre parcel on which the King Philip House is located and sold it to their museum's curator James L. Giddings and his wife Ruth, reserving a right of first refusal on any subsequent sale. Professor Giddings divided the large house into four apartments to augment his academic salary.

In 1986, the house was sold to James and Pam Meyer and David and Karen Angell. The Meyers acquired sole ownership in June, 1990 and enjoyed what Pam described as a "blissful tenure" on the peaceful site. Pam sold the house in March 2007 to historian, attorney, and real estate developer Patrick T. Conley and his wife Gail. This Bristol couple who continue to reside at Gale Winds on Bristol Point, are undertaking a careful restoration of the house and grounds to preserve its historical ambiance and significance. Mindful of the spot's importance to Native Americans, they immediately changed its address from 330 Tower Street to 2 Pokanoket Place with the approval of both the Bristol Town Council and Brown University.

Mount Hope Farm (*c.* 1745, *c.* 1840, *c.* 1914), Metacom Avenue

The land we Bristolians now refer to as Mount Hope Farm, originally consisting of about 550 acres, was in 1680 owned by town proprietor Nathaniel Byfield. Byfield sold the farm in 1702 to his son-in-law Henry Mackintosh. In 1744, the property was inherited by Elizabeth Mackintosh and her husband Isaac Royall from the estate of her grandfather Henry; soon after taking ownership, Isaac Royall began construction of the original house.

The house as we see it today was built in three stages. Royall built the original 2½–story, 5-bay, and gambrel-roof main section consisting of the two-room plan with a central hall, typical of the Massachusetts-style of the day. The brick end walls, containing fireplaces for the main rooms on each floor, are clapboard covered. The west-front entrance is trimmed with a delightful cushion frieze and fluted pilasters with capitals of hand carved flowers bordering an open book.

Upon the death of his father in 1739, Isaac Royall, Jr. inherited the family estate in Medford, Massachusetts. The family owned numerous holdings of real estate, one being Mount Hope Farm in Bristol, Rhode Island. Royall lived in his new Bristol farmhouse with his family for almost 40 years.

A document dated 1762, that now resides in the office of the Bristol Town Clerk, indicates that Royall leased the land for the purpose of farming. The lease agreement states Isaac Royal of Medford has agreed to let his farm (now called Mount Hope Farm) to Bennett Munro. The lease states, "Walls enclosing the fields having been inspected appeared to be in good order." The document is signed by witnesses Simon Tufts, Nathaniel Pearse, and Jonathan Lanton.

The Mount Hope Farm homestead, *c.* 1950.

The Royalls were Loyalists and, one day in 1775 as they left services in King's Chapel, General Gage informed the family that their Bristol house was behind the rebel's lines. Isaac Jr., and his family fled to Nova Scotia and then to England, never to return.

In 1776, the farm was confiscated by the State. The house was used during the early months of the Revolution by Generals Stark, Lee, and Sullivan.

In 1783, the tract was sold by the State to discharge the balance of pay due to the officers and soldiers of the battalions of Col. Christopher Greene, and Col. Henry Shereburne; the new owner was Nathan Miller, of Warren, Rhode Island.

Shortly after Miller's purchase of the farm, he sold it to William Bradford of Bristol. Interestingly, for many years, Bradford was the designated collector of rent on the farm for the State. When he sold it to Bradford, Miller thought he sold a farm of 385 acres and 111 rods. After the sale, the property was resurveyed and found to contain but 368 acres and 40 rods; a difference of 17 acres and 17 rods, the disparity in the value of the nonexistent acres amounted to £103 10s., which was returned to Mr. Miller.

William Bradford (November 4, 1729–July 6, 1808) was a physician, lawyer, and United States Senator from Rhode Island. He was born at Plimpton, Massachusetts, and was the great-great-grandson of the William Bradford who had been Governor of Plymouth Colony. He first studied medicine at Hingham, Massachusetts and then practiced at Warren, Rhode Island.

After Bradford took permanent residence in Bristol, he was elected to the colonial assembly in 1761. He was elected to additional terms at various times up until 1803, and served as Speaker of the Assembly for eighteen non-consecutive terms. He expanded his abilities with the study of law, in 1767 he was admitted to the bar, and then established a practice at Bristol. He served as Deputy (lieutenant) Governor from 1775 to 1778. In 1776, while serving as Deputy Governor, he was elected as Rhode Island representative to the Continental Congress, but he did not attend any sessions.

Bradford served on the *Committee of Safety* of Bristol County, Rhode Island from 1773 to 1776 and on the *Committee of Correspondence* for the Rhode Island Colony. When the British Navy bombarded Bristol on October 7, 1775, his home in the village was one of the few buildings suffering damage; he also joined Capt. Simeon Potter and others in negotiating a ceasefire with Captain James Wallace of the offending British vessel the HMS *Rose*.[9]

It is also important to credit Bradford as being one of Rhode Island's leading Federalists and a powerful force behind Rhode Island's ratification of the Constitution.

After the United States Government was established, Bradford became a U.S. Senator on March 4, 1793. He was the President *pro tempore* of the Senate from July 6, 1797 until he resigned from his seat in October of that year. He returned to his home in Bristol and died there in 1808. Originally buried in Bristol's East Burying Ground, his grave was later moved to the Juniper Hill Cemetery.

After his death, his estate passed to his son John. In 1837 Samuel W. Church, a Taunton, Massachusetts merchant purchased the property and developed it as a model farm. It was Church who added the middle, 2-story Greek Revival section

of the house, with a hipped-gable roof about 1840, and about 1914 the 2-story, gable-roof east ell was added.

In 1917, Rudolf F. Haffenreffer II, a Massachusetts, and Rhode Island brewer bought the property. Haffenreffer began a massive restoration and development of the property's buildings and gardens, and he converted land previously under cultivation into a fine dairy farm with choice Guernsey cattle.

In its three-plus centuries of history, there have been only a dozen non-Pokanoket owners, some descendants of previous owners. They include: Nathaniel Byfield, Henry Mackintosh, Thomas Palmer, Isaac Royall, the State of Rhode Island, Nathan Miller (1743–1790), William Bradford (1729–1837), John Bradford (son of William), Samuel W. Church, R. F. Haffenreffer II (1874–1954) and III and family and The Mount Hope Farm Trust in Bristol.

In 1999, The Mount Hope Farm Trust in Bristol acquired Mount Hope Farm from the Haffenreffer Family. The Trust purchased the property for $3.3 million with the support of a $1.5 million bond issue approved by the citizens of Bristol with an 83 percent margin, a State open space grant of $400,000, a generous loan of $500,000 from Saint Michael's Episcopal Church (1718), and an anonymous donor who gave one-million dollars.

Generally, since ownership of the property by the Haffenreffers, the old house has been referred to as "The Governor Bradford House". Rhode Island historian and author Patrick T. Conley, Ph.D., suggests, and I concur, it is time we stop calling the house by that name. Conley says, "This creates confusion with the much better known ancestor – Governor William Bradford of Plymouth Colony. Bristol's William Bradford held the office of Rhode Island lieutenant-governor, a very inconsequential position, whereas he held the higher office of president *pro-tem* of the United States Senate in 1797. Therefore, wouldn't 'The Senator Bradford House' be more appropriate?"

Here, I must debunk the popular story about President George Washington spending a week as the guest of Senator William Bradford, at Mount Hope Farm. The earliest reference I have found concerning this fictitious event is on page 243 of *The Story of the Mount Hope Lands* by W. H. Munro (1880). Munroe writes, "In 1793, when he [Bradford] was a member of the United States Senate, President Washington passed a week with him at 'The Mount.'"

Official records, including Washington's daily diary, document Washington's journeys through Rhode Island: 1756, Colonel Washington traveled from New York through Newport and Providence to Boston; 1776, as Commander-in-Chief of the Continental Army, General Washington traveled from Boston through Pawtucket and Providence going on to Norwich and New London; 1781, General Washington traveled from Connecticut through Newport, Bristol, Warren, and Barrington on his way to Providence; 1790, President Washington traveled from New York to Newport and Providence by water. Records certify these four known journeys through Rhode Island. General Washington's ride through Bristol, in 1781, is the subject of an amusing ditty sung to him by assembled school children as he crossed Town Bridge at Silver Creek.

Munro offers this account of the origin of the story of Washington's visit with Bradford: "The descendants of Governor Bradford, with pardonable pride, love to tell the story that has been handed down to them..."

This often told story of President Washington's week-long stay at Mount Hope Farm has no basis in fact in any official government record or personal diary of the period. The best that can be said of this tale is that it is a delightful town legend.[10]

Longfield, (1848–1850), 1200 Hope Street

Abby announced the good news at once to the family, and it was not long before it reached the village. What had started out as a statement that Mr. Gibson was to build a home for Abby near the DeWolf Farm had grown into the report that "Mr. Gibson was building a mansion on the Neck."

Josephine Gibson Knowlton, *Longfield, the House on the Neck*

The Abby DeWolf and Charles Dana Gibson House, Longfield, was built for Charles Dana Gibson, grandfather of the artist, of the same name, who created the classic-American Gibson Girl.

Charles Dana Gibson, the artist (1867–1944) was born in Roxbury Massachusetts. It is a Bristol legend that the model for young Gibson's creation was his aunt Josephine Gibson Knowlton. In his youth Gibson often visited Longfield, but it was not his primary home.

The name Longfield is derived from the long-narrow 60-acre meadow, on which the cottage was constructed; the land was part of the 300-acre Henry DeWolf farm, given to Abby DeWolf when she married Charles Gibson.

Longfield is on the National Register of Historic Places because of its association with noted owners and occupants:

 1848 - 1867: Charles Dana Gibson and Abby DeWolf Gibson
 1867 - 1901: Abby DeWolf Gibson
 1901 - 1915: Langdon Gibson, Josephine Gibson, and Annie Gibson Hopkins
 1915 - 1969: Josephine (Mrs. Daniel) Gibson Knowlton
 1969 - 1972: Daniel Gibson Knowlton

The design of the house is attributed to esteemed Bristol architect Russell Warren. A symmetrical, 2½-story, 3-bay house with a steep gabled roof, Longfield is an example of the Gothic Revival style, popular for suburban cottages. Exterior detailing includes the two Gothic casement windows above the front entrance, gable mouldings over all the doors and windows, and pinnacles at the gable peaks.

The interior, which exhibits a mix of stylistic detail including Greek Revival, Gothic, and early Italianate designs, has a traditional four-room, rectangular floor plan with a long center hall.

The once elegant Longfield mansion, *c.* 1902. The house and property has fallen upon hard times over the second half of the twentieth century. At the time of this writing, restoration plans are underway. *Katty Herreshoff DeWolf photo*

Josephine Gibson (Mrs. Daniel) Knowlton. Artist Charles Dana Gibson.

Changes to Longfield have been minor; about 1907, the front porch was rebuilt, and the side porch enlarged. The original color scheme was a bright red with darker red trim. Josephine Gibson Knowlton recorded the history of the house and its occupants in two books, *Longfield* (1956), and *Butterballs and Finger Bowls* (1960). The acreage is now greatly diminished and outbuildings moved, altered, or destroyed.

The historic structure has fallen upon hard times during the past 20 plus-years of neglect. The structure has been neglected to the point that rot has taken its toll, and the grounds have become littered with castoffs. The Bristol Town Council notified the owner of the violation of the town's blighted property ordinance.

During the summer of 2007, the house was offered for sale; the asking price: $500,000 cash. The new owner, historic property developer James Towers, promised to restore the house to its one time grandeur; a conservative estimate of the cost of restoration is close to one-million dollars. That promise was dashed during the hard economic times of the Obama administration, and the house has fallen deeper into ruin.

According to a *Bristol Phoenix* article dated October 17, 2013, rescue of the crumbling manse may be coming soon. New owners Margo Katz and Craig Kratoval of Cranston, Rhode Island plan to establish a not-for-profit organization and seek grants for the for the building's restoration.

Farmer John DeWolf/The Farm (1787, 1798, *c.* 1900), 70 Griswold Avenue

Known simply as The Farm, this two-story, five-bay, gable-roof, Federal farmhouse was built in three sections. After the Revolution, John DeWolf (1760–1841), gradually acquired land on both sides of Griswold Avenue until his farm stretched from Bristol Harbor to Mount Hope Bay. DeWolf began building this house in 1787 as a summer home; he began work on his winter home at 433 Hope Street in 1789.

DeWolf contracted housewright Simeon Pierce from Middleborough, Massachusetts, to do all the work in the same manner as done at his brother, Captain Levi DeWolf's house. Pierce's payment for constructing and finishing the house was $225, of which $50 was "in money and the remaining one hundred and seventy five dollars in West India goods at the customary price." The manner in which DeWolf chose to pay Pierce attests to his shrewd business style. Even after a careful reading of the building contract, it is impossible to determine with any certainty that the agreed payment of $225 includes the cost of building materials or the cost of labor alone.

Following is a copy of the contract between DeWolf and Pierce to build DeWolf's Griswold Avenue house. The few words on the original document that are illegible are indicated by [?]:

Memorandum of an agreement between Simeon Pierce of Middleborough in the county of Plymouth, state of Massachusetts, Housewright, and John D'Wolf of Bristol

in the county of Bristol and state of Rhode Island, March [?]. That I, the said Simeon Pierce, do agree to finish all the carpenter or joiners work in D'Wolf's new house now building by said Pierce, say, the inside of it excepting the lower N.W. room and the chamber above it, that is to say, to finish the S.W. room and the chamber above it, the kitchen, bedroom closets, front entry stairs and stair case, Sinkroom [*sic*] with closet in it and all the chambers above said [?] rooms and sinkroom together with all cupboards, entrys [*sic*] and closets designed and belonging in said house, back and garret stairs and garret floor to be laid he is to [?] the inner sills in a proper manner and do all the necessary carpenter work or fraiming [*sic*] about the chimney and [?] to say, to finish all and every part of the inside of said House [*sic*] in a comp [?] workman like manner. Leaving the N.W. room and chamber above it as above mentioned. The doors are to be made and hung even for those rooms, and the under floors laid in the last mentioned room and chamber. It is agreed that all the work be done in the same manner as Capt. Livi D'Wolf's is done and finished in his house lately by said Pierce. That every room, entry, closet or cupboard in said house is to be finished all ready for the masons for lathing. And during the time the said Pierce is imployed [*sic*] on doing and completing said work he is to find himself and people with vitelles [*sic*] and drink and lodging without any expense whatever to the said John D'Wolf. And to finish said work by the twentieth of August next. And after the inside of said house is finished as [?] and [?] the said John D'Wolf does agree to pay or cause to be paid to the said Simeon Pierce Two hundred and twenty five Dollars [*sic*]. *Fifty dollars in money and the remaining one hundred and seventy five dollars in West India goods at the customary price. In witness whereof we [?] hereunto set our hands this [?] day of June 1798.*

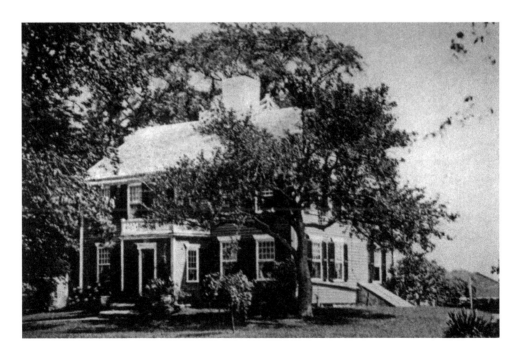

Farmer John DeWolf's Griswold Avenue home. *c.* 1903. *K. H. DeWolf photograph*

(S) Simeon Pierce

(S) John D'Wolf

N.B. It is Particularly understood that the said S. Pierce do agree to make and hang the window blinds for the S.W. and S.E. rooms and a Venetian blind for the closet windows out side.

There is an account of each piece of timber used in the frame of the house: 10,036½ feet.

According to Charles O. F. Thompson,[11] "The house is an unpretentious structure built from timber said to have been cut on the place, well- built and substantial."

According to Herreshoff family historian Nathanael Greene Herreshoff III, the 70 Griswold Avenue farm house was DeWolf's summer home. His winter residence was 433 Hope Street.[12] During his days at The Farm, he devoted his time to agriculture, and the raising of cattle, and sheep; because of this occupation he acquired the familial name of "Farmer" John.

Thompson comments upon some of the produce of Farmer John's farm, [13]

The era of onion raising developed by a direct West India trade and thousands of bushels of onions, carrots and potatoes carried in his Bristol ships, at a good profit, to the lands of sugarcane and coffee, brought a lot of money into the town. In one year alone Capt. D'Wolf's onion crop brought him in over twenty thousand dollars.

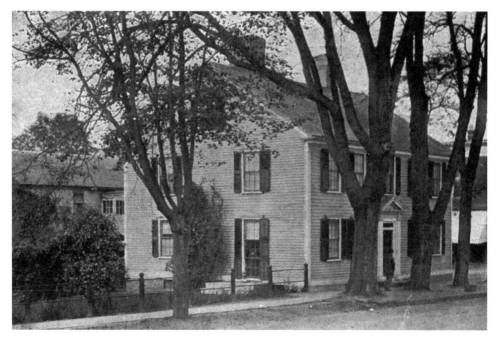

Farmer John DeWolf's town house, built in 1789, on lower Hope Street. The house was moved in 1915 to the southwest corner of Hope and Bradford Streets.

After Farmer John DeWolf's death in 1841, the property was divided between his two grandsons; Dr. John James DeWolf received the land west of Ferry Road (including what is now the Blithewold, St. Columban Monastery, and Wind Hill lands), and Professor John DeWolf (1786–1862), who represented Bristol in the General Assembly and taught chemistry at Brown University, received the land east to Mount Hope Bay including the 70 Griswold Avenue house which he made his home. Upon his death, title to "The Farm" passed to his son Algernon Sidney DeWolf (1822–1879), who married Clara Diman, daughter of Rhode Island Governor Byron Diman, in 1847. Upon the death of Algernon Sidney in 1879, the estate passed to his widow Clara Diman DeWolf (1828–1913), and their children Byron, John, Clara Anna, Lewis, and Grace.

Around 1885, the family divested itself of the land east of Metacom Avenue.

Algernon Sidney DeWolf's daughter Clara Anna DeWolf married Nathanael Greene Herreshoff (1848–1938), founder of the Herreshoff Manufacturing Company in 1883.[14] Captain Nat never owned The Farm. Herreshoff family historian Nathanael Greene Herreshoff III says:

Above left: According to family historian Nathaniel Green Herreshoff III, Dr. John James DeWolf descended from Professor John DeWolf's first marriage to Elizabeth James, who died in 1818; their son John James DeWolf was born in 1807. In 1843 Dr. DeWolf, who had been an orthopedic practitioner in Bristol, R.I., became convinced of the legitimacy of homeopathy and settled in Providence where he established his practice.

Above right: Gov. Byron Diman. As a prominent member of the Whig party, he served as a state senator, and as Rhode Island's Lieutenant Governor between 1840 and 1842, and 1843 and 1846. In 1846, he successfully campaigned for the Rhode Island governorship, and served in that capacity until 1847.

I understand that in 1892, Capt. Nat paid off outstanding debts and had the property put in his wife Clara Anna's name. Upon her death in 1905, her children [Agnes Müller, Algernon Sidney, Nathaniel Greene Jr., Alexander Viets Griswold, Lewis Francis, and Clarence DeWolf] inherited The Farm.

The Herreshoffs lived here only during summer months. It is said that Capt. Nat spent very little time at The Farm finding his pleasure in town at his drawing board and work bench.

In 1950, the family subdivided some of the land from the original house and lot; the house at 70 Griswold Avenue and two acres (Plat No. 163, Lot No. 3) was purchased by John R. and Ruth B. Watson. The Watsons sold the property to Roderick W. and Roberta J. Butlin in 1976; the Butlin's are the current owners of record.

Algernon Sidney DeWolf Herreshoff (1886–1977), married Rebecca Chase (1894–1991), the daughter of Prudence Island's Captain Halsey Chase. At the time of this writing, The Farm consists of Plot No. 163 and Lot Nos 1, 4, 6, and 62 on the south side of Griswold and west side of Metacom; owners of record are Nathanael G. Herreshoff III, Halsey C. Herreshoff, and Halsey C. Herreshoff II.. The Farm that at one time included all the land between Bristol Harbor and Mount Hope Bay is now reduced to about 50 wooded and scrub brush acres remaining in the Herreshoff family.

Remnants of the 70 Griswold Avenue gardens, laid out by Farmer John DeWolf in 1798 and developed by the Herreshoffs are still evident.

Algernon Sidney DeWolf Herreshoff House and Model Room (1930, 1954), 125 Hope Street

Norman F. Herreshoff designed and built this contemporary two-story, ten-room, waterfront house consisting of two hip-roof units with a tunnel-like one-story connector and attached garage for his cousin Algernon Sidney DeWolf Herreshoff.[15] The south unit built in 1954 is the original model room.

After the death of his father, the famous yacht designer Nathanael Greene Herreshoff in 1938, the old Love Rocks homestead remained in the family until 1953. Sidney, with consent of his brethren, sold his father's house to Frank J. Murphy owner of Murphy's Oil Co., located on Wood Street. Murphy allowed Sid to store his father's yacht models at Love Rocks until a suitable gallery for storage and exhibit was available. Later, in 1957, Sid moved upward of 600 models his father had made to the south elevation of his home and installed them as a memorial to his father. On occasion, Sid allowed marine architects and researchers access to view the models.

The house is now the residence of Halsey C. Herreshoff, grandson of Capt. Nat and son of Sidney who designed yachts for the former Herreshoff Manufacturing Company. Halsey carries on the traditional interests of the family. He enjoys a distinguished career as a designer of boats with more than 10,000 vessels built to

The Herreshoff family, *c.* 1910. Back row, (L–R): Nathanael Greene (Capt. Nat), Charles, John Brown Francis, and Louis; {Seated, L–R): John Brown (J.B.), Caroline, Julian, Mrs. Charles Frederick (mother), James, and Sally. Of the nine children of this generation, Louis, J.B., Julian, and Sally were blind.

About 1914, Capt. Nat Herreshoff and his son Sidney built this sporty open-cockpit roadster called NOVARA as a prototype. The start of the European War prevented the car from going into production.

his designs; he has been called to provide engineering consultation to government, industry, and private clients.

He, like his brethren of days long past, is an avid sailor and respected navigator. His experience and knowledge of the finer points of ocean racing is unchallenged. His experiences are enviable; he was a member of the crew of the 1958 America's Cup defender *Columbia*, and navigator in three additional America's Cup defenses: *Courageous* in 1974, *Freedom* in 1980, and *Liberty* in 1983.

Aboard his vintage Herreshoff-built New York 40 yawl *Rugosa*, Halsey completed a 25,000 mile cruise in European waters where she placed first in the Vintage Class of the America's Cup Jubilee and in the Mediterranean races. Halsey remains actively heading Herreshoff Designs, and he is President of the Herreshoff Marine Museum, and the America's Cup Hall of Fame.

Additionally, Halsey has taken on the role of a spirited public servant; before his current election to his seventh term on the Bristol Town Council, he acted as the town's elected chief executive officer (Town Administrator) from 1986 to 1994.

Herreshoff Manufacturing Company Guest House (1876), 140 Hope Street

This two-and-a-half-story, three-bay Second Empire house was built by the Herreshoffs to accommodate guests and clients. Detailing includes paired brackets under all cornices and tall French doors opening onto a bracketed full-width porch overlooking Bristol Harbor.

A permanent resident in this house was Capt. Nat Herreshoff's sister Caroline Chesebrough and her son Albert.[16]

Albert Stanton Chesebrough, a yacht and torpedo boat designer was employed at his uncle Nathanael Herreshoff's nearby boat yard. He died at age 40 in a tragic May 18, 1916 accident when his automobile careened off Col. S. P. Colt's ocean drive seawall into Narragansett Bay; two passengers in the car survived the accident.

Norman F. Herreshoff House (1937), 151 Ferry Road

Architect Norman F. Herreshoff, a Massachusetts Institute of Technology graduate, designed this International Style house for himself; it is one of very few Rhode Island homes built in this style advocated by German architect Walter Gropius founder of the Bauhaus Movement. Herreshoff was also inspired by the work of celebrated American architect Frank Lloyd Wright.

It is a two-story, flat-roof house covered with asbestos clapboards; it has an open interior plan, including a sunken living room. The glazed walls of the living room and the attached dining room open to a view of Walker's Cove and Bristol Harbor.

Herreshoff designed the *Moderne-Style* Bristol Yacht Club house at the foot of Constitution Street in 1939, to replace the one washed away by the 1938 hurricane. This building is now occupied by the Bristol Chapter of Elks, Chapter No. 1860.

Richmond/Bayley/Herreshoff House (*c.* 1800, *c.* 1870, *c.* 1926), 142 Hope Street

Lemuel Clark Richmond, a wealthy whaler who owned twenty ships including the much heralded Bristol-built bark the *Empress*, began building this Federal-style two-and-a-half-story, five-bay, gable-roof house around 1800. In 1854 the house was sold to William H. S. Bayley, publisher of the local *Bristol Phoenix* newspaper.

In 1856 Charles and Julia Herreshoff, moved to the town side of Bristol Harbor from their farm at Point Pleasant on Poppasquash and settled into this 142 Hope Street residence. Several of Charles' relatives remained at Point Pleasant Farm. At first the Herreshoffs rented the house until 1863, when Julia bought it from Rachel Bayley with a mortgage.[17] It was unusual for a woman to buy a house with a mortgage during the Civil War years.

Thereafter the house was moved back from the road and extensive additions made in the rear between 1870 and 1880. A nearby cottage was raised, moved, and attached to the large shed-roof kitchen ell to create additional space.

At the death of Julia in 1901, brother and sister Lewis Herreshoff and Sally Herreshoff Brown[18] became owners of the homestead; Sally predeceased Lewis, when Lewis died in 1926, he left the house to his nephew Norman F. Herreshoff.

Norman, an architect and collector of early American furniture and period accessories, treated the house as his private museum. Norman also did his share of renovations to the old house, including remodeling the kitchen to resemble an "old fashioned" food preparation room. He also replaced the front porch with a small Ionic portico.

The house is now owned by the Herreshoff Marine Museum.

Nathanael Greene Herreshoff House/Love Rocks, (1883) 6 Walley Street[19]

This large rambling three-story, ten-room waterfront home and studio was designed and built by Capt. Nat for himself. The house, called "Love Rocks" is built on a prominent outcropping of ledge on the shore of Bristol Harbor.[20]

Originally two-stories over a raised basement, it was built in 1883, the third-story, with its hip roof, dormers, and balustrade were added by Capt. Nat in 1895 to provide space for his studio and model room. A lower, two-story, gable-roof wing leads to a two-story wing on the east side and a long hipped-gable-roof extends to the second floor on the north side.

Capt. Nat's large comfortable home, was one of the first residences in Bristol to have electric lights – that event was *c*. 1895. Love Rocks is constructed with the same craftsmanship as Capt. Nat's speedy and sleek sailing craft, it stands facing west into Bristol Harbor. The house constructed with its back to the street is not far from his boat yard. The house's isolation and the fact that it fronts Bristol Harbor are indicative of the attitude of its owner toward the general public. He enjoyed his privacy. His chief inspiration always came from the sea. His windows look far down Narragansett Bay, with Poppasquash Point stretching to the south and Prudence Island in the foreground. It is a picturesque bit of scenery, and as Capt. Nat had an interesting family, it is no wonder that he was satisfied with his home.

Capt. Nat willed his estate to his family; in 1952, the house was sold out of the family to Francis J. Murphy. Modern glass doors and porches were added on the west side when the house was converted to multi-family condominiums in the 1960s.

Sevenoaks, the Augustus Osborn Bourne Mansion (1873), 136 Hope Street

Noted New York architect James Renwick, who designed this large hip-and-cross-gable-roof Gothic Revival mansion for A. O. Bourne, founder of the National

Capt. Nat's Love Rocks home at the corner of Hope and Walley Streets; photo by C. B. Brigham, about 1903.

Rubber Company, also designed St. Patrick's Cathedral in New York City, and the Smithson Castle in Washington, D.C. This massive stone building abounds with Gothic detailing: twin turrets and iron roof cresting, the large *porte-cochère* on the north is clustered with square columns and a roof balustrade; it is on the National Register of Historic Places.

After Bourne was elected Governor in 1883, Sevenoaks became the site of many social and political gatherings; he continued to live in Sevenoaks until his death in 1925. Following Bourne's death, the property was purchased by Harold Church Paull a stockbroker, whose family lived there until his death in 1976. His family continued to use the house as a summer residence until it was sold to a syndicate of real estate developers in August 1986.

In 1980 the mansion's carriage house was destroyed by fire. Later, the 0.31 acre of land on which the carriage house stood was purchased by James M. Mumma, Jr., who built a contemporary Victorian-style cottage, on the lot, designed by Bristol architect Lombard John Pozzi, thereby reducing Sevenoaks' lot to 1.41 acres.

Under the house's new owners, a consortium that included local building contractor Anthony Nunes and Nicholas R. Olivio of Wrentham, Massachusetts, the house was slated for development as condominiums. In their attempt to convert the building, the partners added a wood frame ell on the east. After funding dried up, conversion halted and the property was sold to Olivo. Olivo attempted to continue the house's conversion to condo units and in so doing generally removed much of the interior mouldings before he too declared bankruptcy. In December 1991, Olivo's receiver sold the house to Ted and Jacqueline Barrows.

Ted and Jackie lived in the house while repairing damage caused during the failed condo conversion–a monumental restoration of unsympathetic trashing. All of the original horsehair plaster was stripped from ceilings and walls and studded wall dividers were in place. All the elegant Victorian-era trappings were stored in the garage: nine-foot double-doors, fireplace mantels, beautiful mirrors, wonderful pedestal sinks, and a claw-foot tub. The floors are one of the most exquisite features in the 7,200-square-foot house. The pattern of each room's floor is different, with the living room floor being the most ornate; it is composed of seven different kinds of wood in a variety of different shades and hues.

While enjoying nine years of occupancy, the Barrows substantially completed the restoration of the house's interior and grounds. In March 2000, Barrows sold Sevenoaks for $925,000 to Charles and Maria Milot who lived for several years in the historic building. In November 2004, Milot sold the eleven room mansion to Thomas and Marella Deininger for $1,850,000.

Since the Deininger's purchase of the 1873 Renwick designed masterpiece, an extensive exterior restoration has been undertaken; additionally, restoring some of the interior in accordance with original Renwick plans.

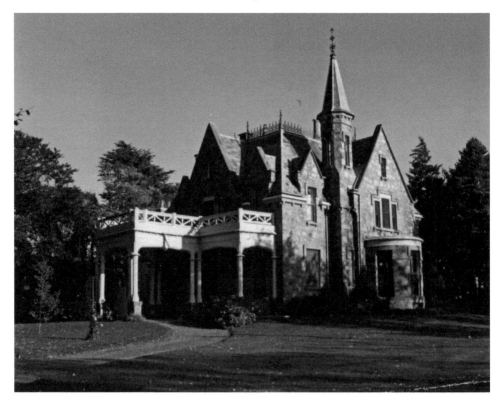

In the author's 1980 photo we see the Augustus Osborn Bourne Mansion Sevenoaks. Famed New York architect James Renwick designed the Gothic Revival mansion in 1873 for Governor Bourne.

Miramar/The Tides (1893, 1960), 217 Hope Street

This large two-and-a-half-story, hip-roof summer cottage with cross-gambrel-roof, set on Bristol Harbor was designed by E. I. Nickerson for State Senator Joshua Wilbour, a banker.

The dramatic Hope Street façade is ornamented with wraparound porches, a large coach port with Ionic columns, pilasters, an over-scale lunette in the attic, quoins, and modillion cornice. Worthy of particular note are the interior accoutrements; much of the original architectural elegance is thankfully intact. Visitors enter from the original eight-foot tall, hardwood door with a period brass knocker to another oversized Dutch door with egg and dart molding around a large square window. Inside is the grand ballroom that once hosted elegant summer parties; hardwood flooring, dental mouldings, window seats, and the original fireplace augment the nineteenth-century charm best exemplified by the extra-wide staircase with mahogany handrail and painted, multi-patterned balusters. An unusual feature is the door knobs of clear crystal with controlled spiraling bubbles made by the Pairpoint Glass Company of New Bedford, Massachusetts.

The hurricane of 1938 did severe damage to the structure destroying the roof balustrade and the large urn-topped fence posts. From 1900 until 1936, the property was owned by Isabella DeWolf. In the early 1970s, it was remodeled into apartments, and in 1986 it was converted to ten condominium units.

Edward Wainwright Brunsen House (1862, 1910), 249 Hope Street

Brunsen, a refiner and wholesaler of sugar, built this Italianate dwelling four years after his marriage to Bristol's Mary Jane Pitman.

The main portion of this two-and-a-half-story house has a high hip roof with an elaborate cornice and balustrade. The two-story north wing, built in 1910, with Colonial Revival detailing, was added by Dr. Frederick Williams for use as an office and servants quarters. Both front and rear porches date from this remodeling. Of particular interest are the original folding outer doors in the entry, paneled doors, etched-glass transoms, and faux rope moldings.

The porch roof's decorative collar and S-scroll brackets. It is probable that these elements were removed and the Ionic columns installed during the 1910 renovation.

Both the house and its stable were converted to condominiums in 1983.

In this 2007 real estate advertising card the splendor of the former Senator Joshua Wilbour house (now the Tides Condominiums), and its location on Hope Street to the east an Bristol Harbor can be admired.

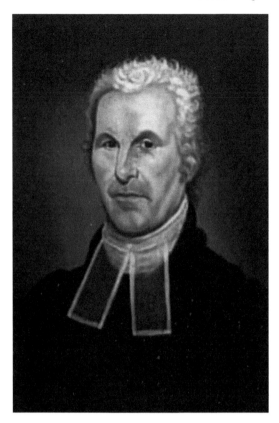

Parson Henry Wight. Rev. Dr. Wight recorded details of buildings being constructed in the late 1700s and early 1800s. His diaries are housed in the Bristol Historic and Preservation Society's library.

Babbitt/Smith/Morice House (1795, 1810), 328 Hope Street

Among the earlier possessions of the Babbitt family was the farm situated on the shores Mount Hope Bay, known as Mount Pleasant Farm; presently known as Hopeworth.

In what we now call the Historic District, Jacob Babbitt had many investments in real estate. Along the waterfront his holdings scattered from the south line of the Namquit Mill, to the south line of the "down town mill" (the so-called Red Mill). He also owned what is known as the Green Lane property, which is just north of Bay View Avenue, which was at that time the extension of Wood Street. Parson Henry Wight recorded that merchants Jacob Babbitt and Bernard Smith built a house, "both in one," on Hope Street in 1795. In 1810, Captain Daniel Morice, a French refugee from the slave uprising in Haiti, purchased the house.

This lovely, five-bay Federal home with an unusual gable-on-hip roof, has an elaborate façade incorporating a pediment Ionic entrance, a Greek fret and modillion cornice, its most distinguishing feature is its large lunette window in the front gable.

The house is flush to the sidewalk, and its garden railing is a continuation of the house's front wall. The house was greatly enlarged around the end of the 1800s, by the addition of a two-story ell on the east side.

Howe/Churchill/Diman House/Four Eagles (1808), 341 Hope Street

John Howe a grandson of Mark Antony DeWolf began building this house after his marriage in 1807 to Louisa Smith. This nearly square Federal is a two-story, five-bay house, noted for its wonderful Chinese Chippendale roof balustrade; it is better preserved than most of Bristol's early nineteenth-century homes. The fine and simple exterior proportions of the house remain unspoiled, it is a splendid example of the Federal style from the pencil of Russell Warren; it sits on the principal thoroughfare, in the center of town.

After graduating from Brown University in 1808, Howe was admitted to the Rhode Island Bar. He served in the General Assembly from 1823 to 1842; in 1844 he was appointed Collector of Customs for the Bristol and Warren District.

One of the house's notable owners was Capt. Benjamin Churchill, who bought the house in 1822. Churchill commanded James DeWolf's little brigantine, the privateer *Yankee*; which was outfitted and set sail from Bristol on the first of six successful cruises at the beginning of the War of 1812. In less than three months, the *Yankee* had taken ten British ships as prizes, and in three years her captures added $1,000,000 to Bristol's economy. The house takes its name from the four spread-winged eagles roosting on the four corners of the roof balustrade; the eagles are traditionally believed carved by the *Yankee's* sailors as a gift for their captain.

One of the wonderfully hand-carved four spread-winged eagles roosting on the four corners of the 341 Hope Street roof balustrade.

In 1825 Byron Diman, Governor of Rhode Island (May 6, 1846–May 4, 1847), acquired the property and lived here, enlarging the house three times. He served in the Rhode Island Militia, rising to the rank of Brigadier General. He was a member of the Rhode Island House of Representatives for several terms and served on the Governor's Council during the Dorr Rebellion. Diman, a protégé of Capt. James DeWolf, was active in whaling, the West Indies trade, and cotton manufacturing. He served as treasurer and as president of the Bristol Steam Mill; he was a director of the Pokanoket Mill and was cashier of the Mount Hope Bank, and later president of the Bank of Bristol.

Senator Bradford/Governor Dimond/Colonel Norris House (1792), 474 Hope Street

When the British Navy bombarded Bristol on October 7, 1775, William Bradford's first home in the village was one of the few buildings suffering damage; later, this house was burned beyond salvage by the British during their 1778 march through town from Warren to boats waiting at Bristol Ferry.

United States Senator William Bradford (see Mount Hope Farm) contracted the building of this two-and-a-half-story, well-proportioned, nearly square Federal house in 1792; it is distinctive because of its massive Russell Warren-designed monitor that in reality becomes a third-story.

After William Bradford took up permanent residence at his Mount Hope Farm, his son Hersey Bradford, owner of a successful ropewalk on Wood Street, became owner of this house. About mid-1840s, Hersey Bradford mortgaged the house to Lt. Gov. Francis M. Diamond who became governor in 1853 when Philip Allen resigned to become a U.S. Senator. Diamond's daughter Isabella married Samuel Norris, a Bristol sugar refiner. Now known as the Norris House, in 1845 architect Russell Warren added the third-story monitor and the fine geometrically patterned Chinese Chippendale balustrades around the second-story perimeter and the monitor roof. At the same time Warren added the Ionic porch, and the north wing. The house remained in the Norris family until 1942.

After the Charles J. Falugo family purchased the house it became their residence. In a fit of temper during the early 1970s, when the town council denied Charles Falugo a permit to build and operate a restaurant and bar on Bristol Harbor waterfront property he owned, he threatened to dismantle Norris House and sell it piece-by-piece.

Painstakingly restored to its original beauty in 1994, by Lloyd and Sue Adams, the Norris House is now an elegant bed and breakfast; it is a testament to the charm of the post-colonial era.

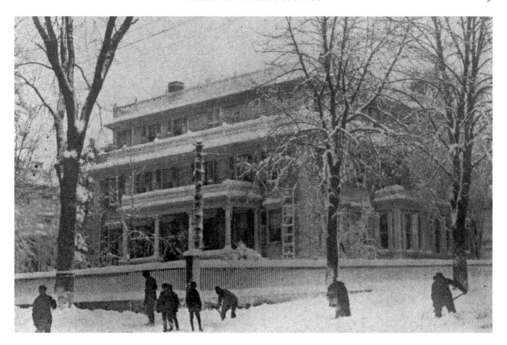

A souvenir card of the Samuel Norris house by photographer Hersey Bradford *c*. Jan./Feb.1903. The third level Russell Warren designed monitor is clearly visible.

General George DeWolf/Colonel Samuel P. Colt House/Linden Place (1810), 500 Hope Street

Merchant George DeWolf (1779–1844) contracted Russell Warren to design and build this three-story, five-bay, monitor-on-hip roof Federal house; it is the most elaborate of Warren's creations. A two-story, tetra-style Corinthian portico, surmounted by a balcony, rises to a Chippendale-type balustrade. The entrance design incorporates two delicate, superimposed elliptical fanlights framed by smaller engaged columns.

When General George went bankrupt in 1825, and fled Bristol to his plantation in Cuba, angry Bristolians, who had invested heavily in DeWolf's enterprises, stormed the house carrying off anything of assumed value. Three years later, during an ensuing depression, Captain James (Jim) DeWolf, George's uncle, purchased the house. In 1834, William Henry DeWolf, Captain Jim's son took possession of the house. It was during William Henry's occupancy that the small but elegant ballroom wing on the north was added and William Henry commissioned Russell Warren to add the one-story octagonal, Gothic-inspired conservatory with long-pointed arched windows on the mansion's south side.

When William Henry died in 1853, he left his widow Sarah Ann totally without funds, forcing her to desperate measures. She leased the carriage house to the local stagecoach operator, the octagonal conservatory to a local barber, and she rented single rooms to day-lodgers. When the railroad arrived in 1855, the stagecoach

line closed forcing Sarah Ann to lease the house to Captain William Vars. Vars built a large three-story addition in the rear, operating it as a "first class hotel with fifty large, airy, and handsomely furnished rooms."

At Sarah Ann's death in 1865, her estate put the house up for auction; it was purchased by Nicholas Harris, for $7,900. Harris immediately transferred title to Edward D. Colt, of Hartford for $1.00.

Colt transferred ownership of the property to his sister-in-law Theodora Gounjaud DeWolf Colt. Old time Bristolians were shocked to learn the daughter of General George DeWolf, had returned to Bristol and taken up quarters in the old family mansion.

Now, with Edward Colt and Theodora DeWolf Colt as owners, in 1866, extensive renovations and restoration of the mansion begin. The Colts removed the Vars' addition, rebuilt the marble path to Hope Street, and planted the linden trees from which Linden Place takes its name.

More changes in ownership of the property came quickly. In 1867, Edward Colt sold the property to his deceased brother's sons, LeBaron and Samuel Pomeroy Colt, for $9,794.44 each. In 1873, Samuel bought his brother's share of the property, and the brothers set up law offices in the former barbershop/conservatory addition. LeBaron Colt entered politics and was elected to the United States Senate a distinction achieved by his great-uncle Capt. James DeWolf.

After Theodora died in 1901, Samuel bought the entire block next to the mansion on which he built the stately marble schoolhouse as a memorial to his beloved mother.

In 1905, Samuel commissioned Bristol architect Wallis E. Howe to design the large yellow-glazed brick ballroom adjacent to the house. Howe's plan included relocation of the *c.* 1850, two-story, wood carriage house, construction of a two-story, yellow-brick garage and chauffeur's quarters on the east end of the garage, and a yellow-brick wall, which was later removed, along Wardwell Street to define the property's northern line. By 1907 Colt has acquired all the land available around the mansion, creating the 1.8-acre estate that exists today.

Colonel Colt traveled the capitals of Europe, and during his travels he acquired many stone and bronze sculptures depicting figures from classical mythology. Colt liberally decorated the mansion's gardens and lawns with his sculpture collection.

Among the guests at the mansion's 100th anniversary party, thrown on July 4, 1910, was famed Broadway actress Ethel Barrymore who married Col. Colt's son Russell; during their occupancy of the house, six bathrooms, outfitted with floor to ceiling mirrors, and silver-colored plumbing fixtures were installed.

Col. Colt died in 1921. His will specified that Linden Place must remain in the family until only one heir remains.

In 1986, Friends of Linden Place, a non-profit organization was formed to acquire the property from Col. Colt's last living relative, a grandchild. The object of the organization is to restore and preserve the historic landmark for public use. Before the 1988 bond issue for $1.5 million was approved by Rhode Island voters to buy the property, several private investor plans were floated.

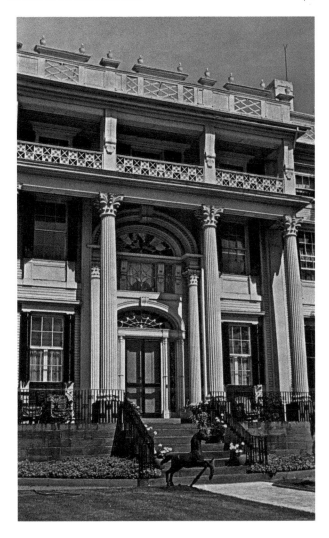

The east front of architect Russell Warren's 1810 masterpiece Linden Place.

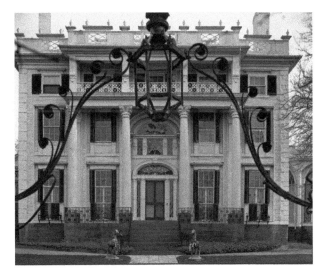

Russell Warren's masterpiece Linden Place; the General George DeWolf/Colonel S. P. Colt residence. The decorative wrought iron bracket supports a lantern the panels of which at one time had colorful engraved lights made by the Boston and Sandwich Glass Company. Sometime after 1937, the vandalized structure was removed. *Library of Congress photo archive*

The DeWolf/Colt Mansion now presents a rather overpowering picture of the 1850s. And along with many another handsome Bristol dwellings it has lost its original charm in the process of being "brought up to date" with the intention of making it more "modern" or "convenient" by its owners in subsequent periods of prosperity. Col. Colt converted the north wing ballroom to a billiard room, which now serves as the Linden Place Museum's gift shop.

Luther/Babbitt/Rockwell House (1809, *c.* 1850, *c.* 1900), 610 Hope Street

In 1809, Col. Giles Luther (1775–1841), built this elegant, traditional Federal house. Originally a perfectly symmetrical two-story, five-bay, hip-roof residence, it has had substantial changes over its two-centuries of existence. Although considerably enlarged, most of its original detailing is intact. Original detailing on the façade includes the Palladian window, modillion cornice, quoins, and wide-beaded window casings with splayed lintels. The exterior includes touches of Georgian, Federal, Greek Revival, Italianate, and Victorian features. It has been featured in several architectural magazine studies as an example of the eclectic style.

Giles Luther was a shipmaster, merchant, and farmer; notably, he was the first chief marshal of Bristol's Fourth of July parade; that memorable parade was in 1826.

In 1825 Luther's businesses failed, and the Commercial Bank took his house and sold it to Jacob Babbitt in 1828. Babbitt was part owner of Long Wharf, he was also an investor in the Commercial Bank and the town's textile industries; in his will of 1849, he left to his son Jacob, Jr. (1809–1862), "use and improvements" of this house. It is assumed the young Babbitt added the rear elevation and Italianate triple-arched door, and full-width porch with its delicate cut-out posts and railings. Jacob, Jr., died at the battle of Fredericksburg in 1862 during the Civil War.

In 1897, Charles B. Rockwell, director of the Cranston Worsted Mills purchased the house. Rockwell added the sun porch and fieldstone fireplace at the rear.

In 1915, Rockwell's daughter June Levy donated the house to the Bristol Nursing Association. In 1973, the nursing association disbanded and the house returned to private ownership and restoration in 1984. It now functions as a bed and breakfast.

On the property grows the largest tulip tree in the state; its age predates the house.

From the Bristol Historical & Preservations Society's May 1988 monograph on the "Rockwell House", the following is quoted:

Porch & Triple Arch Entrance: To keep up with neighbors, the Babbitts gave the house a new face in the 1850s. The portico was removed, the traditional Federal

Producers of the 1973 movie, "The Great Gatsby" staring Mia Farrow and Robert Redford used Linden Place as a backdrop. *Photo courtesy of Ed Castro*

The author's September 2007 photo of the Rockwell House elegant west façade.

door with fan light was replaced with the triple arch entrance, the granite steps were moved forward, and the porch added. Unsubstantiated stories persist that the fret work and curved roof rafters of the porch were made by sailors at sea.

The study provides the only example of the original woodwork that remains on the first floor of the main house. The original mantle in this room was changed. The stencil decoration is an East Indian design from the early 1800s.

The Front Foyer: Of special interest here are the unusual spindles on the stair rail and the plaque that was placed in 1940 when the Rockwells donated the house to the Bristol District Nursing Association. Though most of Bristol's historic houses are known by the name of the original owner, this house is known as the "Rockwell House" because the nurses who worked here always referred to it as such.

Reception Parlor: This is the room in which most guests were received. Between 1830 and 1840, when the Greek Revival style was so popular in Bristol, the chimney stack was removed from this side of the house, the front and rear windows were changed to triple sash windows, the pocket doors were installed, all of the woodwork was changed to Greek revival, and the wide plank floors were covered with hardwood parquet. The pocket doors allowed a large portion of the first floor to effectively become one large room for entertaining. The stencil in both this room and the drawing room is appropriately a classical Greek anthemion and palmetto design.

Gentlemen's Exit: After formal dinners, gentlemen were expected to retire through this exit from the drawing room if they wanted to smoke. This exit leads to a winding walk through the hedges on the right side of the house. The powder room (lavette) is a late 20th-century addition. The stencil in this room is adapted from a Victorian dolphin design that dates to the mid-1800s.

Drawing Room: The drawing room (best parlor) is where important guests were entertained. This room would have been furnished very formally.

Dining Room: This room was bigger and had windows at one end before the side foyer and bathroom were added. The stencil in this room was taken from a Lenox china pattern used by the Getty family.

North Side Foyer: The pineapple stencil in this entrance was taken from an 1860 wallpaper pattern.

Kitchen: The kitchen is in the servant's wing that was added by Giles Luther in 1816. The servants lived upstairs in this wing. There is a difference between the woodwork in this wing and that in the main house. The floor is new (c. 1880), and covers well worn wide plank pine floors. The doors in this room are grained to simulate natural wood graining.

Solarium: The Babbitt family added this room about 1880. Originally, it was a perfect rectangle. The stencil uses a design taken from an 1880 wallpaper frieze preserved in the Victoria & Albert Museum, London.

Courting Room: When June Rockwell was jilted, her father Charles added this room to help his daughter mend her broken heart. This addition dates to about 1910.

Parker Borden House (1798, 1805), 736 Hope Street

Parker Borden was active in the shipping trade in his hometown of Freetown, Massachusetts on the Taunton River. Shortly after the death of his first wife, in 1795, Borden moved to Bristol. He purchased waterfront property just north of the foot of Oliver Street, built a dock and brought his cargo ships from Freetown. Soon, he became one of Bristol's most active commercial shippers.

Borden also became an active participant in town affairs: he was a member of the Bristol Train of Artillery, a member of the Board of Directors of the Commercial Bank, and, in 1829, he was Town Appraiser (tax assessor).

In 1798, shipmaster Parker Borden built this dwelling on land he purchased from Thomas Bosworth. This location afforded Borden an unobstructed view of his Thames Street wharf. This two-and-a-half-story, five-bay dwelling with two interior chimneys is a fine example of federal construction. The elaborate pediment entrance, with a semi-circular fanlight, engaged Ionic columns, and imaginative carving in the door and fanlight frames, and unusual second-story Palladian window with carved garland trim are fine examples of the skill and perfection of Bristol craftsmen working in the Federal style.

The original interior woodwork of the house is as finely executed as the exterior hand-carved detailing; it is considered the finest remaining example of its genre in Bristol.

The new owner, Anthony V. Margiotta, painted the wonderfully weathered shakes and mouldings an insensitive combination of red, green, and yellow; the uninspired choice of colors detracts from the previous distinctive natural color of two-centuries of salt sea air weathering.

The Codman House (1870, 1875), 42 High Street

Mark Antony DeWolf Howe sold 1⅞ acres of land to Bostonians Catherine Elizabeth and Maria Potter Codman on July 30, 1870, for $4,500. Shortly after, the sisters commissioned Newport architect and author George Champlin Mason to design the two-and-half-story, three-bay, and mansard-roof Second Empire house.

Ground was broken on August 1st of the same year. The housewright for the project was respected Bristol master builder John R. Slade. By the end of September, the building's frame was raised, as the custom in those days, during the winter the interior woodwork was turned and put aside for installation in the spring. The house was ready for occupancy on August 7, 1871.

The three-and-a-half-story, hip-roof tower wing was added to the northeast corner of the house in 1875 for Henry, the Codman sisters' brother.

Exterior detailing includes cast-iron cresting on rooflines of the house, tower, and porch; bracketed trim on the entire building, and a full-width bracketed piazza. The interior has a center-hall plan with the original library and dining room on the south and double parlor on the north. These imposing symmetrical

rooms have twin white marble mantels with etched-glass fire screens, each displaying one of the Codman sisters' initials.

In 1914, Martha Codman sold the house to Ezra Dixon, founder of the Dixon Lubricating Saddle Company, which eventually became the Dixon Corporation; the house became the home of his daughter, Fern Dixon Leahy, wife of Judge Edward L. Leahy who served briefly in the U.S. Senate (August 24, 1949 to December 19, 1950) filling the unexpired term of J. Howard McGrath.

In 1984 the house was sold, its contents auctioned to an enthusiastic cadre of antique dealers and collectors; the Newport auction house of Gustave J. S. White, Co., handled the sale with Michael R. Corcoran auctioneer. The display ad announcing the auction reads thus:

> Bristol Estate Auction of antique furnishings, oriental rugs, appointments from historic "Codman Place," 42 High Street. Home of the Late Senator and Mrs. Edward L. Leahy. The furnishings and appointments of this 24 room mansion, one of Bristol's largest, will be offered for sale on the premises, with no additions, on Wednesday, January 18th at 10 a.m. Inspection Tuesday, Jan. 17th from 1 to 4 p.m. In the event of a heavy snowstorm on Jan. 18th, the sale will be held on Friday, Jan. 20th.

Later the house was converted to multi-family condominium units; the exterior retains its most significant architectural details.

John Brown Herreshoff House (1870), 64 High Street

For many years, until 1870, John Brown Herreshoff, president and treasurer of the Herreshoff Manufacturing Company, lived on Burnside Street[21] in the midst of his busy boat yard, when he built this impressive Second Empire dwelling at the head of Burnside Street, overlooking his sprawling enterprise.[22]

This two-and-a-half-story, three-bay, mansard-roof house has a projecting central entrance bay with a two-level turret containing a barrel-vault dormer and a port-hole shaped window. The portico has Corinthian columns on square bases, a modillion cornice, and turned balustrade; the original full-width porch is now removed.

Herreshoff lived in his High Street home until his death in 1915; J. B.'s widow Eugenia lived there until her death 1940.

The house is now owned by the Raymond DeLeo family; it is converted to apartments.

Stephen S. Fales House (1811, *c.* 1870, *c.* 1900), 139 High Street

It is thought that Stephen Fales contracted one of the Warren brothers, Russell or James, to build his fine two-story, five-bay, hip-roof Federal residence.

The original roof-and-porch Chippendale balustrade (now removed) was derived from the Linden Place balustrade, and the Ionic columns similar to the Dimond House at 617 Hope Street, are typical of Warren's work.

In 1813, William Fales, a West Indian trader, purchased the house; in 1821, Fales' estate sold the house for $1,250, to Capt. James DeWolf, who sold it to his son William in 1824. Alexander Perry who owned the house around the turn of the twentieth-century may be responsible for some of the building's alterations.

Upon close inspection are seen many changes and alterations; additions include an ell and barn on the west, *c.* 1870, an expanded conservatory, and rear ell, *c.*1900.

Richard V. & Irene V. Simpson House, (*c.* 1811, *c.* 1928) 332-330 High Street

This is the author's two-and-a-half-story, five-bay Federal residence with gable roof, handsome flat-head entrance with fanlight and engaged Doric columns, *c.* 1811. The two-story flat roof, south elevation, in the academic style was begun *c.* 1928.

In July 1988, I contracted Raymond Battcher III, to research the history of my house; the following is the result of that research.

On June 3, 1811 Samuel Bradford purchased "a lot or parcel" of land at the southeast corner of High Street and a "thirty feet gangway or road" (later transactions identify this road as Bourne Street), for $430. This transaction mentions no buildings on the property.

The extraction made of Parson Henry Wight's House Diary, located in the library collection of the Bristol Historical and Preservation Society, entitled, Rev. Wight's Buildings, Index to diary by Date, Type, Area, at page fifteen states: "1811 House of Samuel Bradford on High Street."

The first transaction [listed in town records] which actually mentions the house was four years and ten months later, on April 30, 1816, when Samuel Bradford mortgaged the property "with a dwelling house" on it, to Thomas Swan.

The conclusion therefore, is that Samuel Bradford bought an empty lot on June 3, 1811 from Joseph Wardwell, Jr., and before the year was over Parson Wight noted No. 332 High Street under construction.

The original humble wood-frame building's siding was clapboard with quoins, two chimneys to accommodate eight-fireplaces, and six-over-six double-hung sashes, with shutters, and flayed lintels. Over almost two centuries, considerable changes have taken place to both exterior and interior. The original clapboard siding is now covered with vinyl siding that simulates wood clapboard. With the installation of central steam heat, four fireplaces and a chimney were removed from the north side; the other four fireplaces are no longer functional, they are closed behind plasterboard.

Some interior renovation occurred in the 1930s when the second floor was converted into a separate apartment with kitchen and bathroom. Removal of four

fireplaces and the large brick chimney on the north side allowed additional space in those four rooms; the doorways to those rooms were reconfigured thus loosing much of the original doorframes and mouldings. Thankfully, three of the original fireplace surrounds and mantels remain as decorative elements, and most of the decorative mouldings, chair rails, window and door casings, and crown moldings remain unaltered. The front door is replaced by a mid-to late-Victorian-era door with glass panels; the original door is in storage on the property.

Raymond Castro told me that at one time, during the mid-1800s, the second floor rooms and possibly the attic were used as a day-care facility for the children of women working at the nearby National India Rubber Company on Wood Street. There is much to believe in Castro's account, because the attic is partly finished with two chests of drawers built into a roughly plastered wall and old fashion linoleum covering the original wide floor boards.

Battcher continues:

The Bristol tax books covering the period from 1884 to 1925, under the several owners for that period only list a house and lot. In 1926, under Albert Velleca and wife Mary, a house, garage and lot is mentioned and the valuation of the buildings jumped from $2,800 in 1925, to $3,000 in 1926. I therefore feel it is safe to assume that the garage was built between 1925 and 1926.

I believe the addition (330 High Street) was added between 1928 and 1930, as the valuation of the land and building rose significantly over that period of time. Also on June 1, 1928 Albert Velleca and his wife Mary took out a mortgage from the Industrial Trust Company, on this property for $2,300. The valuation on the property and buildings increased by $1,200 between 1926 and 1930.

A Velleca descendent informed me that the building at 330 High Street began as an enclosed porch with access through a window converted to a doorway in the first floor south-west room of 332 High Street. Shortly after, construction of the two-story, eight-room academic style elevation began. This addition was originally intended to house members of the Velleca's growing family. To accommodate easy flow of family members between the conjoined houses, the window-doorway was retained on the first floor, and another "secret" door was cut through the wall on the second floor of 332's south-west room.

The current owners use the entire 1811 building as a residence; the first floor door into No. 330 from No. 332 no longer exists. The first and second floors of No. 330 are rental units; the second floor "secret" doorway between No. 330 and No. 332 still exists and functions as a fire escape.

Jonathan Russell Bullock House (*c.* 1850), 89 State Street

This two-story, three-bay, stone Tuscan-style villa with a patterned slate hip roof is attributed to Russell Warren and thought to be his last house design. The symmetrical façade has a bracketed, triple-arched portico with paired square columns rising to a triple-arched window. Tall, triple-hung windows with heavy stone lintels and sills flank the portico. The unusual and spacious interior, based on a center-hall plan, has a half-octagon hall and a combination of Romanesque and Gothic arched doorways. To the east of the entrance hall, double parlors are separated by a Gothic-arched doorway.

This was the residence of Judge Jonathan Russell Bullock, who opened a law office with Joseph M. Blake in 1834; he was also active in politics, serving in the Rhode Island General Assembly from 1844 to 1853. In 1860 he was elected Lieutenant Governor, and in 1862 he was appointed a member of the Rhode Island Supreme Court where he served through 1864. On February 9, 1865, Bullock was appointed to the U.S. District Court and held that judgeship until September 15, 1869. He died in 1899 at the age of eighty-four.

Judge Bullock sold the house in 1871 fearing that the steeple of the State Street Methodist Episcopal Church, towering 162 feet, on the lot to the immediate east of his house would come crashing down. His fears about the steeple were well-founded because during the 1938 hurricane the powerful winds sent the church's majestic steeple crashing into the church's sanctuary.

Richard D. Smith House (*c.* 1852), 105 State Street

In 1822, Capt. James DeWolf began planning construction of a grand house here, on a lot, which extended to High Street. For reasons unknown, construction did not proceed as intended. Monro writes that construction materials lay scattered about the lot until Smith acquired a piece of the land and began construction of his home.

Richard D. Smith, a ship captain, and investment partner in some DeWolf enterprises, built this two-story, three-bay, hip-roof, bracketed Italianate dwelling. Interior detailing is reminiscent of Longfield (1200 Hope Street), which was assumedly designed by Russell Warren only four years earlier than this house.

Beginning in 1921, until the mid-1990s the building was the meeting hall of the Bristol Knights of Columbus. The Knights sold the house to the East Bay Community Development Corporation, which converted it into four moderately priced apartments for low-income Bristolians.

The Dr. Lemuel W. Briggs House (1849), 117 State Street

This is a two-story, three-bay Italianate house with a shallow hip roof and slightly projecting gable-roof bays on the façade. The center arched entrance is in a recessed bay. The siding is of both flush boarding and clapboards. The flush board-sided carriage shed and barn retains its cupola.

The stout three-foot thick, six-foot high granite wall along the west side of High Street running to the south property line of the Congregational Church's parish house (formerly George DeWolf's stone barn), marks the eastern boundary of Capt. James DeWolf's planned house construction.

Dr. Briggs studied at Harvard Medical College; he later graduated from the Medical College of Castleton, Vermont, and practiced with Dr. Joseph Clark in Middleborough, Massachusetts, before returning to Bristol to begin his local practice.

The house is now owned by Our Lady of Mount Carmel Church, as a convent for the church's teaching nuns.

The Patrick and Gail Conley House/Gale Winds (1899), One Bristol Point Road

This two-and-a-half-story, three bay, residence sits at the tip of Bristol Point at the confluence of Mount Hope Bay and Narragansett Bay. Its most striking asset is not its architecture but its angle of vision. Its prospect is eleven miles south to the Newport Bridge and beyond, offering the finest view of any home on Narragansett Bay. Six towns—Bristol, Tiverton, Portsmouth, Middletown, Newport, and Jamestown—are visible from its grounds.

Judge Nathaniel Byfield was the first English owner of the property, holding it from 1680 until 1711. Originally the property consisted of about 224.5 acres; sell-offs of the land over the centuries has reduced the estate to about 1.53 acres.

Other long-tenured owners included Captain Samuel Little (1711–1741), the William Pearse family (1754–1859), and Captain William West and his heirs (1859–1893). After the death of West, a farmer and a deep-water sailor who operated the sailing sloop ferry and later the one-horse treadmill ferry from Bristol Point to Portsmouth until 1865, the so-called West Farm became a bone of contention among West's heirs.

When the commissioners appointed to subdivide the West estate completed their work, a new era in the history of Bristol Point began. Prominent summer residents replaced the mariners, ferrymen, and farmers of the first two centuries of white ownership. The first and most distinguished of this new breed was the family of Dexter Thurber. Dexter was the fourth child of Gorham Thurber, two names synonymous with Providence's rise to national leadership in the fields of jewelry and silverware.

Patrick and Gail Conley's estate on Bristol Point with magnificent views down the east passage of Narragansett Bay. *Paul A. Darling's 2007 photo*

The Thurber family bought the land from the West estate in 1893 and built the house now designated One Bristol Point Road in 1899. Intended as merely a summer retreat, the original structure had no basement to house a heating system, and it was much smaller than at present. The original two-and-a-half story, shingled, wood frame building was designed similar to the Prairie Style houses of Frank Lloyd Wright with an inconspicuous front door facing east and two doors emptying into an open porch that faced due south down Narragansett Bay.

The first floor of the Thurber house consisted of an entrance living room, a dining room, a small pantry and kitchen, and a large open porch extending for forty-two feet along the entire south side of the building. The porch was fronted by an elevated stone patio. The second floor had four small bedrooms and two full baths. The third-story level consisted of two tiny, unfinished storage rooms divided by a hallway.

Little is known about the long Thurber tenancy. As summer residents, the family appears to have avoided involvement in town affairs. Gorham N. Thurber, the beneficiary of the trust in which title to the house was placed, died in 1919, at the age of thirty-three. The trustee under his will, Rhode Island Hospital Trust Company, conveyed the house to Charles C. Marshall.

Marshall, the house's second summer resident, lived at 105 Prospect Street in Providence. He was the treasurer of the Hope Webbing Company and later president of People's Savings Bank. Marshall's tenure was brief; in March 1925,

he conveyed the property to Donald S. and Mary T. G. Babcock of Providence. Donald was the financial secretary and consultant to Stephen O. Metcalf, treasurer of the Wanskuck Textile Mills and president of the Providence Journal Company. During the Babcocks' twenty-one year ownership, the house acquired a rear one-story addition that added a bedroom, a lavette, and a laundry room, while doubling the size of the kitchen. The Babcocks also built a large east-facing three-bay garage to the north of the house containing a workroom on its southern end.

On December 9, 1946, the Babcocks conveyed the house to Leonard C. Tingley of Providence who was president of Federal Products Corporation, a large Providence manufacturer of precision measuring devices. When Tingley died in 1953, he left his Bristol summer home to his only child, Virginia Tingley Johnson. She soon conveyed the property to William A. and Virginia P. Bowen in January 1956.

At the time he purchased the Bristol property, William Bowen was an officer with Rhode Island Hospital Trust Bank and ran the Apponaug Branch of that bank. The Bowens became the house's first year-round residents. Mr. Bowen became involved in local town affairs, serving as treasurer of the Bristol County Visiting Nurses Association. He later became president of Plantations Bank of Rhode Island.

On August 26, 1969, the Bowens conveyed the house to Frank Pardee III, grandnephew of the mistress of Bristol's Blithewold estate, and his wife Gertrude G. Pardee.

Seventeen years later, the Pardees transferred title to Harold I. Schein, a Providence businessman by deed recorded on July 17, 1986.

On September 1, 1986, without ever occupying the house, Schein entered into a five-month lease-option agreement with Patrick T. Conley of Providence, giving Conley possession of the property, and then conveying the house to Conley on February 9, 1987. Conley promptly transferred title to himself and Gail C. Cahalan as joint tenants and named the property "Gale Winds" in her honor.

During the period of their occupancy, from September 1986 to present, the Conleys have transformed the property from a crudely winterized summer house into an elegant, year round mini-estate and secured for it the address of One Bristol Point Road. They began by thoroughly refurbishing every room, integrating the porch into the house by making it an all-year sunroom; digging a partial basement for the heating system, which had been located in the garage; finishing the two attic storage rooms; restoring the stairway to the beach; consolidating the two east bedrooms on the second floor into a master bedroom with a full bath; and building a 39-foot ocean-facing, balustrade deck over the old porch, with access from the master bedroom and the den, from the design of architect Donald Conlon.

Throughout their occupancy the Conleys continue to expand and upgrade the house and grounds by adding such amenities as a second-floor recreation center, a studio in the garage consisting of four rooms and a bath, a mahogany fireplace

wall in the living room sculpted by Korean master carver Sang in Kim, decorative painting on most interior walls and ceilings by artist Michael Borbone, a 13 foot by 23 foot glass conservatory built by Bristol contractor Arthur Hanoian on the west side of the main house off the dining room, patios and a system of brick walkways crafted by Bristolians Charles Coehlo and Joseph Rego, a large ornate fountain, and a fish pond.

The Conleys' most notable addition is the Jeffersonian-style library, designed by Dr. Conley and built under the direction of contractor Harold Brown. The octagon-shaped structure is twenty-two feet in diameter with a full basement and a main level with a fireplace and a twelve-foot ceiling. The intricate moldings and shelving were crafted by furniture-maker Joseph Voltas, carpenter Mark Giroux, and finished by artisan James Marshall. The two-level library is designed to house over 7,000 volumes.

In 2002, the Conleys built the final major addition to the Gale Winds estate—a 200 foot fixed pier with a ramp-float addition designed and constructed by Richard DeSalvo that extends approximately 133 feet past mean high water.

Chapter 4

The Public is invited

St. Michael Episcopal Church, (1860), 375 Hope Street

After more than two-and-a-half centuries it is not easy to pinpoint the exact beginnings of St. Michael's Church in Bristol, Rhode Island. The problem is made even more difficult because many of the early records of the church were lost in a [1858] fire.

(Rev.) Delbert W. Tildesley, 1989

The St. Michael Episcopal parish was established in Bristol as one of the four original mission churches in the Colony of Rhode Island by the Society for the Propagation of the Gospel in Foreign Parts, home-based in London.

The first church edifice was built in 1720; it was destroyed by the British and their Hessian mercenary allies during their incursion through the town in 1778. The British burned the Anglican Church mistaking it for the Congregational Meetinghouse where munitions were suspected of being stored.

The second edifice erected on the footprint of the original church was begun in1785; it was a plain wood framed structure, 40 feet wide and 60 feet long, it was not fully finished until 1793, but services were held in the shell beginning on May 31, 1786.

After some four decades of service and with growth in the parish community of worshipers, this building was deemed too small, so in 1833, it was replaced by a Gothic inspired edifice, which unfortunately burned in 1858.

The fourth and present edifice built on the same land as the original 1720 structure is a brownstone Gothic Revival church designed by Saeltzer & Valk of New York City and George Ricker of Newark, New Jersey; construction began in 1860.

The façade is dominated by a three-level square tower. A clock was installed in 1871. The original steeple was replaced in 1891. A large, colored and leaded glass window representation of Raphael's painting in the Louvre of St. Michael slaying the dragon, executed by Tiffany Studios is installed over the alter and dedicated on July 23, 1899.

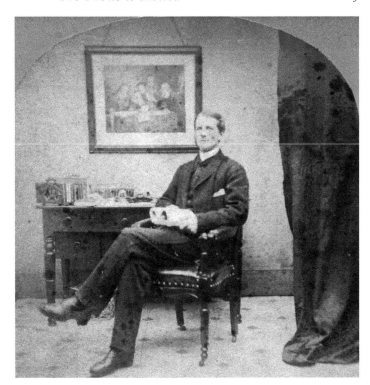

Rev. George Lyman Locke, D.D., Rector of St Michael's Episcopal Church, 1892–1919.

A view of St. Michael's Episcopal Church edifice with spire after the clock was installed, *c.* 1885.

St. Michael's Church Chapel, (1876), 380 Hope Street

St. Michael's chapel, one of the most beautiful edifices of the kind in the country, was erected.

W. H. Munro, 1880

Architect Stephen C. Earle designed this Gothic Revival one-story structure with a hip-roofed tower, surmounted by a steeper hip-roofed belfry on the east side, northwest corner of Hope and Church Streets. Earle combined Massachusetts brownstone with red mortar joints. The offset entrance porch has a large Gothic arch, matched-board doors, and a leaded, colored glass transom. Gothic window surrounds, used singly in the tower and in compound and triple units on the main part, replicate those forms on St. Michael's Church across the street.

The chapel's foundations are solidly built of local stone and enclose a cellar the full size of the building. The building is in the pointed style of architecture, with walls of brown stone from the McGregor quarries at East Longmeadow, Massachusetts, laid in rock-face broken ashlar, with joints pointed with red mortar. The roof is covered with the best dark Pennsylvania slate. At the northwest corner is a small bell turret, terminating in a metal cross. The open porch at the front leads to a commodious vestibule, which connects directly with the main room.[23]

A screen of cathedral and corrugated glass that can be easily thrown up like a large window separates this room [the vestibule] from the Sunday school room.

Architect S. C. Earle's St. Michael's Chapel sketch.

This room is large and airy; is twenty-five feet in height, and finished with an open ceiling showing the beams. There are four, double-arched windows of the same glass as that used in the screens. All the wood-work in this room and in fact the entire building is of southern ash, excepting the rafters, which are pine stained with watercolors. The benches are also of ash, while the furniture of the chancel is of black walnut, made from designs drawn especially for the chapel. Over the arch of the chancel is the sentence, "The entrance of Thy words giveth light." At the right is a recess intended for an organ to be placed there. On the left is the robing-room, conveniently furnished.

For many years the people of St. Michael's parish talked and planned and waited for this Chapel. And certainly their patient waiting has not been a loss. It is built in the most through manner.[24]

In 1961 a bell tower of red brick was built in the front yard by Anna C. Gross as a memorial to her parents. The tower's bells are from the Trinity Church, which stood on the north side of Bradford Street just east of Hope Street. Trinity was torn down in favor of building the Andrews School.

Burnside Memorial/Bristol Town Hall (1883), 400 Hope Street

Architect Stephen C. Earle of Worcester, Massachusetts, the architect for the Rogers Free Library (1877) and St. Michael's chapel (1876), designed this elaborate, polychrome, 2-story Richardsonian Romanesque, brown granite public building. The main mass of the building has a slate, cross-gable roof and a large two-story, projecting hip-roof tower on the Hope Street elevation with an arcaded porch in its base.

The main entrance, topped by a colored-glass fanlight, is recessed in a semi-circular arch. Colored glass is used extensively in lunettes on the second floor and in the tower. Aesthetically, this building complements its neighboring St. Michael's Chapel.

President Chester A. Arthur and Governor Augustus O. Bourne dedicated the building to the memory of General Ambrose E. Burnside, whose statue was intended to be the focus of the porch. Alas, funds for the commissioning of the statue never materialized.

By mid-twentieth century, the town had out-grown the Burnside building's cramped offices. In 1969 the adjacent Court Street Garage was purchased, and renovated into office space for the rapidly growing municipality. The new town hall has more counter space and room for offices; it is handicap accessible, and has air conditioning.

During Halsey C. Herreshoff's 1988 administration as Town Administrator, only a few offices occupied the Burnside Building, otherwise it was vacant. During a Town Council workshop with Mr. Herreshoff and Councilman Louis Cirillo, Director of Community Development Gerhard Oswald suggested a rehabilitation of the Burnside Building. Council Chairman Anthony Iasiello concurred saying,

"When you have a thing like this as a Town Hall☒my God!" he said, referring to the former garage in which the council's workshop was taking place.

Several proposals involved different offices being moved from the ex-garage Town Hall into the Burnside with some remaining where they are. The planners agreed the Burnside would become the official entrance to Town Hall and council chambers would definitely occupy the Burnside's second floor. With that move, the Court Street ex-garage annex then would be less of an embarrassment, they reasoned, it being used as the back door rather than the main entrance to Town Hall.

Such a change had been discussed ever since the council moved out of the Burnside, but nothing was done about it. At this time, the council had $105,000 in the budget to start on some renovations, as soon as the decision was made of exactly what they want and what they need.

The Town Council asked Bristol architect Lombard John Pozzi to submit an estimate for a possible multi-year plan for the renovation. Mr. Pozzi recommended the second floor for the council chamber, saying that if the council only renovates the first floor, and then wants to expand further into the building, it will cost more money in the long run.

After renewal of the council chamber on the second floor, council meetings were held there until that room became too small to accommodate the growing crowds of interested citizens attending meetings. At some point in the mid-1990s council meetings moved back into the former garage-town hall, and the Burnside remained largely empty of any official town offices.

The Burnside Memorial Building's second floor interior is now remodeled into a large comfortable meeting room decorated with portraits of former Bristol public school principals; a few artifacts from Bristol's notable past are exhibited in glass cases. The first floor also has a comfortable meeting and lecture room, a visitor's information desk, a public toilet, and an elevator making the second floor handicap assessable.

Belvedere Hotel/Harriet Bradford Inn (1901), 423 Hope Street

In 1901, famous yacht builder, John Brown Herreshoff president of the Herreshoff Manufacturing Company began construction of this elegant, four-story, 100-room, red-brick hotel to accommodate customers waiting to take delivery of their expensive sailing craft.

To make room for the Hotel Belvedere, a Russell Warren-designed Greek Revival temple-form dwelling on the site, known as the Jonathan Russell Bullock House, had to be removed. Instead of demolishing this fine, nearly new *c.* 1885 building, J. B. Herreshoff who bought the house and land in 1896, moved it around the corner to a vacant lot at 15 John Street. The house is now sitting on a one-story brick foundation, making the original first floor, the second-story. Herreshoff also put a new gambrel roof on the building.

The author's June 2008 photo of
Herreshoff's 15 John Street property, before
the Belvedere at Bristol Condominium
project began.

Completed in 1902, the Belvedere had as its fifth-story, a glass-walled roof garden with a pyramidal glass ceiling, affording visitors sweeping views of Bristol Harbor and Narragansett Bay; here high-society dances and wedding receptions were held. The powerful hurricane of 1938 destroyed this roof-top pavilion.

J. B. Herreshoff died in 1915 and, pursuant to his will, his estate sold the hotel in 1917. Edward and Katherine Kunz became the new owners and innkeepers until 1955. That year, James St. Angelo and his wife Harriet bought the hotel and, using her maiden name, renamed it the Harriet Bradford Inn.

In 1969, the property was sold to Charles J. Falugo Sr. Over the next few decades the hotel lost its well-to-do clientele and became home to low income families and suffered benign neglect.

After several warnings to the Falugos concerning unpaid real estate taxes, which had risen to $70,000, the town seized the property and offered it at a tax sale. In October 1995, a group of Bristol and Chicago investors acquired the tax title to the hotel and other portions of the downtown properties in that same Hope and John Street block owned by the Falugo family.

When the Bristol Economic Redevelopment Authority unveiled plans for the wholesale renovation and revitalization of a downtown block owned by C. J. Falugo Inc., in October 1995, officials were hopeful developers would jump at the chance to be part of the ambitious project.[25]

From an architectural perspective, the building suffered esthetic indifference; the hotel has been spared the kind of remodeling that destroys valuable architectural details. The wood paneling that Herreshoff's craftsmen installed is still in place, as are the original pressed-tin ceilings.

There is no record of an architect for the original building; it is thought that J. B. Herreshoff–being blind, therefore being unable to draw plans–may have dictated the design to an assistant.

Gerhard Oswald, who was director of community development in the 1990s, said he was told that from the very beginning the south side street level store front was a bar. A 1911 map of the central Bristol commercial district shows this store front as a general store. The same map indicates that on the north side street level was the hotel's office or lobby. There was a large reception area on the south side of the central corridor near the stairway, which had ample light, and the entire rear of the ground floor was devoted to public rooms.

The hotel is solidly built. The walls of all four floors are poured concrete, with stone and brick facing, except for a portion in the rear, which is wood-frame with brick veneer.

The new owners, Brenton Realty Investments, LLC, received the unanimous vote of the Bristol Planning Board for their preliminary plan for the Belvedere at Bristol Condominium project, nudging the long-delayed project a little farther along toward construction. By August 2007, the building was encased with a network of scaffolding, and canvas shoots projected from windows on the west side through which scrap building material slid into monster dumpsters. By 2009, rehabilitation was finally completed.

Customs House and Post Office (1857), 440 Hope Street

Before talking about the history and architecture of the customs house, an explanation of the reason the customs office came to Bristol is in order.

In 1789, the Rhode Island General Assembly outlawed the slave trade as well as the outfitting and provisioning of ships involved in transporting slaves; in 1808, the U.S. Congress passed legislation prohibiting all activity relative to the shipping of slaves to or from U.S. ports on U.S. ships. These prohibitions put a severe crimp in the fortunes of Bristol's DeWolf boys who were greatly invested in the traffic.

Customs agents in Newport and Providence were enforcing the laws. A way was needed to circumvent the law; an agent was needed who would turn a blind eye to comings and goings of Bristol ships engaged in the triangle trade.

Captain James DeWolf served as a U.S. Senator from March 1821 to October 1825 during the administration of James Monroe (1817–1825). However, before becoming a Senator, his influence in political circles was such that he managed to convince President Thomas Jefferson (1801–1809) to establish a customs office in Bristol and to appoint Charles Collins as collector of customs. An extremely good choice for the post as far as Bristol slave ship captains were concerned because

A very rare *c.* 1890 stereo view photo by Charles Pollock of the wood frame customs house on the State Street steamboat wharf.

Collins was himself once a slave captain and still part owner of the slave ships the *Armstadt* and the *Minerva*.[26]

The first customs house was a wood frame building on the State Street Dock.

Until the year 1846, and for many years previous to this date, Shearjashub Bourne's tavern stood on the site of the brick customs house until it was removed to Court Street.

Ammi B. Young supervising architect of the U.S. Treasury, from 1853 to 1862, designed this two-story, three-bay, Renaissance Revival structure. It is constructed of red brick with a corbelled cornice and grayish sandstone moldings and granite trim, the building originally had a cast-iron balustrade on the concave-hipped roof; the balustrade, paneled chimneys, and dormers have been removed.

The west façade contains a slight projection bay with a delicate iron balcony and three arched openings on each level. The north arch served as an entry to the customs offices on the second floor. The center arch was the entrance to the post office on the first floor. The interior has granite and cast-iron piers, brick arched vaulting, and cast-iron staircases. Of particular interest are the square, cast-iron Corinthian columns on the first floor.

By 1872, the accumulated records of commerce in the busy port had become so voluminous that additional storage space was required; for this reason the mansard attic story was added. In the 1910s, business at the post office prompted the construction of an east wing. Later, the second floor became the headquarters of the American Red Cross–Bristol Branch.

In 1962, the post office moved to new quarters at 515 Hope Street on the site of the former Bosworth, Fales, Wardwell House (1915–1961).

Bristol architect Philemon F. Sturges and contractor Raymond DeLeo were so unhappy with the government's plans for a sterile-looking post office building that would be a blot on the face of town's Federal-era streetscape, they petitioned the government with new plans that would incorporate elements from the Bosworth, Fales, Wardwell House. The façade of the new post office is a reflection of the grand late-Victorian-era mansion. Architectural elements salvaged and used are the front entrance surround under a lunette window with hand-painted glass-lights, window frames and windows with etched colored glass (likely the product of the Boston and Sandwich Glass Co.), Corinthian columns, cornices, and roof railings.[27]

In 1964, the adjacent YMCA bought the abandoned former federal building and installed a modern swimming pool in a wing added to the east. In 1967, a new entrance and lobby designed by Philemon F. Sturges was constructed, thus linking the original YMCA to the old U.S. Post Office and Customs House. During the1980s indifferent alterations were made to the building's exterior by the new owner the Newport Hospital– the arched doors were sealed and the original double-hung, twelve over eight arched sashes boarded over.

The Bristol County Courthouse and Rhode Island State House (1817)

When in 1816 the Rhode Island General Assembly decided to build a new courthouse, which could double as an alternate Rhode Island State House, Bristol offered the state the site ultimately chosen. The architect of the Bristol County Court House is unknown, but because of similar structures built in Bristol by Russell Warren, the general consensus is that this building is the product of Warren's pencil.

The building has seen many changes and alterations since its completion in 1817. After two centuries of use, abuse, and disregard of its remarkable historic value, a group of concerned Bristolians formed the Bristol State House Foundation in 1995, the objective of which was to restore and preserve the historic building.

The principal mover of the Foundation concept was Patrick T. Conley, Esq. Dr. Conley is author of the following letter to the *Bristol Phoenix* dated August 8, 2013, in which he outlines his commitment and that of the other charter members of the restoration foundation. Conley agreed to my suggestion that his letter appear in this publication in its entirety.

As president of the Rhode Island Heritage Hall of Fame, I nominated and inducted my friend George Sisson into that pantheon of eminent Rhode Islanders, because he performed many wonderful civic activities. However, he did not create the Bristol State House Foundation as the article [by Professor Kevin Jordan in the August 1, 2013, *Bristol Phoenix*] asserts. I did!

When I became the volunteer chairman of the Rhode Island Bicentennial of the Constitution Foundation in 1986, I chose this nearly vacant building as its headquarters.

When I became president of the prestigious United States Constitution Council in 1988, I moved its headquarters to the Bristol State House. The Council brought its national tours of the Magna Carta and the Bill of Rights to Bristol for public viewing.

After these celebrations, my continued occupancy of the building convinced me that it needed saving. Accordingly, I discussed the matter with [Town Administrator] Halsey Herreshoff, [State Senator] Mary Parella, [historic restoration contractor] State Representative Chuck Millard, and Larry Ferguson, Dr. Dale Radka, my wife Gail, [architect] Lombard Pozzi, and George Sisson, all of whom agreed. Therefore, I proceeded to create the Bristol State House Foundation on March 17, 1995 with me, Gail, Dale, and George as the incorporators. I was designated the legal agent and the founding president; George was my executive director. This arrangement lasted until my resignation in January, 1999, when the building had been stabilized.

Before I stepped aside in favor of George Sisson, the foundation had secured a sizable grant (eventually totaling $815,000) from a Rhode Island foundation [the Champlin Foundation] for the building's restoration and expansion—largely as a result of George's efforts and influence. The renovation project began in 1997 under the supervision of preservationists Lombard Pozzi and Kevin Jordan.

During my tenure of nearly four years, I drafted the foundation's bye-laws, obtained for the foundation IRS 501 (c) (3) designation for fundraising purposes, made (with Gail) the first substantial donation towards the structure's preservation, absorbed all its incidental expenses, used my legal secretaries as its staff, and presided over all board meetings, many of which were held at our home.

Most of all, I used my close association with House Speaker John Harwood to get the General Assembly to pass a resolution deeding the building to our private foundation, making it the only one of the six surviving statehouses not in public hands. I drafted the House resolution and deed of transfer, dated October 16, 1996.

It pains me to write this letter. I do not blame the reporter, Ms O'Connor, for her failure to interview me, or to check the records at the office of the Secretary of State, the Town Hall, and her own *Bristol Phoenix*. I fault the professor, Kevin Jordan, who has not only misled her but has also attempted to expunge my role as founding president with the distorted and inaccurate signage he has placed throughout the building.

The Old YMCA Building (1899, 1912, 1967), 442–448 Hope Street

Originally, the YMCA was housed in the Commercial Bank building at 565-567 Hope Street.[28] The Y's growing membership prompted the governors of the organization to construct a building that would be suitable for the growing community. Bristol architect Wallis E. Howe designed this two-and-a-half-story,

five-bay, gable-roof, Tudor Revival building as the new headquarters.

A rich effect was created with red brick and white mortar in combination with Tudor half-timbers, painted bottle green, and buff-colored stucco.

The ground floor contained four store-fronts; original commercial occupants included a barber shop, a store selling sundries, a pharmacy, and dry goods emporium.

Architect Howe designed a large center arch, which led to the public spaces on the second floor, including the Howe Library, a chapel, and the Rockwell auditorium and gymnasium.

After the customs building was physically joined with the YMCA building in 1967 and the swimming pool was built in the customs house's east wing, membership swelled. However, because of mounting financial costs to sustain the conjoined buildings, membership dues were increased. The rising cost for citizens to enjoy the Y's facilities resulted in a decline of membership during the early 1990s. The cost to do business eventually resulted in the governors' decision to close the facility and sell the property.

In the mid-1990s the YMCA-block, as it was called, was sold to Newport Hospital and rehabilitated. The east wing containing the Y's swimming pool was demolished, filled in, and converted to a parking lot. The new owners renamed the block, Custom House Square, and the new tenants, the Vanderbilt Rehabilitation Center, took over control and operation of the old YMCA and Custom House buildings.

Chapter 5

Colonel Colt's Farm/
Colt State Park

Touring the Farm

If Col. Samuel Pomeroy Colt, dead since 1921, were to return to visit his 466-acre farm on Bristol's Narragansett Bay shore, he would find only a few changes. He would notice old roads have been reconfigured and new ones constructed, a modern steel and concrete bridge spanning Mill Gut, and his fabled pleasure dome, "The Casino" no longer standing among the willowy and wind-twisted trees that bordered it. He would be gratified to find a combination family retreat and place for public relaxation and communing with nature.

One frosty February morning in 1963, Col. Colt's grandson John Drew Colt, escorted William H. Cotter Jr., chief of the Rhode Island State Division of Parks and Recreation on a tour of the farm.

Governor John H. Chafee asked Cotter to look into the possibility of obtaining the farm for use as a state park. Cotter said the Governor wanted recommendations how to keep maintenance costs at a minimum if the state acquired the farm. Cotter said he believed the estate could be taken over and used for recreation without an immediate heavy outlay for development.

Cotter had toured the estate many times; he was closely involved when former Governor Christopher DelSesto tried and twice failed to get the Colt Farm acquisition on a referendum, but was unsuccessful because of Democrat legislative opposition.

In 1959, the Rhode Island Development Council estimated the property could be bought for around $423,000 and that a full-scale recreational development might cost an additional $695,000.

At the time of the State's inquiry, the farm was held in trust by the Industrial National Bank for the benefit of the four grandchildren born during Colonel Colt's lifetime. The trust stipulations were that the heirs could not sell or otherwise dispose of the property, unless the trust is altered by the courts.

Three of the heirs were children of the late Russell Griswold Colt, who was married to actress Ethel Barrymore. They were John Drew Colt, Ethel Barrymore Colt Miglietta of New York, and Samuel Colt of California. The fourth was Elizabeth Stanfield of Arizona, daughter of the Colonel's other son, Roswell.

This pair of marble putti welcome visitors to Colt's farm through the Sunrise Hill gate. Illustration is from *The Field Illustrated*, August, 1921.

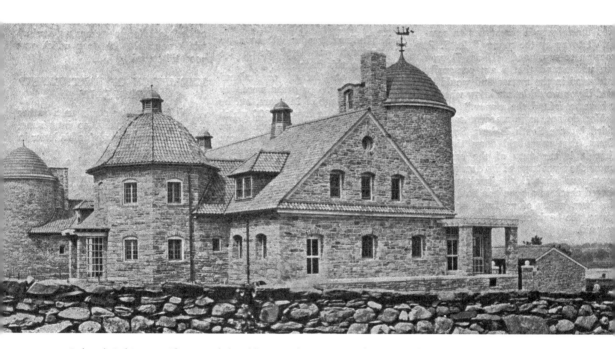

Colonel Colt's magnificent and durable stone barn; its combination of weathered gray and red stone project ruggedness and simplicity without excessive ornamentation. The large stone silo gives the effect of a medieval Norman tower. Colt's dairy herd composed of registered Jerseys won numerous ribbons. Photo from *The Field Illustrated*, August 1921.

Located in Colt State Park, sculptor Bruce Papitto memorialized U.S. Senator John H. Chafee (1977-99), US Navy Secretary (1969-72), Rhode Island Governor (1963-69), and decorated U.S. Marine in his life-size bronze likeness. Governor Chafee acquired Colt Farm for the enjoyment all Rhode Island citizens. *Author's photo*

John Drew Colt assured Cotter of the accord of trustees and heirs that the farm should become a public recreational facility. The Colonel had always invited the public free access to enjoy the pleasures of nature's bounty evident on his seaside farm by posting the well-known sign "Private Property; Public Welcome."

With a mile of waterfront and rambling acres of pasture and woodland, the estate represented one of the best sites available on either side of the bay for public acquisition.

The estate had two impressive structures: a stone barn and office, and the rambling wooden "Casino," a large dwelling set back about 50 yards from the waterfront.

At the time of Cotter's tour of the estate, Clinton J. Pearson, president of the boatbuilding firm of Pearson Corp., was leasing the barn and pastures for a herd of 50 cows; Francis J. Luther was general manager of the estate and Everett P. Church was superintendent.

The Colonel's farm office was on the first floor of the barn's corner tower, the tower's upper room housed trophies won by his prize winning cows and bulls.[29] The barn's ornamental marble tower door was designed by famous architect Stanford White. Over the fireplace in the tower is the family coat of arms, depicting three colts rampant. Small bronze colt statues appear everywhere: at the Colonel's in town mansion, Linden Place, on the lawn and in front of the Casino.[30] A profusion of bronzes litter the Colt property: a doe and fawn, a sitting hound (the target of vandals, it is now missing), the familiar twin bulls by sculptor Isidore Bonheur, the life size lions which guard the gate to the stone barn, and many more, both on the farm and at Linden Place.

The arched stone bridge, built in 1915 by Bristol stonemason Remie Guevremont, that straddles Mill Gut was graced with several marble statues of Roman and Greek deities by French sculptor Auguste Rodin; two Vatican boars guarded the bridge entrance. Colt put the statues of a nude Venus, and Diana and other mythical goddesses along the shore-drive because he thought they would enrich the lives of visitors. So enriched were the visitors that they often spoke of the Colonel's, "bulls, boars, and bares".

Over the years, vandals have hacked, painted, stolen, lassoed, and dragged some of the statuary. The four Auguste Rodin marble statues were removed to Linden Place for safety.

Colonel Colt used the Casino as a place to entertain and to house any overflow guests from Linden Place. Parties in the "good old days" consisted of live music and fountains bubbling champagne. Henry Paquin, a retired Rhode Island state police dispatcher, and amateur violinist, who often fiddled at Casino parties, was sworn to secrecy about the "wild and decadent" parties thrown there. It was rumored that Colt's male guests, of high social rank, mingled freely with "New York show girls."

In the May 1993 issue of the magazine *Old Rhode Island*, Beatrice Levin shed some light on Col. Colt's Sunday outings at his Casino:

To Colt's Casino, after church on Sundays, guests traveled by bicycle or auto. Colt enjoyed watching the young women in Annette Kellermanns swimwear that was very daring for the time. Colt, in a white waistcoat, carried a gold-headed cane and wasn't averse to slapping a woman's bottom as she passed. In the afternoon, the dining room would be set for fifty. Townspeople called these afternoons "orgies" when a bronze goatskin poured milk punch from the Squantum Club into goblets.

The last big party at the Casino was in October 1962, when John D. Colt, the unsuccessful Republican candidate for state senator from Bristol, was host to Governor Chafee and other party leaders during the election campaign.

North of the Casino, along the winding Colt Drive, is a flat grassy strip, which Mrs. Stansfield laid out for her private plane, other airplanes whose pilots spot schools of menhaden for commercial fishermen sometimes landed there.

Just north of the farm, across Asylum Road, are the Bristol town beach and athletic fields; these facilities are on land that was once part of the estate.

At one time, Bristol could have bought the entire farm for a song. Colonel Colt, in a rare moment of civic pique, said he would be happy to sell it to the town for half what it cost him to acquire. That was not characteristic, however, of the man who gave the town Colt Memorial High School in memory of his mother Theodora DeWolf Colt.

As head of the US Rubber Co., Colt was known as the "Rubber Baron of America"; he also founded and held firm control of the Industrial Trust Co., parent of the Industrial National Bank; now the Fleet Bank.

When he returned to Bristol, in October 1909, after a two-year absence for health reasons, he was greeted by a torch-light procession, illuminated

A unique elevated view of Col. Colt's stone bridge over the Mill Gut tidal pond. The figure at the boat-launching ramp is Nathanael G. Herreshoff. The photo is *c.* 1910; the most likely photographer is Kitty Herreshoff DeWolf.

An excellent view of Colt's stone bridge over Mill Gut showing placement of the marble reproductions of classic sculptures.

A family of clam diggers take a rest in the shade of the Colonel Colt's stone bridge. This c. 1910 image from a glass photo-plate.

One of the many marble reproductions of classic statuary that adorned the stone bridge, in this case the Venus de Milo; she now resides safely at Linden Place.

buildings and cheering citizens. In tears, he called it, "the happiest moment of my life."

The Colonel had many elaborate plans for the farm, which he did not live to complete. He warned his heirs against the dangers of speculation, which had ruined his grandfather, General George DeWolf. In his will he said:

> Speculation, besides unfitting one for regular occupations, does not pay and is almost certain to end in disaster ... the possessor of solid, unencumbered securities, who neither speculates not borrows money, feel strong and independent and is in far better condition to cope with the trials of life which come to all.

Colonel Colt displayed in his will both his generosity and his love for the town of his ancestry. He left more than $300,000 for public works and charities, which included grants for orphanages, homes for the aged, and $100,000 for the poor of Bristol, Warren, and Barrington.

He made The Industrial Trust Company trustee in charge of the farm, and left a sizable sum for its maintenance. He included in his will the expressed wish that the farm not be sold to outsiders, and for ten years after his death the farm continued much as it had during his lifetime.

Property taxes were rising; costs of maintaining the farm were rapidly becoming prohibitive. To meet expenses, The Industrial Trust Company leased the land to the Luther Brothers as a dairy farm. In 1955, after considerable haggling over the terms of the Colonel's will, the town succeeded in purchasing 26 acres north of Asylum Road for use as a much needed town beach.

Colt Farm becomes Colt State Park

Governor Chafee was intent on making the land part of the state's park system. Following ten years of debate over acquiring the land, in 1965, his efforts culminated in the purchase of the remaining acres of the farm, for one million dollars; consequently saving it from the inevitable commercial development and keeping it forever in the public domain. Thus the Colonel's wish that the public have free access to his magnificent seaside estate was fulfilled.

In 1970, the Casino was marked for demolition. Some local citizens made an effort to save it–Peter Church, son of the man who had been superintendent of the estate, wrote an impassioned letter to Governor Frank Licht, but he was told that the $100,000 necessary to restore the building was not available.

Conrad and Pomeroy

As a result of his many travels in Europe, Colonel Colt developed a passion for fine art statuary. He fronted the entrance to his stone barn with bronze reproductions

Marked for demolition, Col. Colt's summer retreat bites the dust.

of the lions that guard the entrance to the Louvre in Paris. Beyond the seawall, a bronze hound surveyed the horizon over the bay from a huge boulder, two bronze colts, and a centaur marked the entrance to the Casino.

The two most impressive bronzes, however, are not on the ocean drive, but at its entrance on Hope Street. On nine-foot-high carved marble plinths, two massive, life size one-ton, six-foot bronze bulls face each other across Asylum Road.

The local legend concerning the bronze bulls says the statues are supposed to represent two of the Colonel's prize bulls: Conrad and Pomeroy. Colt named one of his $50,000 bulls "You'll Do Conrad" because supposedly, the bull "wouldn't do." Different reports have the beast killing one or two of its handlers within a month in the barn. Saddened by the realization the contumacious animal proved too dangerous to keep, Colt had it shot. The legend continues:

> Colonel Colt commissioned noted French sculptor Isidore Bonheur to immortalize the bulls by sculpting their likeness and casting in bronze. The name of Parisian sculptor Isidore Bonheur (1827–1901) appears as a signature in the bronze at the base of each sculpture.

Research reveals that the possibility of the Colonel commissioning the sculptures is remote. But another mystery remains.

Colonel Colt's sturdy stone barn entrance guarded by a pair of massive bronze lions.

Sculptor Isidore Bonheur's pair of magnificent life size, one-ton, six-foot bronze bulls stand guard at the entrance of Colt State Park. This image is a *c.* 1910 real photo postcard; note the trolley tracks in the foreground.

By 1913, when the bulls were delivered to Bristol, Isidore Bonheur had been dead for twelve years. It appears that the original models for the bulls were cast in several sizes sometime before 1865.

We learn the following from an article by Frank Davis in the December 14, 1989, issue of *County Life*. Included with the article is a photo of "Pomeroy."

> The bull is one of a pair—one of them 79.5 inches by 114 inches, the other 67 inches by 114 inches—which were sold [at a Sotheby's auction] for £187,000. The models were first exhibited in plaster at the Salon of 1865, and were cast in an edition of three sizes by Bonheur's uncle by marriage, Hippolyte Peyrol. The original life-size casts were commissioned by the Sultan Abdul Aziz for the gardens of the Palais deBelerbey. But, at the time of the Sultan's death in 1876, they had not been paid for, and the whereabouts of these original casts is unknown. Two others are recorded, one of them sold in New York, the other going for the entrance to the abattoir at Vaugirard, Paris. A set of six of the life-size, cast-iron groups belonged to the town of Deauville [France]. This pair was sold by the town.

The above article agrees with an earlier piece about Bonheur found in the 1971 book, *The Bronze Sculpture of Les Animaliers* by Jane Horswell. The same two bulls were made for the Sultan of Constantinople and exhibited as plaster models in the Salon de Paris in 1865. Horswell writes, when the Sultan died without paying for the work, the original casts disappeared and their whereabouts are still unknown.

Another cast of Pomeroy was advertised for sale in the March 1975 issue of the magazine *Hobbies*. The seller, Littlefield's Antiques of West Haven, CT, offered a signed Bonheur bull measuring 16 inches long and 12 inches high for the price of $1,200.

These time frames are troubling: the Bristol bulls were installed at the Hope Street gate to Colt Farm, with great fanfare, in 1913. Bonheur died in 1901, and the original plaster models were exhibited in 1865, forty-eight years before the life-size casts came to Bristol. So the mystery persists; how did Colt get hold of these casts? Could Colt have met Bonheur, in Paris, sometime before the artist's death? Perhaps the molds or the casts were stored at his uncle's foundry, and the artist, with Colt as a client, introduced him to the possibility of their purchase. All references say that the original life-sized casts were commissioned but disappeared, could the bronze casts that reside at the entrance to Colt State Park be those originals? It is a delicious mystery.

Restoring the Gate

Plans to repair the marble balustrade and capstones at the Hope Street entrance to the State Park were initiated shortly after the pedestals were damaged by a car in

1977. However, the work was delayed because of a dispute over elements of the restoration plan and the source of funds.

In January of 1983, Town Administrator Thomas Byrnes said he had spoken with state officials who had devised a plan to move the bull (Conrad) at the left of the gate about ten feet south in effect widening the opening for two twelve-foot traffic lanes. He said the pieces to repair the broken marble balusters are all in storage at the park.

Meanwhile, state Representative Gaetano (Kelly) Parella said he was the one responsible for obtaining the $25,000 to repair the gates. Parella added, "Mr. Byrnes should be more interested in local affairs. To come along and usurp all the credit is not statesmanlike." Parella said he favored his plan to widen the entrance even further, about 30-yards. He said, "If the state refuses to move the bull that far, I'll get a town wide petition going."

Representative Parella one of the owners of the downtown Hope Street, Bristol Furniture Store presided over informal discussions concerning town politics and general news of the day with friends and town gossips. Rather than circulating a town-wide petition about moving Conrad 30-yards, south, away from Pomeroy, he asked the opinion of the many who came to pass the time of day at his store.

When Parella asked my opinion, I told him that if the gate was opened by the number of feet he proposed, the "tension" between the bronze figures would be ruined, thereby destroying the total aesthetic. He said he heard this argument from at least two other people, but he didn't understand the relevance of "tension" between the figures.

Town Administrator Halsey C. Herreshoff made a welcome announcement in the September 9, 1993, issue of the *Bristol Phoenix*:

> I'm elated that finally we can have the damage to the gateway repaired. It has been more than a decade since a car smashed the balustrade. Since then, water damage and ice have gotten into the pedestals for the two bull statues, to the point where those support structures for the bulls are at risk of falling apart. The funding ($300,000), approved by the Rhode Island Department of Transportation (RIDOT) is critically needed to preserve this important landmark.

Dory Skemp, chairperson of the Historic District Commission and the person who wrote the RIDOT grant, said that the large sum was requested because much of the money will be used to purchase marble to replace pieces that are broken or missing. Another $50,000 was planned for new curbing and granite bollard to protect the sculptures from further wayward automobiles.

"We don't intend to move the bulls," said Skemp, referring to the 1981 furor generated by members of the Historical and Preservation Society. They loudly rejected a plan to move the southerly most bull to the shoulder of the park's exit road, some 30-yards away from its brother bull. The protesters claimed that separating the bulls would destroy "the artistic tension" created by the impression of the powerful animals' sharp or angry look.

"Plans call for Conrad and Pomeroy to get a thorough cleaning. The one-ton bronzes will be blasted with walnut shells," said Skemp. "It's like sandblasting only not as abrasive or damaging to the metal. It will take away the decades of aging and green patination." She added that the bulls would then be coated with a protective coat of wax, a process repeated every few years.

The project did not begin until late summer of 2000. Conrad and Pomeroy were gently lifted from their lofty perches, secured on a flat-bed trailer, and haled to the foundry for cleaning and restoration. The marble plinths and balustrade were dismantled, the marble slabs numbered, crated and removed to the stone barn for cleaning.

Rededication

As of January 2001, the marble balustrade was back in place with the formerly broken pieces replaced. The carved marble slabs again covering the thick red brick foundations of the pedestals. The entire town waited anxiously for Conrad and Pomeroy's return in the spring.

On Tuesday, August 21, 2001, Governor Lincoln Almond presided over a simple ceremony of rededication of the restored bronze bulls. The date coincided with the 33rd anniversary of the dedication of Colt State Park. At the ceremony Almond said:

> By restoring these majestic gates, we're continuing to preserve the historic integrity of Colt State Park. For 88 years Conrad and Pomeroy have greeted all who drive through these gates. They're the tell-tale sign that you are entering one of the most glorious state parks in all New England.

Chapter 6

Commerce and Industry

Founding a Commercial Empire

The earliest recorded commercial venture, November 6, 1686, was organized by none other than Proprietor Nathaniel Byfield. In his Bristol-built ship, the *Bristol Merchant*, he sent a cargo of horses to Surinam in northern South America After only four years, fifteen Bristol vessels were engaged in the West Indies trade; their cargos included fish, horses, sheep, timber, and farm produce; the return cargos were coffee, molasses, sugar, and tropical fruits. From the earliest days of trade, the Bristol onion was the leading farm product exported; onions remained an important export commodity until the beginning of the twentieth century.

During the mid-eighteenth century Bristol vessels engaged in the nefarious slave trade.[31]

Under protection of state-issued commissioning letters called "marque and reprisal" Bristol ships acted as privateers. A privateer is a civilian contractor who acts in an official capacity for the state, or in twenty-first century vernacular, a "rent-a-cop". In reality, privateers were no more than legal pirates.

Captain Simeon Potter was one of Bristol's most celebrated privateers; his notable voyage aboard the *Prince Charles of Lorraine*,[32] on which he was joined by young Mark Antony DeWolf, as ship's clerk, was made in 1744. On this voyage to the West Indies and the Spanish Main, Potter and his crew plundered the richest settlements and brought great riches home to Bristol. It is well to note the foundation of the DeWolf family's wealth is derived from such piratical adventures; it was the basis of their extensive mercantile operations.

The DeWolfs

Toward the end of the eighteenth century and the first decades of the nineteenth, Capt. James DeWolf was the busiest, shrewdest, and wealthiest merchant in Bristol. His ships were actively and lucratively engaged in the triangle trade. During the War of 1812, by engaging in privateering, he took vengeance upon British shipping for losses he incurred from His Majesty's Navy.

Other men of the DeWolf family followed in Capt. Jim's wake. William, Charles, and George DeWolf were each enterprising merchants.

The DeWolfs were involved in mercantile operations much the same as John Brown and Charles Francis of Providence. In his youth James DeWolf skippered ships for John Brown in the West Indies and African trade. It was this early experience that he later successfully used in forging his career as a merchant and slave trader. Following the example of the astute Providence and Newport merchants, the DeWolfs entered the established triangular trade, sailing to Africa with cargos of New England rum, iron, copper, food-stuffs, and English made goods that they traded for slaves, gold, and ivory. Then the run on the middle-passage to the English, French, Dutch and Spanish colonies in the West Indies where the slaves were sold for cash, sugar and molasses; the ships returned to Bristol with their cargo from which more rum was distilled.

In 1808, the ship the *Juno* was responsible for bringing into Bristol the port's first cargo from China. The ship's master, John DeWolf, because of his singular three-year adventure of circumnavigation of the globe via Siberia is forever known in the annals of Bristol history as Nor'west John.[33] The principal owners of the *Juno* were James, Charles, and George DeWolf, their profit on this three-year, eight-month voyage was $100,000.

The expansion of Bristol's sea trade was dominated by prominent family names in the town's mercantile chronicles: the Bordens, the Bournes, the Wardwells, as well as the DeWolfs. These families brought capital, experience, and a wide variety of personal, commercial, and political contacts to the maritime economy. Bristol ship owners, ship's captains, and investors in the enterprise became very wealthy. Members of families organized partnerships, purchased goods, outfitted ships, planned complex voyages, took large risks, and, in many cases reaped great profits.

The partnership of Shearjashub Bourne and Samuel Wardwell, in the years immediately after the end of the War for Independence, distilled rum and sent ships to the coast of Africa for merchandise and slaves. It is said at one time this firm owned forty-two Bristol berthed vessels.

During the first quarter of the nineteenth-century the average population of Bristol was considerably less than 3,000 souls. Included in this number were indentured white servants, African, and Indian slaves. The disproportionate amount of its business is plainly evident.

Wilfred H. Munro in his *Picturesque Rhode Island* (1881) informs us:

It [Bristol] maintained extensive commercial relations with the ports of northern and southern Europe, with China, and with the "Northwest Coast," with Africa, and of course with the West Indies. In the year 1825 Bristol merchants began to make large investments in the whale-fishery, and, as a consequence, the general commerce of the port began to decline. In 1837 twenty whale-ships bore the name of Bristol upon their sterns; the aggregate tonnage of this fleet was 6,256 tons.

With the discovery of gold in California in 1849, the whaling industry was gradually abandoned as many of the ships were pressed into duty carrying hopeful prospectors and equipment to the other side of the continent. Sadly, it is written that many ships and lives were lost on the torturous voyage.

Augustus Osborn Bourne and the National Rubber Company

As governor of Rhode Island for two terms, 1883–85, Bourne ably administered the affairs of State and gave to public duty the same conscientious attention as to his private affairs. While state senator his powers of oratory were invoked to deliver memorial addresses upon President Garfield, General Burnside, John F. Tobey, Henry B. Anthony, and others. Before a large gathering at Bristol he delivered an eloquent address upon the life and services of President Grant.

His work on behalf of the Republican Party was rewarded in 1889 when President Benjamin Harrison appointed the Bristol industrialist as United States consul general to Italy.

Bourne incorporated his Providence Rubber Company in 1861, as the successor of Bourne, Brown & Chafee. Before the expiration of the Goodyear rubber patent in 1865, he organized the National Rubber Company and built a large plant in Bristol. In January 1868, the Providence Rubber Company consolidated with the National Rubber Company and moved their plant to Bristol. A. O. Bourne was treasurer and active manager of the National from 1865 until 1887 that company

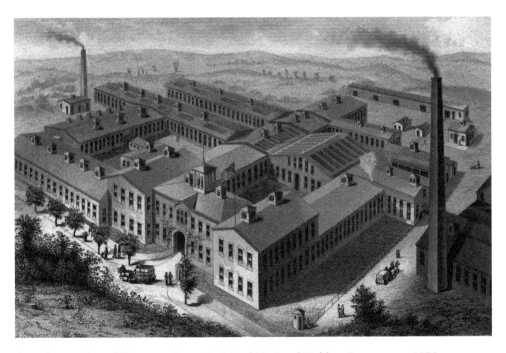

A steel engraving of Governor Bourne's Bristol National Rubber Company, *c.* 1880.

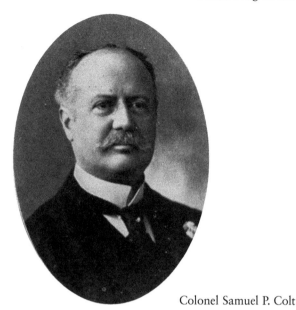

Colonel Samuel P. Colt

becoming the most important employer of the town, nearly half the population was working at the Wood Street plant.

After his return from Rome in 1894, Bourne discovered he had lost control of his NRC to Col. Samuel P. Colt. In the same decade, Bourne again began rubber manufacturing in Providence. His interests with the old Providence Rubber Company were merged and reorganized as the Bourne Rubber Company. He managed to rebuild his business in Providence, he remained active in the Rhode Island militia; he often used his oratorical skills to stimulate audiences at public ceremonies and he continued to live in Sevenoaks until his death in 1925.

Samuel P. Colt and the National India Rubber Company

Samuel Pomeroy Colt, entrepreneur, politician, lawyer, gentleman farmer, and philanthropist, was born in Paterson, New Jersey on January 10, 1852. He was the youngest of six children of Christopher and Theodora Goujand DeWolf Colt and the nephew of Samuel Colt, inventor of the Colt revolver. After his father's death in 1855, he lived in Hartford for a time with his uncle Samuel. In 1865, Colt moved to Bristol with his mother when she returned to the DeWolf family's ancestral home now known as Linden Place. He lived in Bristol for the rest of his life.

In 1875, at the age of twenty-three, he was appointed aide-de-camp to Rhode Island Governor Henry Lippitt with the honorary rank of "colonel," a title by which he was addressed for the remainder of his life. In 1876, while still on Lippitt's staff, he was elected to the Rhode Island House of Representatives from Bristol. Colt left the legislature in 1879 to accept an appointment as an assistant attorney general. In 1882, he was elected to the first of four, one year terms as

The sprawling Kaiser Aluminum wire complex, the former Colonel Samuel P. Colt National India Rubber Company. This April 1, 1993 *Bristol Phoenix* graphic illustrates the mill complex revitalization plan that includes apartments for low income elderly, assisted care senior housing, and industrial park, a planned community center, and possible retail space.

Rhode Island's attorney general. Colt's active public political career waned after he was denied election for a 5th term as attorney general in 1886.

At the age of thirty-three, he ceased his active participation in the legal profession to pursue his interests in the business world. In 1886, Colt founded the Industrial Trust Company, a banking corporation that was absorbed by Bank America. The early incorporators, representing the political, business, and industrial elite of late nineteenth century Rhode Island, included William and Frederic Sayles, Zechariah Chafee, Nelson Aldrich, Lucien Sharpe, and John B. Herreshoff.

A year after founding Industrial Trust, Colt was appointed as a receiver for the bankrupt National Rubber Company located in Bristol. By the spring of 1888, he had succeeded in reorganizing and reopening the factory as the National India Rubber Company, which manufactured rubber boots and shoes. In 1892, he participated in the merger of National India Rubber Company with a number of other rubber companies to form U.S. Rubber Company, the forerunner of the UNIROYAL Corporation. Colt served as president of U.S. Rubber from 1901 to 1918 and oversaw its growth into one of the largest corporations in the world. By 1917, a year before Colt's retirement from the presidency, the company had absorbed more than forty smaller rubber companies and employed more than 20,000 people in Rhode Island, Massachusetts, and Connecticut. In addition to Industrial Trust and U.S. Rubber, Colt had a major financial or personal interest in railroads, lumber, public utilities, and publishing. He served on the boards of directors of more than forty companies and was one of the wealthiest men in the country.

The Herreshoff Manufacturing Company (1863)[34]

In beginning his boat building business in 1863, twenty-two year old John Brown Herreshoff hired a crew of skilled carpenters and cabinet makers, procured supplies and seasoned lumber, and fitted out the old harbor-side leather tannery as a shop. In the following year nine sailing craft ranging in length from 22 to 35 feet were launched. As his business grew, J.B. (as he was called), bought the old Burnside Rifle Factory and converted it to a saw mill. As his yachts steadily increased in size, the old tannery was lengthened to accommodate them.

During the next several years, the direction of the business turned almost entirely to steam craft. Their complex machinery required a proportionate increase in engineering work. J. B.'s brother Nathanael Greene worked at the boat yard evenings, making designs and drawings for the manufacture of machinery for his brother's steamers. He did this while employed in Providence by the Corliss Steam Engine Company.

Eventually, Nathanael resigned the Corliss Company and joined in partnership with his brother. The successful business relationship of the brothers is legend; the wealthy yachting fraternity flocked to Bristol to have their vessels built by this world-renowned boat yard.

The great amount of construction handled by the plant required more buildings, and in 1894 a sail loft was built, followed in 1899 by a foundry for brass, iron, and lead casting. In 1902 buildings were erected for small yacht construction and for electrical work and storage; it goes without saying that the yard's employment steadily grew as contracts were signed and completion dates loomed. Changes in construction techniques and materials made through the years brought the plant to its peak of perfection, every detail of yacht construction from the designs of sails, engines, keels, and auxiliary equipment including propellers was handled at the yard.

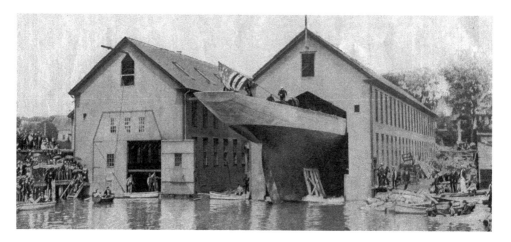

The 1895 launching of the America's Cup yacht, the *Defender* into Bristol Harbor.

John Brown Herreshoff (left), and Nathanael Greene Herreshoff.

Construction sheds of the Herreshoff Manufacturing Co., on Bristol Harbor where seven champion America's Cup yachts were built.

John Brown Herreshoff, president and founder of the company, died in 1915, his brother Capt. Nat carried on for a few more years before selling the yard to a syndicate of wealthy yachtsmen. Later the yard was sold at auction to Rudolf F. Haffenreffer. The Haffenreffer family carried on the old traditions of craftsmanship with most of the old personnel. At the close of WWII the yard went out of business, its assets sold and its harbor-side construction sheds torn down.

Bristol Steam Cotton Mill/White Mill/Namquit Mill (1843)

In 1836 the Bristol Steam Mill Company erected Bristol's first cotton mill on the site of the current Stone Harbour Condominium complex. The original mill was a total loss after a devastating fire in 1843; but it was quickly rebuilt. Typical of Rhode Island's second generation of mill buildings, the structure was a five-story, five by twenty-bay, end-gable-roof Greek Revival structure of rubble stone, with an offset square stair tower on the southeast corner. During the Hurricane of 1938, the tower lost its original roof and belfry. The deeply recessed main entrance with a limestone surround, key block, pilasters, and leaded glass transom survives. In 1880, after several changes in ownership, the Namquit Mill (the so-called White Mill) was acquired by the Richmond Manufacturing Company, which also owned the Pokanoket Mill on Thames Street.

These prosperous plants contained 21,152 spindles and 484 looms, producing print cloth and sheeting. In 1903 the mill was used for weaving, carding, frame spinning, rug spinning, and dressing. The Cranston Worsted Mills purchased the property in 1904, expanding operations already established in the Pokanoket Mill. In 1914 the Namquit Mill was used primarily for spinning. By 1927 the Cranston Mills merged with Collins and Aikman Corporation. The C&A used the facilities to produce automobile fabrics. In 1942 the C&A built an additional factory with a modified Art Deco façade, a large three-story, brick-, concrete-, and glass-walled weaving mill. The Premier Thread Company acquired the entire complex of buildings in 1966, and added a one-story, prefabricated steel building.

This row of mid-nineteenth and twentieth-century industrial buildings running north to south on Thames Street, at the foot of Bradford Street, are now high-end luxury waterfront condominiums, renovated for that purpose by a development group led by Timothy Fay.

Charles B. Rockwell's Cranston Worsted Mills (1866)

The history of textile manufacturing in Bristol goes back to the early nineteenth century with the building of the Pokanoket Steam Cotton Mill, known by its familiar name "the Red Mill," and the Namquit Steam Cotton Mill, known locally as, "the White Mill." These mills operated independently under these names until their purchase in 1891 and 1904 by Charles B. Rockwell founder and treasurer of the Cranston Worsted Mills.

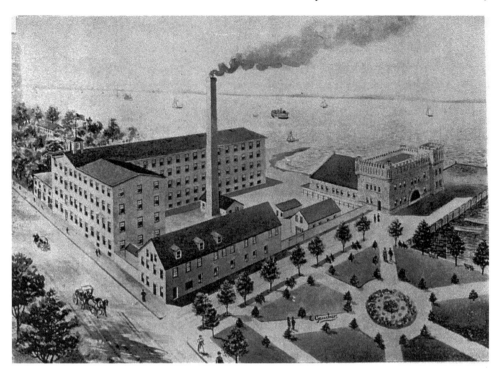

The Pokanoket Steam Cotton Mill on the Bristol waterfront, 1891. The Cranston Worsted Mills started in Cranston, RI; in 1891, the mill pictured here was purchased and all machinery transferred to Bristol.

The Cranston Worsted Mills founder and Bristol benefactor Charles B. Rockwell.

After Rockwell acquired the Pokanoket Steam Cotton Mill, on Thames Street he moved his Cranston operation into that facility. The floor space of the Red Mill was enlarged to about 20,000 square feet. In 1904, the need for additional floor space resulted in the purchase of the neighboring Namquit Steam Cotton Mill.

Establishing the Cranston Worsted Mills marked the beginning of manufacture of fine worsted yarns and quality worsted fabrics in Bristol. As these mills flourished, their physical size increased with construction of additions to their manufacturing facilities for expanded manufacturing space and storage of raw goods.

Rockwell travelled to Germany where he studied the art of making novelty yarns. Upon returning to Rhode Island he introduced those weaving techniques here. He began an importing business in New York; buying wool and mohair from the best sources available in the world. He paid more for superior goods believing use of the best material to be the best investment in the long run.

In 1915, The Cranston Worsted Mills decided to inaugurate a new policy—an experiment, of putting cost considerations aside and specializing in making the finest yarns possible. Consequently every department of the business was upgraded in equipment and personnel. Foremen with vision, imagination, and knowledge were hired to head the various departments, and a chemist was hired to check and maintain the quality control standards expected. The resulting high demand for the mills' product exceeded the expectations of the most optimistic of the business' officers.

In 1923, the Cranston operation acquired a Burnside Street building owned by the Herreshoff Manufacturing Company, remodeled it into the most modern type of sorting plant and used it as a place of storage for an extensive reserve stock of 700,000 pounds of unsorted wool and mohair; while an equal amount of stock was kept constantly in the bins ready for spinning. The need for additional storage space resulted in the 1924 purchase of the O'Bannon Artificial Leather Company plant in West Barrington.

A precursor to the Collins & Aikman Corporation was founded in 1843 by Gibbons L. Kelty. He sold window shades in lower Manhattan, New York City and gradually added home furnishing lines and upholstery fabrics. On August 1, 1927, the Cranston Worsted Mills merged with the Collins & Aikman Corporation. The merger was a happy marriage because Collins & Aikman Corporation (a subsidiary of General Motors Corporation, manufacturers of Ca-Vel and other plush automobile upholstery fabrics) was using much of Cranston's quality yarns in its production of automobile fabrics.

Additionally, the firm still produced the worsted knitting and weaving yarns and the famous Cranston novelty yarns which were the special high-grade products of the company.

Charles B. Rockwell died in 1929, but he laid an enduring foundation upon which Bristol industries built for several more decades. Rockwell left his mark on the town by funding a school that bears his name, and donating the land for the waterfront Rockwell Park.

In 1930, the Collins & Aikman Corp. ran the following advertising statement in Bristol's 250th anniversary commemorative program:

The Collins & Aikman Corporation the largest manufacturer of Plush in the world, have their yarn making plants in Bristol—formerly the Cranston Worsted Mills.

These mills are represented by the properties known as the old Pokanoket Cotton Mills, and the Namquit Steam Cotton Mills the oldest mills in the town, built about 1840 and still in excellent condition.

The old Burnside Rifle Factory is also used by them.

Thus forty-eight years of yarn making in Bristol is associated with the oldest and most historic buildings to which has been added 5 acres of the most modern floor space.

The owners and employees are proud of the record of less than four weeks idleness since the panic of 1893.

The Collins & Aikman Corporation stands pre-eminent today in the manufacture of mohair and worsted yarns, being admittedly the leaders in plush yarn manufacturing thruout [*sic*] the world.

In 1942, a modern weaving plant with corporate offices was built at the foot of Bradford Street; this is the so-called "red and white building", the Art Deco inspired structure that morphed into The Coats and Clark Premier Thread building (now Stone Harbour Condominiums), it is built on the footprint of the old Richmond Manufacturing Company, the mill wharf, the former Wardwell Lumber Company, and a right-of-way to the shore.[34] Bradford Street ended at the front door of the Premier Thread Coats-American building.

The October 20, 2005 edition of the *Bristol Phoenix* carried this editorial by Stephen V. Martino:

Long before the Stone Harbour Condominiums rose within the former Premier Thread factory on Thames Street, Bradford Street ran straight down to the water, allowing public access by residents to Bristol Harbor and its sweeping vistas.

Now, more than 60 years after the factory was built, the condominium complex obstructs the view of the water and, ultimately, the public's access to it via that old right of way. But the project's developer isn't to blame.

At a town meeting in February 1941, the Bristol Town Council voted to sell the several hundred foot-long strip of Bradford Street for $400. The Collins and Aikman Corp. purchased the parcel and expanded the old mill building onto a tract of land just to the north. That expansion later became the Premier Thread building.

Under the deed signed by the town and Collins and Aikman, Bristol gave up its right to the land, which "ceased to be useful to the public."

While town officials today have no answers for why the town sold a public right of way outright, Bristol Town Clerk Louis Cirillo said it may have been because the factory was producing uniforms for the military. The United States did not enter World War II until about 10 months after the deed was signed, but Mr. Cirillo said the factory might have been making uniforms for American soldiers.

They would have pretty much gotten what they wanted at that point," said Mr. Cirillo. "They did things differently then."

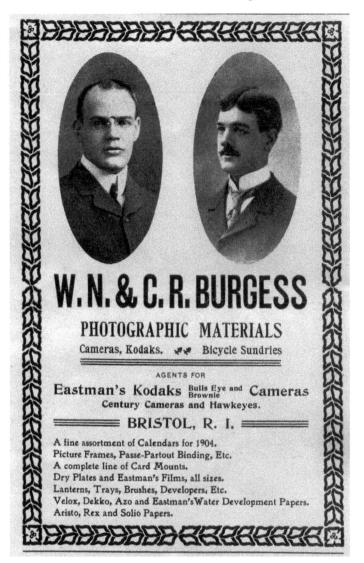

Display advertisements from a *c.* 1903 *Bristol Phoenix*

In a letter to the *Bristol Phoenix* published last week, High Street resident Richard V. Simpson expressed concern about the public's right to access the water along Thames Street. In his letter, Mr. Simpson wrote that although Stone Harbour has agreed to build and dedicate a boardwalk to the town, the public right of way existed long before the condominium's owners hashed out a deal with the town to open the boardwalk.

The boardwalk is "mostly good news," wrote Mr. Simpson. "I say 'mostly good', because Bristol citizens should know the Stone Harbour folks are not giving us anything we did not have in the first place."

Chapter 7

And Now, a Few Words from our Sponsors

Throughout the nineteenth century, the spirit of individual entrepreneurship flourished and reigned in Bristol on a greater plateau than any town of its size and population in the state. Display advertisements in nineteenth and early twentieth-century newspapers, fraternal organizations' brochures, theater and celebration programs, and numerous independent merchant's trade cards attest to the town's flourishing private enterprise. The diversification of the types and size of local business are legion.

Merchant's trade cards, an inexpensive form of direct advertising, were handed out to potential customers in the same way business cards are today; in effect, trade cards were the business cards of the nineteenth-century. Informative and whimsical, they were eagerly collected, hence—the foundation of the hobby of collecting "scraps" and pasting them in *scrapbooks*. Today, surviving trade cards present an enormous source of information to the societal anthropologist.

The *Bristol Phoenix* dated Saturday, December 27, 1851 is the source of the following assortment of classified advertisements hawking a diverse range of goods and services. For the reader's enlightenment and entertainment the 150-year-old advertisements presented here are punctuated with Bristol merchants' trade cards.

REMOVAL, Albert S. Pearse. Would notify his friends and customers that he has removed from his old stand to the Brick Store No. 80 Thames Street, one door south of Wm. R. Taylor's Store. Feeling very grateful to his Friends for past favors and for a continuance of their patronage. Having recently made his selection of Butter and Cheese at the West he will be able to supply those who will favor him with a call for the above articles. He also intends to keep on hand an assortment of Flour of extra brands and qualities in bbls and half barrels. Rye and Indian Meal, also, groceries, such as sugar, Molasses, Tea, Coffee, Rice, Oil, Nutmegs, Cinnamon, Ginger, Saleratus, Pepper, &c. Also, a few barrels of the best quality Pilot Bread for family use. All the above goods will be sold at Reasonable Prices of Cash.

Furniture & Coffin Wareroom! No. 40 BRADFORD STREET
Furniture and Coffins of every description constantly on hand, or made to order, such as Mahogany, Blk Walnut, Cherry, and Pine Finished, in neat style. FURNITURE: Bureaus, tables, Bedsteads, Sofas, Mahogany, Spring Seat Chairs,

Anania (Uncle Tony) Antonio's State Street lunch room at 11 State Street. Uncle Tony is behind the counter. Santo Degoti, Sr., is sitting at counter wearing cap.

Common Wood, and Cane Seat do. Bird Cages. Palm and Straw Mattresses, Willow Caaches [*sic*] and Cradles, Wooden Ware of all kinds. Old Furniture made New, &c. &c. GEORGE MUNRO, 2d.

STOVES! STOVES! L. A. BISHOP. Air Tight Parlor and Republic Cook Stoves. The Republic and Old Colony and Air Tight Cook Stove which for convenience, durability and economy, are unequalled; which together withal modern improvements, make them as desirable as any stove in use, are now selling at a reduced price, for cash, at No. 59 Thames Street.

STOVES, STOVES. GEORGE TILLEY. No. 17 Bradford Street. Has for sale the Bay State Cook Stoves, so much admired by those that used them last Season; also, the Eastern Queen, a New and Beautiful Pattern with very Large Ovens; together with an assortment of Parlor and Shop Stoves, Trimmings and Linings, &c.

DYSPEPSIA IN ITS WORST FORMS, Also liver complaints, Jaundice, Heartburn, Costiveness, Faintness, disorders of the Skin, Liver, and Skin. Loss of appetite, Low spirits, nervous Headache, Giddiness, Palpitation of the Heart, Sinking and Fullness of Weight at the Stomach, and all other diseases caused by an impure state of the blood, liver, etc., which tend to debilitate and weaken the system.

Santo Degoti, Sr., (standing center) at his State Street bicycle rental and sales store.

Buffington's Central Drug Store on south State Street, *c.* 1910.

FEMALES who suffer from a morbid and unnatural condition will find this Medicine of INESTIMABLE VALUE. In all cases of General Debility, this Medicine ACTS LIKE A CHARM. Price 50 Cents per Large Bottle. For sale by JOHN B. MUNRO, Sole Agent for Bristol.

1851. 1851. FALL IMPORTATIONS At The STATE STREET CLOTH, CLOTHING and DRY GOODS STORES The largest, cheapest, and best assortment of Cloth Clothing and Dry Goods can be obtained of the proprietors of this well known establishment.
Splendid FRENCH CLOTHS. A splendid assortment of French Cloths of all colors.

BEAVER CLOTHS of every texture, color, &c. FRENCH DOESKINS &c. Every description of French Doeskins and Cassimere can be found among this large stock, also Tweed, Satinett, Jeans, &c. in abundance. Nos. 31 and 35 State Street, opposite the Post Office. HAZARD & BROTHER

LIVERY STABLE MASON W. PIERCE Would announce to his friends and customers that he has removed his branch Stable from the rear of the Bristol Hotel to his Stable on Thames Street, where he has a number of fleet and gentle Horses, and carriages and Sleighs of every description, which he will furnish as low as any other establishment.
 Parties furnished at all hours with double or single teams, with careful drivers. A continuation of patronage is respectfully solicited.

FRESH MEAT On and after Monday next, we shall be able to supply our customers with whatever they may want in the Meat line. Beef, Pork, Poultry, &c., give us a call.
F.G. BABCOCK

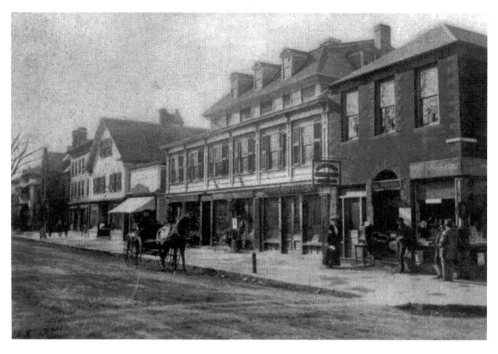

The Bristol Center business district at the west corner of Hope and Bradford Streets.

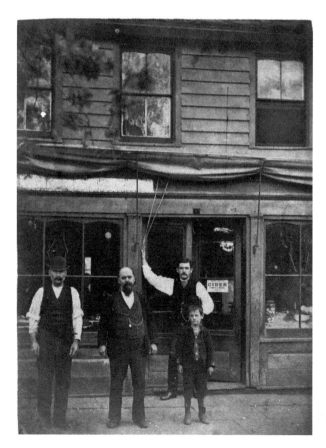

An unnamed dry goods and grocery store on the southwest corner of Hope and Bradford Streets.

Chapter 8

Remembering Historic Bristol

Unlike other show towns, however, the life of Bristol does not focus about its [Massachusetts-style] common, but ranges up and down Hope Street, an incomparable highway affording unexpected glimpses of the water of Narragansett Bay at every cross-street, and ending in a marine prospect scarcely inferior to that of a drive out of Naples. If you go down to the wharves close at hand, you will spy across the water two very imposing estates–the DeWolf-Myddleton [sic] and DeWolf-Mudge, respectively. They are on the Poppasquash Road to Bristol Neck, another drive of no less enchantment. It is pretty, also over at Mount Hope–only, don't stop there: for that would mean social extraction.

The White Pine Series of Architectural Monographs; Vol. III, October 1917, No. 5
The Bristol Renaissance by Joy Wheeler Dow

The Privateer Yankee

With war declared between Great Britain and the United States in 1812, there came an opportunity for James DeWolf and other Bristol ship owners to get even with their ancient foe who had deprived them of acquiring wealth during the earlier conflict. The business of privateering was again a worthy occupation for Rhode Island's ship owners and sea captains.

The merchants of Bristol were not slow to take advantage of this chance because they had suffered many deprivations during the late war at the hands of the English. Among them James DeWolf, a descendant of Simeon Potter was especially bitter. He fitted up his brigantine the *Yankee*, a ship of one hundred sixty tons burthen, with a crew of one hundred twenty men, mounting eighteen guns commanded by Captain Oliver Wilson.

A generous agreement was drawn between owners DeWolf and John Smith, the officers and men; this privateer armed with its *Letter of Marque and Reprisal*, sailed in the summer of 1812. Unexpected success attended the *Yankee* from the start and she paid for herself repeatedly, besides generously rewarding those who risked their lives in this dangerous occupation.

A brigantine in the time of the *Yankee.*

The First Cruise

The *Yankee* was immediately and immensely successful. In this respect, she was unlike many of the other privateers of the War of 1812. It is a mistake to suppose that the business of privateering was, as a rule, a successful one. Most of the vessels engaged in it barely paid their expenses. To many the cruises resulted only in a loss. Much depended on the sailing qualities of the ship, and the way in which she was handled; but much more depended upon sheer luck. The privateers, as a rule, did an enormous amount of damage to the shipping of the enemy without reaping any corresponding advantage themselves. The *Yankee*, however, not only inflicted enormous damage upon the enemy but also was enormously profitable to her owners.

The *Yankee* captured her first prize within two weeks out of port. One prize taken on her first cruise was the ship *Francis*, whose confiscated cargo brought over $200,000. That first cruise paid for the brigantine several time over, and resulted in a dividend of more than $700 per share.

The Second Cruise

On Saturday October 17, 1812, the *Yankee* prepared for her second cruise, this being of six months duration. One hundred young, active, and enterprising mariners and fearless, seasoned officers, all thirsting for fame, fortune, and glory signed on with Oliver Wilson in command.

Captain Wilson, a Connecticut native, about 27 years of age was accustomed to the rigors of the sea from his earliest years. He was impressed by the British and for several years was compelled to serve His Majesty. During his forced service, he learned every part of a seaman's duty.

Early in her second cruise she captured the brig *Shannon*, with a cargo of cotton valued at more that $670. Captain DeWolf converted the *Shannon* into a privateer, renaming her *Balance*.

On the 106th day of the cruise, the *Yankee* lay about four leagues distant from Pernambuco[35] after sailing from Ascension to Cape St. Augustine.

At 1 P.M. piped all hands to quarters, cleared for action, run down under the lee of the large armed English brig, pierced for sixteen [cannon], and mounting eight eighteen-pound carronades, when within pistol shot, ordered the enemy to strike his colours [*sic*], he replied, "I am all ready!" Captain Wilson ordered his men not to fire and again commanded the enemy to lower his flag and quit the deck. He replied, "Surely you are joking!" our commander still observing that the enemy was not prepared for action, prevented his men from firing and a third time ordered the enemy to strike, or he would sink him, which he now did with good reluctance. Sent our boat on board and found our prize to be the large armed letter of marquee brig *Harriet & Matilda*, from Cork bound into Pernambuco, Captain John Inman, burthen 262 tons, coppered [bottom], with a full cargo of fine goods, crates, porter, cheese, butter, potatoes, etc. *The Harriet & Matilda was formerly a Danish sloop of war, is a fine strong Burthensome-vessel and sails well. This prize and cargo may reasonably be estimated at $45,000.*

A. Wanderer, Clerk of the Brig Yankee

The Third Cruise
On May 10, 1813, the brig Yankee prepared for her third cruise; Elisha Snow was her Captain. The Atlantic coast was alive with British war vessels. Captain Snow received intelligence of a frigate and a fourteen-gun brig lying in wait for him near Block Island. Choosing his time well and aching for a fight he sailed from Newport on May 20 sailing blissfully into the waters of the waiting Englishmen.

During a three-month cruise, seven prizes were taken, but most of them were recaptured. However, the most important was the ship *Thames*, of 312 tons burden, with 287 bales of cotton; the auctioned vessel and cargo netted a total of $110,000, for a payment of $173.54 for each share.

The Fourth Cruise
With Captain Elisha Snow in command, the Yankee's fourth cruise was nearly a failure; the two prizes taken yealed only $17.29 per share.

The Fifth Cruise
On her fifth cruise, Elisha Snow was again in command of the *Yankee*. The cruise did not finish as planned—an English man-of-war drove the *Yankee* into New Bedford and almost her entire crew deserted. However, four prizes were taken, three of which were of practically without value. Nevertheless, the *Yankee's* prize crew sailed the fourth ship into Portland, Maine safely. She was the *San Jose Indiano*; the fully rigged ship with her cargo sold for a half million dollars. This was the *Yankee's* most profitable cruise reaping all hands sizable dividends.

Captain Snow's "lay" was $15,789.00, and the owners realized $223.313.10. It was the most profitable cruise of any privateer during the war.

The Sixth Cruise

The sixth and final cruise, under Captain Benjamin K. Churchill, lasting 105 days reaped five prizes taken. Only one of these was of any value and that one the brig *Courney* with her cargo sold for $70,000.

There were several other privateers sailing out of Bristol Harbor: the *Rambler* did efficient work along the coast of Africa; another brig, the *Macdonough* was also sent out by the owners of the *Yankee*.

In all, the bold *Yankee* made six voyages and always had some profit to show for the risk. However, it was not always without cost; the sailors were sometimes seriously injured in the execution of their dangerous work and even the commander on one cruise lost a leg during a heated exchange with the enemy.

Hope Street Saltbox

Gone but not forgotten is this saltbox-style house located at 837 Hope Street, which was built in 1710 by the son of Jonathan Glassing. When the 185 year old dwelling was torn down in 1895, it was owned by Ann Harding. The man in the doorway is Charles Salsteen, who was living there at the time. *Phoenix photo.*

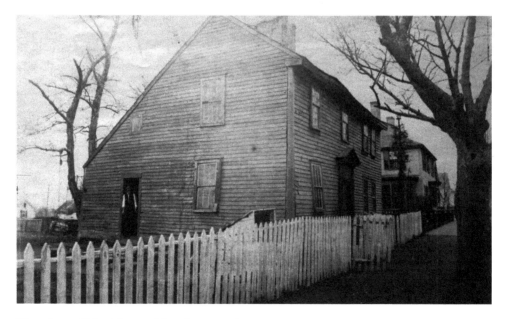

Hope Street Colonial-era saltbox homestead.

Horton's Hotel

The Bristol Hotel, known locally as Horton's Hotel was an 1804 Federal style brick building of imposing dignity located on the south side of lower State Street. Visitors to Bristol from the town's outlying plantations, from Warren, Barrington and Providence relied on Chadwick's Bristol to Providence stagecoach as a trusted and scheduled means of transportation.

Early Sunday morning, July 10, 1960 the hotel renamed The Colonial Inn, was consumed by fire, with the tragic loss of six lives. The still vacant lot is now a municipal parking lot.

Searching for Mt. Hope (Massasoit) Amusement Park

That a "pleasure resort" and amusement park existed on the shore of Mt. Hope for as many as twenty years is not in doubt. However, recorded history reveals precious little about it. Knowledge of the conditions of how it came about and how it developed is foggy, but the reason for its demise can be reasonably assumed.

In his *Picturesque Rhode Island*, published in 1881, Wilfred H. Munro presents his readers with an engraving of the east shore of Mt. Hope as seen from Mount Hope Bay. Unfortunately, Munro neglects to grace his readers with any description of the contemporary use of the buildings seen there.

Munro's illustration, identified only as "Mt. Hope" is a view of the shore with two large pavilions, one long and narrow and the other a two-story building with the distinct features of a garrison house flying a pair of American flags; on the crown of the hill is a structure that appears to be an observation tower. Near the shore, a dozen well-dressed men and women stroll.

It is doubtful this is the "amusement park" of legend, but it is crystal-clear that people were gathering on Mount Hope's east shore prior to 1881. Records appearing in the press point to the year 1898 as the date the area became the full fledged Massasoit Amusement Park.

Early in 1897 the *Bristol Phoenix* announced to subscribers of plans on the horizon to establish "Mt. Hope as a Summer Resort."

> For some time past the proposed summer park at Mount Hope has been the subject of talk among those interested in the scheme and some preliminary preparations have been made. The project has now taken definite form and the work of pushing it forward has begun in earnest. A short time ago Philip Walsh, the manager of the People's Steamboat Company of Fall River and Messrs D'Wolf and Bullock of this town went to Providence and filed formal application for incorporation. The charter was granted last week; last Tuesday manager Walsh and several others came to Mount Hope in Captain Murphy's sloop [the] *Kismet* and made soundings and measurements about the proposed location of the wharf. From the figures obtained the plans for a dock will be drawn. The dimension will be as follows: length from

shore, 135 feet; width of face 200 feet; width of run, 30 to 50 feet. The wharf will be built of the best material in the strongest manner possible and will be one of the finest in this section. Extensive work will be carried on ashore. Pavilions and smaller buildings will be erected and what nature has failed to do about the grounds man will accomplish.

Under the headline, "The New Summer Resort", we read the following in a late 1897 issue of the *Bristol Phoenix*.

A meeting of the stockholders of the Mount Hope Park Company was held Thursday afternoon at Fall River. The committee on the wharf to be constructed on the shore at Mount Hope opened the bids of the contractors and the contract for building the wharf was awarded to Capt. Joseph Terry of Fall River. Capt. Terry will begin the work immediately as the spiles [piles] are already on the shore, having been cut during the summer in the woods at Mount Hope. The wharf is to be constructed according to the new plans and is to be 215 feet in length and 90 feet in width. It is expected that about nineteen feet of water in depth can be obtained at the head of the wharf.

 The plans for the several amusements are now in course of preparation by parties in Boston and their locations were discussed at the meeting last week.

A paragraph in an April 1898 *Bristol Phoenix* article titled, "Mt. Hope Summer Resort", announces the opening of the new entertainment venue on Mt. Hope.

The prospective pleasure resort at Mt. Hope was visited by many people Sunday. The evidence of careful design in the location of everything can now be seen. The old farm house has been renovated and will be used as a hotel [This is most likely the King Philip House at 2 Pokanoket Place.]. Near this building on the west is the neat new barber shop to be run by B. H. Rogers, the popular High Street tonsorial artist. The dancing hall is located about half way between the hill and the shore, while the large dining hall where shore dinners will be served, and is near the water, with a row of bathing houses east of it on the shore. The new wharf is substantial and is well located just north of the dining hall. Another wharf will be built north of this one. Roads have been laid out, leading to the various buildings. The base ball ground will be at the north end of the park and the big amusement enterprise at the south end. A "chute de chute" will also be located at the south end.

On an Internet web site called New England's Lost Amusement Parks, Professor Kathleen Dunley presents an overview of a few facts she has found concerning Mount Hope [Massasoit] Park.

According to one source, the park featured lunch stands, popcorn machines, a photograph gallery, a phonograph, a soda fountain, a ball game, a range finder, African dodger, and a striking machine. Quite a list of amusements! A hotel, a dance

The abandoned amusement park's wharf, carousel, and shore dining hall *c.* 1910 image from a glass photo-plate.

hall, a ball park, bowling alleys, and pool tables—even a merry-go-round—were all on the grounds.

The park was difficult to access because the trolley line did not reach the shore. Apparently, the park faded due to problem with drunkenness resulting in the park losing its liquor license, leading to the final drop in attendance before the park closed in 1901.

On the Mount Hope Farm Internet pages we learn that in 1902 Rudolf F. Haffenreffer II bought the 69 acres on which the park was built; and in 1916, Haffenreffer bought the remaining 550 acres. The Haffenreffer's summer house, on the slope of Mount Hope (called King Philip House) was originally the eighteenth-century farmhouse and late nineteenth-century hotel mentioned in the above quote.

Professor Dunley's premise of drunken reveling is surly one factor in the closing of the park. It is well known that nineteenth-century Bristol was a hard-drinking and hard-playing town. Every weekly issue of the *Phoenix* newspaper carried one or more reports of rowdiness caused by the evil spirits of Demon Rum.

Although documentation is not currently available, we can reasonably assume the Newport and Providence Railroad Company, owner of the ferries *Sagamore* and *Bristol*, used these vessels as the principal means of bringing patrons to the park grounds from Bristol's Constitution Street landing; the People's Steamboat Company of Fall River was the transport service for Fall River folks crossing Mount Hope Bay to Massasoit Amusement Park. Otherwise, it was a long dusty mile-and-a-half ride in horse-drawn buckboards and carriages over the bumpy, dirt Tower Road.

Dr. William Canfield's Hopeworth Sanitarium/Woodmoor Lodge/ Hopeworth Estates (*c.* 1905)

About mid-nineteenth-century Dr. Charles Doringh erected cozy granite and timber walled Victorian-Gothic cottage; its general location was on the present site of the Hopeworth Estates' playground.

During the time of Drs. Herman and William Canfield's operation of their Hopeworth Sanitarium, they gradually expanded their facility to include about a dozen ancillary buildings. These buildings included a carriage house, boathouse, servants' quarters, a bowling alley, and a casino. An artesian well and pump supplied ample fresh water. Deep in the woods, a spring flowing from Mt. Hope was dammed forming a fresh-water pond. During the winter ice was harvested and stored in a wood and stone barn for summer use.

Doctor William Canfield's Hopeworth Sanitarium was located in the Hopeworth section of town called the Middle District. This clinic was not the kind of sanitarium that we associate today as an asylum for treatment of mental disorders. Dr. Canfield's clinic was more of a rest home and resort for the cure of drug and alcohol dependence. The Woodmoor Lodge building itself was a 44-room Victorian Gothic built around 1906, deep in the woods bordering Mount Hope Bay on Canfield's 65-acre estate.

At the beginning of the twentieth century, the Hopeworth section of Bristol consisted of many large dairy farms and gentlemen farmers' country estates stretching from Back Road, now called Metacom Avenue (Route 136), east to the shore of Mount Hope Bay.

Far away from the busy and bustling Bristol center, and temptations of the many Thames Street pubs, Dr. Canfield's patients had countless opportunities for sober rest, relaxation, and contemplation. The spacious grounds of the sanitarium offered a variety of natural surroundings for the lover of nature. The advent of modern medicine caused Dr. Canfield's sanitarium to become redundant forcing its closure.

In the early second-decade of the 1900s, the estate was operated by Miss Ethel T. Mason as an inn fronting Mount Hope Bay; it was then renamed "Woodmoor Lodge". With new management, the facility, with all its amenities, became a retreat for wealthy individuals and families seeking solitude.

The earliest and most complete information concerning Hopeworth Sanitarium is from an advertising brochure titled *Woodmoor Lodge* dated 1913, courtesy of Skip Castro.

> Woodmoor is an estate of sixty-five acres, situated on an arm of Narragansett Bay [should be Mount Hope Bay] and lying on the northern slope of Mt. Hope, two miles from Bristol [center], midway between Newport and Providence and fifteen miles from each.
>
> The Lodge, part granite and part wood, is provided with modern conveniences, well furnished rooms, steam heated and lighted by electricity. The public rooms have open wood fires, three parlors, a spacious, airy dining room, and a conservatory,

eighty-feet long connecting with the dining room; give plenty of room for the comfort of guests.

An artesian well and the necessary pumping engine insure a supply of water of exceptional purity. Guests preferring to be outside in cottages can be accommodated and take their meals at the Lodge.

Suites of two or four rooms with private bath attached in large cottage if desired. Suites steam heated and lighted by electricity. The Lodge is surrounded by gardens bordered with box and privet hedges. In the garden south of the conservatory is a bowling alley, tennis court and croquet ground.

The trees and shrubs of Woodmoor contribute largely to its beauty. Many of the shrubs upon the lawn were imported from England years ago and have now assumed fine proportions. All the fruits of this section are grown in abundance. A large vegetable garden supplies the table.

The great variety of wild flowers found upon the place is frequently commented upon.

West of the Lodge is a stretch of woods with massive forest trees, and tangled undergrowth. The woods furnish a safe nesting ground for an extensive variety of bird life as can be found in New England.

Half a mile from the boat house is the famous Northman's Rock. Near the boathouse, a private pier forty-foot broad extends into twelve-feet of water at high tide affording a landing place for boats and a good fishing stand.

The sailing in Mount Hope Bay is safe and delightful. Many small coves and rivers offer interesting points for exploration, and the main part of Narragansett Bay is within easy sail. The summer winds are generally light, variable in the morning, strong, and steady from the southwest in the afternoon, favorable for quiet or exciting sailing.

Just south of Woodmoor raises Mount Hope, the historic landmark of Rhode Island. The home of the Indian, King Philip, and his tribe, the [Pokanoket] Wampanoags. In the swamp one hundred feet west of Mt. Hope, a boulder monument marks the spot where King Philip was shot. The death of King Philip closed the war and the fertile Mount Hope lands [extending into present day Warren] fell into the hands of the English, by right of conquest. Three years after the war in 1680, the Town of Bristol was settled.

A typical old New England seacoast town, with broad streets shaded by large elms [since decimated by the Dutch elm disease]. Bristol has a wide reputation for its salubrious climate, No more delightful and healthful place can be found among the coast towns. Warm in winter, and cool in summer, the prevailing southwest winds are always laden with a saline softness always refreshing, the thermometer seldom goes above 85° in the summer, during the day, and the nights are always cool.

The roads around Bristol are good for driving or automobiling. A large stable on the grounds furnishes accommodations for automobiles or private carriages.

For those, therefore, who seek the inspiration of country life, who need at once the refinements of life and the fellowship of the woods, the water and meadows, and especially for those who demand repose without loss of human interests, Woodmoor has been so arranged by Nature as to meet those needs.

For further particulars, rates and reservations, address Miss E. Mason.

Mason sold her interest in the retreat in January 1928 to the Pokanoket Reality Company. Nine years later under reality company president Charles B. Rockwell, the former sanitarium was transferred to Dr. and Mrs. Frederick Martin. Coming from Ithaca, New York, Dr. Frederick VanDoorn Martin relocated his Martin Hall National Institute for Voice Disorders to the Hopeworth-Woodmoor Lodge estate. Also making the move was Marion Bouman, then the Assistant Director of the Institute. She later married one of her patients, S. Morton Giles an author and director of theater stage productions.

After the death of Dr. Martin in the late 1940s, Mrs. Marion Bouman Giles continued the Martin Hall Institute in a building at the southeast corner of Union Street and Noyes Avenue, originally erected in 1887 as a home for destitute children.

In 1952, Dr. Martin's widow, Kathryn Hawks Martin sold the estate. It was purchased by Hopeworth Incorporated headed by William A. Rego. On November 2, 1959, the vacant Gothic mansion was destroyed by fire. Today, many of the original guest cottages remain as part of the secluded subdivision neighborhood known as Hopeworth Estates.

Edghill Farm and Ferrycliff Farm

After his election to the United States Senate, General Ambrose E. Burnside (1824–1881) appeared to take a greater interest than ever before in cultivation of the soil.

Ben: Perley Poore, *Life of Burnside*

An Indiana native and West Point commissioned officer (1847), Ambrose Everts Burnside served six years in the regular artillery, including garrison duty in Mexico; in 1849, he was wounded in a skirmish with Apaches in New Mexico Territory. He resigned his commission in 1853 to manufacture his breech-loading carbine in Bristol, where he settled after marrying a Providence woman. He failed to gain a government contract for his rifle, so he was forced to assign his patent to creditors. During this period he was also a major general in the Rhode Island militia.

Burnside named his Bristol estate, Edghill Farm, after his father Edghill Burnside, and his great-grandfather, James Edghill.

Edghill Farm was located on a hill overlooking Mount Hope Bay, about two miles from Bristol Center on the well-traveled Ferry Road. As one entered the estate through a gate, nothing but the roof of the house could be seen, because the ground on which the house stood was somewhat lower than the road. As you can see by Kitty Herreshoff DeWolf's 1902 photograph, the house was somewhat unusual in its shape, having grown by gradual additions, from a small cottage into a spacious residence.

The principal portion, surrounded on three sides by glass windows, outside of which was a covered porch, reminded one of the rear cabin of a large steamer. On

In this Mathew Brady studio photo of General Burnside he is seen wearing the badge of the Ninth Corps. Burnside designed this badge; it was manufactured by Tiffany and Company of N.Y. The badge was officially adopted by the Ninth on April 10, 1864 upon Burnside's resumption of command of that unit. Noted for his bushy cheek-whiskers, Burnside is forever remembered for lending his name to the men's fashionable hair style.

Kitty Herreshoff DeWolf's 1902 photograph of General Burnside's residence on his Bristol Edghill farm.

the other side was a large, old-fashioned fireplace, with brass andirons and a high mantelshelf, over which was a stag's head with spreading antlers. In describing the interior, there were airy chambers above the general's own rooms, below comfortable quarters for the servants, wide porches, bathrooms, a well-ventilated kitchen, and a host of conveniences suggesting more possibilities for comfort.

The chief charm of Edghill was its natural beauty, without any attempt at artificial ornament. There was a garden, with fruit trees and grapevines, and the ground descended gently from the house to the shore of Mount Hope Bay.

During the summer of 1875, plans were made for a visit by President U. S. Grant to his old friend and fellow Civil War warrior A. E. Burnside. When news of the President's visit became public knowledge, the town council formed a committee headed by Isaac F. Williams to arrange a suitable welcoming and reception. When the time arrived for the distinguished visitor to taste Bristol hospitality, the principal highways of the town were "strewed with bunting, flags, streamers, and festoons".[36]

General, then Senator, Burnside arrived at the train depot in time to greet his old friend President Grant when he alighted from the train; the official party immediately entered carriages for the ride through the old town's decorated streets to Burnside's Edghill Farm on Ferry Road.

We can only guess what took place there when the two old friends finally sat down for a quiet chat and refreshments while the rest of the population boiled over with excitement. The President probably walked around Burnside's spacious farm, undoubtedly looking at, and admiring, Burnside's stable of fine horses, inspecting the farm's poultry house, and remarking about the unbroken view of Mount Hope Bay and its environs, perhaps they uttered their thoughts about King Philip and his people who for a thousand years had basked in the same prospect.

In 1875, Dr. and Mrs. Herbert Marshall Howe purchased a large tract bordering Edghill Farm from H. B. Bowen for $20,000. Here, the Howes established their dairy farm called Ferrycliff Farm. The name is derived from the nearby ferry to Aquidneck Island and the steep terrain at the water's edge. At some point in time after Burnside's death in 1881, the Howes adsorbed Edghill into Ferrycliff; exactly how or when Burnside's house ceased to exist is unknown.

Dr. Howe, a Philadelphia physician and artist, was in the habit of residing each summer with his father and family on the Weetamoe Farm, whose elegant yellow house still exists on Metacom Avenue just south of Mount Hope Farm. Dr. Howe's father, a Bristol icon, Bishop Mark Anthony DeWolf Howe, was a cultured gentleman whose religious convictions and ministry experience brought him honor when in 1871 he was chosen to preside as Protestant Episcopal Bishop of the new Diocese of Central Pennsylvania. After returning from his post, he spent his few remaining months at Weetamoe.

During the Cold War years from the 1950s through the 1970s, the federal government acquired 40 acres of this land for use as a NIKE missile site. The Army moved into Bristol in 1956 and began building a Nike Ajax Missile complex, which was to be one of seven defending the city of Providence. The radar control

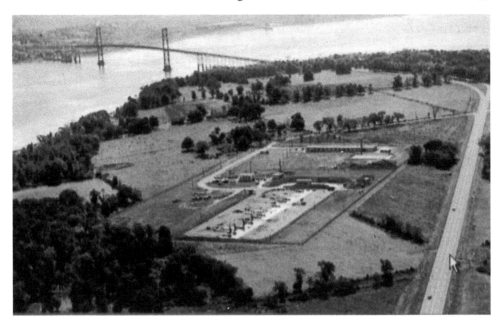

The NIKE missile launch site *c.* 1959, on land formerly the farm-residence of General Burnside. Above the site are the bucolic pastures of Ferrycliff Farm, which is now the campus of Roger Williams University. On the right is Rt. 136, Metacom Avenue.

area was constructed on the crown of Mount Hope and the launcher area was located several thousand yards to the southwest, just north of the Mount Hope Bridge and east of Rt. 136. The total project was done by Ferber Construction Company of New Jersey at a total construction cost of $1,600,000 for both areas.

Burnside's residence once stood southeast of the NIKE site. In the mid-1970s fragments of the house once belonging to the Union general, Rhode Island governor, and United States senator could still be seen amidst the scrub of underbrush.

Since 1969 the combined Burnside and Howe farms form the campus of Roger Williams University.

Nor'west John DeWolf/Mark Anthony DeWolf Howe/Weetamoe Farm (*c.* 1745, *c.* 1790, *c.* 1810, *c.* 1833, *c.* 1870), 242 Metacom Avenue

This is a handsome two-story, hip-roof Federal dwelling with a full monitor, bold quoins, and modillion cornice on three sides; it was built in several stages with additions in the style popular during the residency of its several owners.

Owned by Henry Mackintosh in the early 1700s, Weetamoe Farm developed as part of Mount Hope Farm. Mackintosh gave his granddaughter Elizabeth and her husband Isaac Royall the south half of Mount Hope Farm in 1744, and they

began construction of a house (see article about Mount Hope Farm). In 1776, the estate was confiscated by the State of Rhode Island to raise crops to feed colonial troops.

After the Revolution, Deputy Governor William Bradford bought Mount Hope Farm and gave this 33-acre tract to his daughter Hannah Baylies. Later, in 1811 for consideration of $8,000, Hannah assigned title to Weetamoe to her cousin George DeWolf; but her husband Gustavus retained use of the land as a farm.

After returning from sea in 1828, Nor'west John DeWolf took his residence in the old manse, cultivating the land until 1832. In 1833, he sold the farm to attorney John Howe, father of Mark Anthony DeWolf Howe, who added a Greek Revival Ionic porch and balustrade (now removed) to the house.

The bucolic fields of Weetamoe, gently sloping to meet the shores of Mount Hope Bay once used for grazing cattle and sheep, cultivating onions and a tree nursery, are defined by beautifully capped stone walls. A stone pier was constructed (*c.* 1800) on the shore of Church Cove intended for shipping to move produce and other material in and out of Weetamoe Farm. Out buildings included a summer house (*c.* 1795), once the cupola of James DeWolfe's Mount Hope Academy which stood on Bristol Common; a one story partially below grade stone milk house (*c.* 1790) with a cross gable roof just south of the main house; a caretakers' cottage (*c.* 1850), a roof bracketed cottage once located at the crest of a slope east of the main house; and a small shed roofed play house overlooking Church Cove of which only the brick chimney still stands.

These acres of fertile fields are now cluttered with esthetically unattractive condominiums, referred to by locals as the "frog eyed condos".

The following is an abridgement of a biographical sketch of the Right Reverend Mark Anthony DeWolfe Howe, D.D. by his son M. A. DeW. Howe, 1901.

Mark Anthony De Wolfe Howe was born in Bristol, R. I., April 5, 1808, the only son of John and Louisa (Smith) Howe. Through his father he traced direct descent to James Howe, who came from England to Roxbury in 1637, and settled the next year in Ipswich. When Bristol was settled in 1680, the first town clerk was Richard Smith, the ancestor of Mrs. John Howe. The mother of John Howe was Abigail D'Wolf, a daughter of Mark Anthony D'Wolf and sister of Captain (and United States Senator) James D'Wolf. A full inheritance of Massachusetts' blood and Rhode Island traditions was thus transmitted to the subject of this sketch.

Of his schooling in the Bristol Academy, at Phillips-Andover, South Kingston and Taunton, it is not necessary to speak in detail. It prepared him to enter Middlebury College, Vermont, which at the end of two years he left to become a member of the junior class at Brown University, his father's *alma mater. Here he graduated in 1828, with the honor that belongs to a class poet, and the sense, destined to live through all his years, of a large personal debt to the influence of President Francis Wayland.*

Before he decided to enter the ministry there were several years of teaching in the public schools of Boston and as tutor in Latin at Brown University preceded

The 1745 Weetamoe Farm Homestead, photo *c. 2005. Courtesy of Michael Byrnes*

by a beginning at the study of law in his father's office. But while he taught at Brown, his studies for the ministry, directed by the Rev. John Bristed, son-in-law of John Jacob Astor, and father of the graceful writer, Charles Astor Bristed, were in progress. In January of 1832 he was ready to receive deacon's orders, administered in St. Michael's by Bishop Griswold of the Eastern Diocese, his spiritual father in an intimate sense peculiar to the time and place.

In the spring of 1895, Bishop Howe felt that the time had come for committing all this leadership to his successor. Accordingly he removed to his well-beloved home, Weetamoe Farm at Bristol, Rhode Island, where on the 31st of July, 1895, he died.

It is in this home that his immediate family and his kinsmen, or whom especially these words are written, love best to remember him. Here, perhaps more than anywhere else, he gave and enjoyed the pleasures of hospitality in fullest measure. His love for the place of his birth, and for all those to whom the tie of common blood bound him closely or remotely, was an essential element of his nature. A wonderfully retentive memory made his mind a store-house of local and family tradition. Travel and wide acquaintance never moved from the first place in his heart the scenes of Bristol and his interest in her sons and daughters. This brief outline of his life, therefore recording the chief events of eighty-seven years truly devoted to the service of his fellowmen in many places, should rightly end where it began, at Bristol.

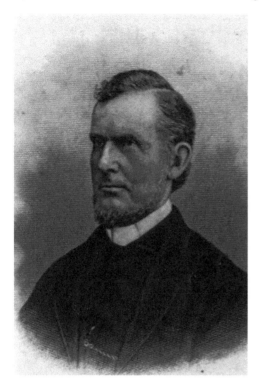
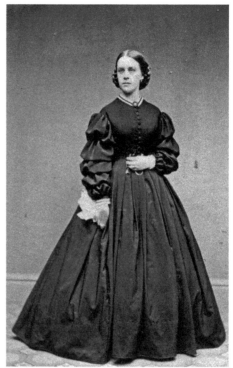

Above left: Bishop Mark Anthony DeWolf Howe, D.D.

Above right: Elizabeth S. Marshall (1820–1855), wife of M. A. DeWolf Howe.

The DeWolf Farm on Bristol Neck

The following excerpts are the only descriptions of the DeWolf Farm on Bristol Neck currently known to exist.[37]

Along a country road two miles from Bristol, Rhode Island (called Bristol Neck), where stood the D'Wolf Farm, a tract of land ran along the edge of Narragansett Bay for a mile, then reached across meadow, rough country, and fields, covering some 300 acres. It had been bought in the early days from the Indians and developed by William D'Wolf, the eleventh child of Mark Antony D'Wolf and his wife Abigail Potter. William and his wife, Charlotte Finny, built a substantial home near the main road, and there they raised five Children.[38]

In the spring of that year, [1815], her parents ["her" being the author's mother, Annie], Mr. and Mrs. Henry DeWolf moved up to the "Farm" on the Neck, which was to be thenceforth their home. Though not of great architectural pretensions, the house was most interesting and attractive, finely built, and the interior beautiful in finish,—the old Italian mantelpieces of peculiarly artistic form and design. The size and shape of the two main rooms, the "North Parlor" and the "Hall" as they were called, were uncommon and dignified; the furnishing was of the date of Chippendale,

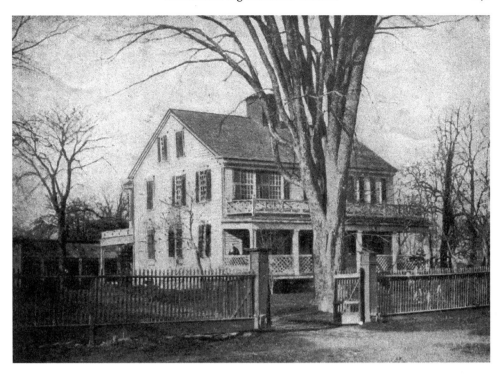

The DeWolf Farm on Bristol Neck; the house was torn down after the death of its last occupant Fitz Henry DeWolf. *c.* 1903. *Phoenix photo*

Sheraton, etc.; the silver, glass, and china of the rarest—of the latter there was a set of six hundred pieces of the blue-edged India of the same pattern as Washington's of which some eight or ten pieces still remain [1929]. The setting of the house was most happy, receded from the road; a little to the south and near the entrance gateway, was one of those absolutely symmetrical trees so large and so perfect that it was known in the country round as "The Great Elm."

Three or four hundred feet to the rear was a grove of primeval oaks, interspersed with stretches of water which formed an ideal drinking place for the cows as they were driven to and from their pasturage, The farm lane running through the grove continued, between meadows and fields of grain, first to the rising uplands commanding a view of the whole expanse, length and breadth of Narragansett Bay; then falling abruptly for a few rods and afterwards in a gentle slope to the shore; in those days, before the invasion of the railroad, entirely secluded and only available for the family. From early youth it was the delight and daily custom of my mother to run down through the grove (from the east) to see the sunrise on the shore, the bay and the western hills beyond. [Annie memorized prose and verse and] came over to Pappoosesquaw [Poppasquash] to repeat it to the aunts. At that time Pappoosesquaw meant the home of her grandparents, Mr. and Mrs. William DeWolf, he being the eleventh child of the first Mark Antony D'Wolf and Abigail Potter, his wife. The only other residence at that time on the peninsula was the old Vassall place now owned by the Herreshoff family. There were, of course, several fine farms, two or more owned

by brothers of William DeWolf, but he laid out the first country seat and built the beautiful house now known as "Hey Bonnie Hall."

DeWolf/Middleton/Hey Bonnie Hall

A particularly notable example of Russell Warren's genius must be mentioned. It is the DeWolf-Middleton-owned Hey-Bonnie Hall.[39] Facing Bristol's eastern shore from its pleasing location on the gradual rise of Poppasquash from the harbor stood this early nineteenth-century mansion.

Commissioned by Henry DeWolf of the second generation of that notable Bristol family, building began on this magnificent mansion in 1805 (or 1808). At an early age, barely into his mid-twenties, Henry became a wealthy merchant under the auspices of Nathaniel Russell of Charleston, South Carolina. His immediate success and recent marriage to Anne Marston of Boston prompted him to begin this elegant home as a showcase for his success. However, his financial achievements were short lived; business failures did not allow completion of his grand residence.

Henry's father, William, came to his son's relief with an offer to swap his home, the farm on Bristol Neck, for the unfinished Poppasquash construction.

Like his three brothers, William took to the sea at an early age, soon to become a sea-captain, shipmaster, and a wealthy and prominent merchant.

Following the occupancy of the DeWolf family, the mansion passed through their descendants into the possession of the Middleton family. The Middletons, formerly of South Carolina, were a family prominent in Southern political circles.[40]

The house presented, until its end, a rare and delightful picture of the northern house with southern plan, reproducing in its New England location the characteristic attached "wings" of the old Carolina plantation house. The building,

Russell Warren built this nineteenth-century mansion for William DeWolf, called Hey-Bonnie Hall on the Poppasquash peninsula facing Bristol's eastern shore. Photo *c.* 1808.

elegant and generous in its proportions remained preserved in its tranquil setting for about 150-years. Unfortunately the hurricane of 1944 sent the front portico roof over the house and did other serious damage. Shortly after that event the house was pulled down.

The house received its unique name from a Scottish ballad, which begins, "Hey the Bonnie, ho the Bonnie..." which young Annie DeWolf would sing when she came to visit her aged grandfather William. In his dotage, William would often long to see his beloved Annie, calling out, "Where is my little Hey Bonnie?" It was Annie, who in later years gave the house its name.[41]

As a footnote to the Bonnie Hall saga, it is worthy to note that a Herreshoff-built SPAR torpedo boat, Hull No. 60, built for the government of Peru, was never delivered; she was left in the builder's hands at the end of the 1879–1881 Peruvian-Chilean War. The unsalable torpedo boat was stored in the open on land adjacent to the DeWolf property (Herreshoff's Point Pleasant Farm) where she remained a local curiosity, slowly deteriorating as a children's plaything, until about 1910.

The Barracks House

In 1780, when actual clashes between American and British troops and their Hessian mercenaries had moved from Newport and Narragansett Bay, some of General Washington's French allies—part of Rochambeau's army—were still stationed in Bristol. French soldiers were quartered in barracks erected on Loyalist William Vassal's abandoned Point Pleasant Farm, and they were granted land for a burial ground; the bones of many French are presumed to still lie there.

During the winter of 1784, one barracks house was hoisted on a sled and hauled across Bristol Harbor by six oxen on ice reported to be "several feet in

The Barracks House, (*c.* 1775), 325 High Street, photo *c.* 1955.

depth." The house was deposited on a foundation at 325 High Street by its owner Robert F. Munro; after Munro's death, it was sold to Joseph Vital, Jr., it was still owned by the Vital family in 1955. In the mid-1960s, the historic old house was beyond repair and it was torn down. In its place a modern bungalow with attached garage stands.

The W. G. Low Cottage

This superior example of the Rhode Island Shingle Style, the William G. Low Cottage, designed and built by McKim, Mead and White, in 1887 on Low Lane at Bristol Point was torn down in 1962.

Built as a summer residence, the one-and-one-half stories were dominated by a low pitched gable roof placed across the width of the plan with broad gables framing symmetrical façades of banked windows in horizontal overhangs. The great sloping roof, like the wings of a giant raptor, enveloped and protected the spacious veranda and unified the horizontal mass of the building.

According to Bonnie Warren, writing in *Historic and Architectural Resources of Bristol, Rhode Island* (1990):

> The Shingle Style was most popular in fashionable seaside resorts. In Bristol, at least, the style was not popular in the more urban setting of the densely developed center of town, nor was the style adapted for vernacular building.

Pastime Theatre Totally Destroyed in Town's Most Spectacular Fire
From the files of the *Bristol Phoenix*, Tuesday, February 6, 1934

> Bitter cold and wind make work of firemen very difficult—Blanket of snow prevents general conflagration—two alarms sounded—Great assistance rendered by Warren and Barrington firemen.
>
> In one of the most spectacular fires that have ever been witnessed in Bristol the [old] town hall that housed the Pastime Theatre was completely destroyed early yesterday morning at a loss totaling about $20,000. Two alarms were sounded and Fire Chief Robert J. Anderson lost no time in summoning aid from Warren and Barrington.
>
> With the temperature hovering slightly over the zero mark and with a fresh northwest wind carrying burning embers as far away as Burton Street, the only thing that saved the town from a frightful holocaust was the fact that every roof was covered with a heavy blanket of snow from the recent storm. For once it was a real blessing that this winter is proving to be an old fashioned one because there is not the slightest doubt but that a very large portion of the town would have been swept by the flames with losses running into thousands and thousands of dollars and possibly

William G. Low designed and built this Rhode Island shingle-style cottage in 1887, at Bristol Point on his private access road he named Low Lane. The house was torn down in 1962. This *c.* 1960 photograph is from the Library of Congress photo archive of historic Rhode Island architecture.

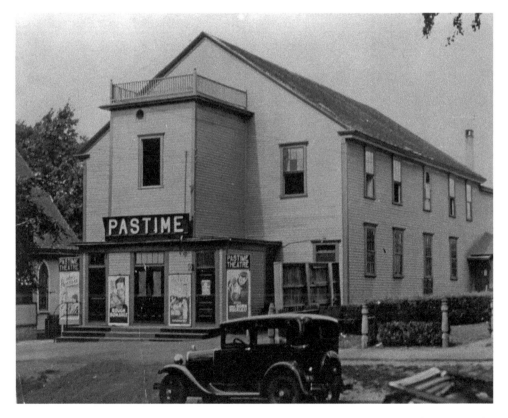

Housed in this 1784 wood frame structure the town opera house and Pastime Theater was the entertainment venue for Bristolians for more than 50 years. This photo is *c.* 1930.

loss of lives. As it was, there were many people whose homes were far from the scene of the flames but directly in the path of the sparks and flying embers, who made preparations to leave their homes, thinking they surely must catch on fire.

The exact cause of the fire is not definitely known but at about 2:40 a.m., Peter Mousseau on night duty at the Mt. Hope Diner heard a muffled explosion and running out of the diner saw smoke pouring out of the building. He immediately sent in for a general alarm, The Osterberg family living nearby on Central Street was also awakened by the explosion and saw a flame shooting out of the side of the theatre. In a very few minutes the place was a mass of flames.

Fire Chief R. J. Anderson immediately sensing the danger to the nearby property and wishing to take no chances sent in a call for help from the Warren and Barrington fire departments and in a short time the Bristol companies were reinforced so that 10 streams [of water] were in use. One was being used on the property of John R. Magee, another on Trinity Church and the other eight were played on the main blaze. Mr. Magee also had a garden hose in use. The tower and part of the roof of Trinity Church was ignited but the firemen succeeded with some difficulty in extinguishing the blaze on that building with but little damage, the Mt. Hope Diner was also in constant danger but did not catch fire.[42]

The extremely low temperature made work on the fire ladders a hazardous undertaking but no serious mishaps were reported. Lawrence Ashton of the Hydraulion Company, however, who was directing a line of hose, was found overcome by the cold and was carried into the Magee home where he received medical attention.

Fred E. Suzman gave out mittens, gloves, rubber boots, and other things to the firemen while the Mt. Hope Diner and Mrs. Magee passed out coffee and rolls to make the firemen more comfortable in their efforts to confine the blaze to one building.

The town carried insurance amounting to $6000 on the ruined building. The moving picture business conducted there represented an investment of $16,000, according to Mr. Vail and was insured for $8,500. The annual revenue to the town from the rental of the building to Mr. Vail was $1700.

Chief Anderson's opinion of the origin of the blaze was that it was probably due to an explosion of coal gas in the furnace.

Fire Chief Walter Beauregard was in charge of the 1000 gallon pumper, which responded from Warren, while Deputy Chief Leon A. Nichols was in command of the Barrington truck. Chief Anderson praised the valuable assistance given by these two companies and was also enthusiastic in his comments on the work of the firefighters in the Bristol companies.

The original Congregational Meeting House

The town hall was built as a Congregational Meeting House in 1784 and was first located at the southeast corner of Bradford and Hope Streets. It was presented to the town in the year 1856 and was removed to its present location on Bradford

Street. A second story was put in and was used by the State Normal School from 1858 to 1864. From 1865 until 1873 the second story was used as a high school but in 1873 the high school was transferred to the top floor of the Byfield School where it remained until the Colt Memorial School was erected. In 1876 the second story of the hall was taken out and the galleries were installed. In 1933 the interior and exterior of the building were entirely renovated and equipped with new fixtures so that the town finally had a motion picture theater in which it could take pride.

The Poor Farm

The following description of the origin of the town's poor farm is from Charles O.F. Thompson's, *Sketches of Old Bristol.*

> A story concerning this old structure up on the Neck known as the "Poor Farm", situated on "Poor House Lane" [Asylum Road] is interesting. According to tradition, Capt. Jim D'Wolf built this edifice, using the stone on his land, and when it was finished gave it to the town. At that time a fellow townsman said to him, "Why Captain D'Wolf, there'll never be a need for such a large poor house in this small place." The old captain, who had already begun to be troubled at the tendency to increasing extravagance on the part of his sons, replied, with one of his quizzical smiles, "O, my grandsons will be coming to live on the farm yet, and they are accustomed to plenty of room."

The ruins of the abandoned Bristol Poor Farm is seen in this *c.* 1953 photo. The viaduct in the foreground is the Asylum Road railroad track overpass. *Phoenix photo*

The student of history, by careful research of the past, soon learns that traditions are rarely true in their entirety and are of little value when at variance with recorded facts. A search of the town's records for 1822, the year that the farm was built, shows that the facts and the traditional account of the gift of the farm to the town are not in accord. There is no record of the gift, instead we find in the Town Meeting records of Nov. 16, 1822: "House of Industry" (that is what they called it in those days)—"Contracted with Mr. Benj. Norris to build said house for $3500." The records of April 17, 1822, show that earlier in the year the town had purchased the land for $2500.

Residents of the "House of Industry" were expected to work for their keep. Food and lodging was not considered a form of free public welfare. Thus, the large tract of land on which the house was built was used for sustenance farming; produce over and above the needs of the residents was sold locally and the money used for maintenance of the farm poor house.

This paragraph from *Sketches of Old Bristol* traces the origin of the North Burial Ground. It appears that a portion of the poor farm's farming land was set aside for use as a cemetery. Conjecture is that paupers who died while in residence in the poor house were interred in this plot.

In 1822 the town purchased a tract of land on the Neck for the purpose of erecting a "House of Industry" (Poor House). At the time according to the town meeting records, April 17, 1822, it was voted that "A part of said town land be set apart for a burying-ground, the same to be well enclosed."

Town council records reveal more on the history of the poor farm:

October 6, 1937: The local welfare director suggested that the building should be remodeled to accommodate the poor as a "Community House."

January 19, 1938: The local welfare director asked that the council consider asking the town meeting for electricity for the poor farm since its inhabitants were using kerosene lamps.

February 1945: Local fish dealers were using the property for a fish dump; there were health concerns.

August 6, 1946: The Town council asked the solicitor to determine if the town could sell the poor farm since there was an inquiry for the same.

June 4, 1953: The Building Inspector issued a report on the condition of the poor farm. It appears to be in ruins at this time.

The abandoned Poor Farm had caught fire on a number of occasions and was finally gutted on July 4, 1953.

The uncontrollable fire, which completely destroyed the remains of the old building, was blamed for the poor performance of the local Defiance hand tub team. The Defiance volunteers were at the New England Veteran Firemen League's 57th annual championship muster held at the Town Common. Hand tub units from many New England towns had assembled for the parade and muster. The Defiance, defending champs, was unable to defend its title due to insufficient manpower on the pumping bars because many of the men had responded to the scene of the Poor Farm fire, albeit fewer men than required to arrest the flames.

Steamers, Trains, and Trolleys

Until 1830 communication with Providence was maintained by means of packet sloops and stage coaches. In that year a steam boat line was established between Fall River and Providence with a stop at Bristol on each run. Alas, unable to compete, the packets found they were servicing fewer and fewer customers. With Bristol's economy growing at a rate surpassed by all expectations the demand for manpower for industry along the waterfront drew new settlers into the town, by the mid-1800s Bristol's population was slightly greater than five thousand.

With this unprecedented surge in population, and industrial production, in 1855 Bristol was connected with Providence by rail. Rail service provided by the Providence, Warren, & Bristol Railroad followed the shore of Narragansett Bay; its principal purpose to serve the several Bristol industries clustered on nearby Bristol Harbor.

In 1867 a line of luxury overnight steamers was established between Bristol and New York. Two fine steamers, the *Bristol* (launched in 1866), and the *Providence* were built expressly for this run; they were operated by the Narragansett Steamship Company and commanded by captains from Bristol. In 1869 the ships were transferred to the Fall River Line. These two enormous floating palaces were

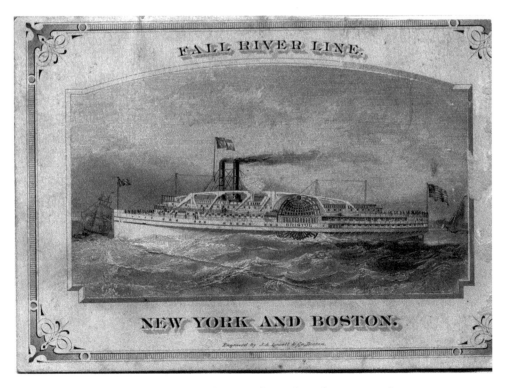

The Fall River Line of elegant overnight steam boats ferried passengers from Boston to New York with a stop in Bristol. Pictured in this Fall River Line trade card is the steamer *Bristol*.

part of a combination boat-train service cobbled together by Jim Fisk of Erie Railroad fame.

By 1875, the Old Colony Railroad had developed a network of railroad lines extending from New York to Boston and southeastern Massachusetts. Steamers connected the railroad lines at various points. The Fall River Line steamers docked at piers on the North River in New York City; in the evening the ships eased out into the East River, then headed east on Long Island Sound to Newport.

Now quoting from Joseph P. Schwieterman's fine anthology, "When the Railroad Leaves Town", we learn:

> Many of those [commuters] arriving into Bristol's Harbor made connections to PW&B [Providence, Warren, & Bristol Railroad] trains to Providence and some continued on to Boston via the Boston & Providence Railroad.
>
> Although considerable fanfare accompanied the inaugural voyages of these overnight steamers, they proved disappointing investments. Due to the concerns of Bristol's devout residents about boat activity breaking the Sabbath, as well as other complications, the operators of the ships moved their northern terminus to Fall River, Massachusetts, shortly thereafter.

In the fall of 1880, The Providence, Warren, and Bristol Railroad Company began making extensive improvements on its property near the Thames Street depot. The large old brick building that stood near the marine railway was pulled down and a new brick building intended for use as a blacksmith shop was erected opposite the foot of Franklin Street. The new building was 50 feet in length, 36 feet in width, and the sidewalls 16 feet high.[43] The roof was formed of a segment of a circle, close boarded, and covered with tin. Bristol housewright John R. Slade did the carpenter work.

In 1891 the Old Colony Railroad leased the PW&B, later; in 1893 it joined the New York, New Haven, and Hartford Railroad. By 1900 the NY, NH, & HRR had invested heavily in the route thus establishing it as one of the country's first electrified main lines.

Around the turn of the century, electric trolleys operated by the Suburban Branch of the Rhode Island Company ran over the tracks of the New York, New Haven & Hartford Railroad. Upon entering Bristol at Franklin Street, the trolleys connected to the Rhode Island Company's tracks and ran over the streets of the town. The trolleys ran east on Franklin and south on High Street to the intersection of Burton Street.

There, the conductor changed the trolley's direction simply by changing the car's electrical connection to the overhead wire. The car would then head back to Franklin Street and onto Warren over the NY, NH & HRR rails. The residence at 341 High Street was originally a passenger waiting station and overnight lodging for those who missed connections.

In June 1904, more than two decades before construction of the Mount Hope Bridge, the Newport and Providence Street Railway connected Newport with

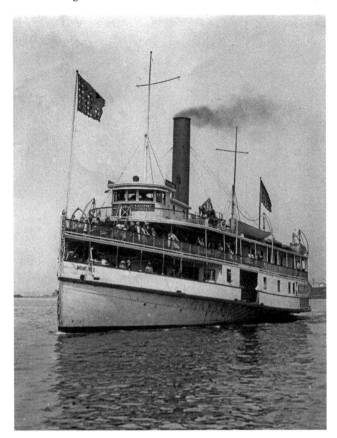

The Rhode Island Sound steam excursion ferry Mount Hope. Affectionately referred to as "The Queen of Narragansett Bay", she daily plied the route from Providence, to Newport, and Block Island with a stop at Bristol.

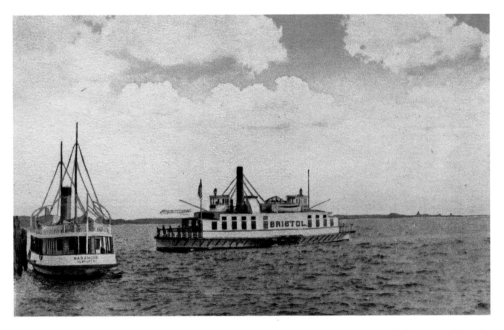

The Newport and Providence Railroad Company ferries the *Sagamore* and the *Bristol*, at the Constitution Street slip, *c.* 1930.

The railroad depot at the foot of Franklin Street is now the location of Bristol's bucolic waterfront Independence Park. During the rail road days, locals called this area, "the high walls," because the large brick terminal freight building totally blocked views of Bristol Harbor.

The so-called "High Walls" of the Franklin Street depot, *c.* 1910.

Looking north from Church Street, the Warren and Bristol trolley is picking up passengers on High Street. *c.* 1904 postcard published by Bristol jewelers Stevens and Company.

Providence via Bristol Ferry which had moved its Bristol terminus from Bristol Point to Constitution Street a decade earlier. The steam-powered ferries the *Sagamore* and the *Bristol* were owned by the Newport and Providence Railroad Company. The service began in 1903 and ran between Bristol and Portsmouth. The ferry ran across Mount Hope Bay connecting the trains from Providence to Bristol, and the trolleys from Newport to Portsmouth and Bristol. The steamers docked at the foot of Constitution Street at Thames, which was the terminus of the train from Providence. Later, with the advent of bus service, a slip was built at the end of Ferry Road to accommodate walk-on passengers, buses, and private vehicles.

The timing of the trip was as follows: 45 minutes from Washington Square in Newport to the ferry, 20 minutes on the ferry, then another 45 minutes from Bristol to Providence. The trolley ride to Bristol Ferry was 20 cents. The ferry was 10 cents. Counting delays between connections, the total elapsed time was usually about two hours and fifteen minutes; this became the shortest route from Providence to Newport.

In 1900 the last steam passenger service was used to and from Providence and Bristol. It is understood that the plan most favored by the railroad officials was to add more gas motor car units, which would operate with only one or two trailers instead of increasing the number of trailing coaches and slowing down the operation time.

The demise of the former New Haven Railroad set the stage for the creation of the East Bay Bicycle Path, one of America's best-known rail-trails. The railroad's property became the jurisdiction of the Rhode Island Department of Transportation in 1982, and through a series of transactions beginning four years later, came under the stewardship of the state's Department of Natural Resources. After the path opened in 1994, through the efforts of such Bristolians as Thomas Byrnes, Jr., and George L. Sisson, it earned wide recognition for its attractive landscaping and panoramic views of Narragansett Bay.

Not all East Bay politicians and citizens held favorable opinions about establishing a bike path along the old railroad right-of-way; dissenters were abundant. For an in depth history and time line of the bike path debate, see Simpson, *Bristol Montaup to Poppasquash*, Arcadia Publishing, 2002.

Archaeologists Uncover Nineteenth-Century Distillery

For weeks before the November 29, 2007 *Bristol Phoenix* published news of the archaeological excavation on Thames Street, parties of workers were secretly digging and exposing the remnants of an 1800s rum distillery. The site of the dig is on the planned condominium construction site on the vacant lot just north of Gillary's Tavern (on east side of Thames Street and north of John Street).

Excavation for the foundation of the combined retail and condominium complex halted immediately when the long-forgotten, nineteenth-century structures

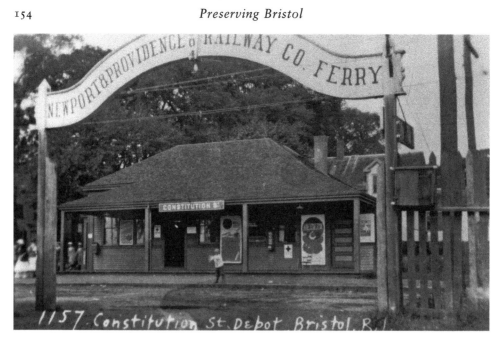

The Constitution Street ferry slip and street railroad depot. Travelers from Aquidneck Island disembark the *Sagamore* and *Bristol* ferries and catch the trolley to Bristol Center, and towns north.

The author's ink drawing of the New York, New Haven & Hartford Railroad's Constitution and Thames Streets depot as it appeared *c.* 1900.

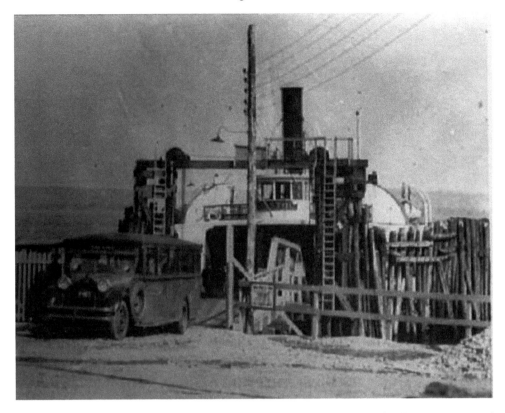

The Bristol ferry is discharging a "Short Line" bus from Newport at the landing at Ferry Road near the Bristol lighthouse.

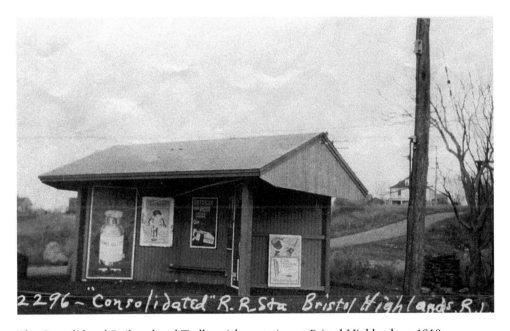

The Consolidated Railroad and Trolley pickup station at Bristol Highlands, *c.* 1910.

Another view of the Consolidated Railroad pickup station at Bristol Highlands, looking south.

The "Papoosesquaw" (Poppasquash) Road railroad and trolley depot, *c.* 1910. Note the neatly lettered Papoosesquaw street sign.

were exposed. Site developer, James Roiter, contacted state Coastal Resources Management Council (CRMC) on the unexpected archaeological find. The CRMC contacted the Public Archaeology Laboratory in Pawtucket to conduct a full scientific exploration of the site.

The dig uncovered a large rum distilling operation that is believed operated during the 1800s, perhaps for as little as ten years. To the trained-eye of the professional archaeologist, the dig has proven a treasure trove of information on trade and commerce in post-colonial Bristol.

Historians have long thought that the last of Bristol's distilleries closed around 1830; excavations at the site seem to fit that timeline.

It is further believed that this distillery was run by a group of Bristol businessmen who also owned a wharf and store directly across the street from their distillery. The men, Jarvis and Joseph Pierce, Benjamin Bosworth, William Noyes, Nathaniel Paine and Thomas Lindsay each owned shares in the operation.

The site is exceedingly rare; though dozens of rum distilleries operated between New York and Boston during the 1700s and 1800s, this site is one of only four found undisturbed.

Hog Island Shoal Light (1885–1901)

Long before the Hog Island Shoal Lighthouse existed, at the confluence of Mount Hope Bay and Narragansett Bay, beginning in 1838 a buoy marked the shoal remaining there until replaced by a floating light. The small floating light boat was maintained by the Old Colony Steamboat Company from 1866 until 1885. In 1885, the United States Government established upon the shoal a lightship station.

During November 2007, archaeologists uncover the remains of a nineteenth-century distillery several feet below street level. *Phoenix Photo*

The unearthed brick-walled distill remains in reasonably good condition after being buried for nearly two centuries. *Phoenix Photo*

The 1895 annual report of the Lighthouse Board mentions the Hog Island Lightship in need of general repairs and it is unfit for anything more than temporary service. By 1896, the Board determined that a lighthouse could be built on the shoal for half the cost of the lightship.

Congress approved the funds needed for the construction of a lighthouse and fog signal at Hog Island Shoal on March 3, 1899. The Annual Report of the Lighthouse Board had the following entry:

> Hog Island Shoal, Narragansett Bay, Rhode Island—By act approved March 3, 1899; an appropriation of $35,000 was made for establishing a light and fog-signal station to take the place of this light vessel. The structure is to be an iron cylinder filled with concrete and surmounted by an iron tower. A preliminary examination of the site was made in June, 1899.

The U.S. Coast Guard maintained the so-called "sparkplug" tower until the lighthouse became obsolete and available in 2004 under the National Historic Lighthouse Preservation Act of 2000. The lighthouse was offered at auction on May 23, 2006; John and Juli Chytka became the new owners with a winning bid of $165,000.

Preserving Bristol's Celebration Tradition

No story about Bristol, Rhode Island is complete without mention of the town's Fourth of July celebration tradition; therefore I offer this concise overview.

During the first 30 years of Bristol's consecration of Independence Day as a secular holyday the citizens themselves were the organizing force.

The town's government may or may not have contributed to those early observances and celebrations. Not until 1815 is there a record of government involvement. Committees, when appointed by the town, were selected from the so-called "great folks," or "gentry," the freemen, merchants, and electors of the town.

This Bristol tradition owes its longevity to the tenacity of people such as Rev. Henry Wight and William Bayley; to Edward Anthony, Jr. who served on the Celebration Committee for more than 50 years (from about 1860 to 1912) and during those years he acted as its chairman 24 times; to Everett LeBaron Church (1922–1931) and James F. Meiggs (1937–1947); three who guided the celebration through some 70 years–from the late nineteenth century through the first half of the twentieth century; to the current committee a stalwart team of volunteers– Bristolians all–who work to continue this Bristol tradition.

Those citizens and strangers who gathered at the Congregational Church on July 4, 1785, heard the Reverend Wight deliver this impassioned prayer:

> We rejoice and thank God on this joyous anniversary, that we may assemble in a temple dedicated to His service, and offer homage of our grateful hearts for His deliverance bestowed to our Fathers when the storms of war lowered upon their destinies; and the blood-nurtured battalions of a cruel Despot swarmed upon their shores.

The author's collection of Bristol Independence Day parade ribbons. The collection may now be viewed at the Rogers Library special collections room.

As often as this glorious day rolls round, we should assemble before our Country's Altars, and there tell the story to our listening children, that they may know the awful price our Fathers paid for Freedom.

Today, these continuing exercises are the answer to Rev. Wight's supplication and reaffirm the love Bristolians have for their First Amendment rights.

Every year since 1785, Bristol has marked this day with "Exercises." Each new sending forth of prayer, song, and oratory from Bristol's Fourth of July Patriotic Exercises, and each annual patriotic *Grand Military, Civic and Firemen's Parade* proves again they are truly unique for their longevity.

The Patriotic Exercises in 2014 was the 229th edition, and the parade was the 175th official one.

Chapter 9

A Gallery of Distinctive Doorways

Bristol folks are justifiably proud of the town's architectural heritage. One particular feature of the Federal-era homes easily recognized by admirers of the inspired architect is his interpretation of intricate and delicately ornate residence entrances and surrounds.

This chapter is a salute of recognition to the known and unknown architects and builders who have left their indelible mark on the old town's character.

Genealogy of 610 Hope Street

OWNER	OCCUPANCY	REMARKS
Giles Luther	1809–1828 19 years	House built for $890.67. Luther is the first recorded 4[th] of July parade chief marshal.
Rev. Isaac Lewis	1828–1832 4 years	Pastor of the First Congregational Church.
Maj. Jacob Babbitt, Jr. and family	1832–1897 65 years	Jacob Jr., died in 1863, of wounds suffered at the Battle of Fredericksburg which was fought on Dec. 13, 1862. Because he died intestate, an inventory of the contents of the house was required.
Charles Bristed Rockwell and family	1897–1940 43 years	Founder of Cranston Worsted Mills. Built the "courting corner" for his jilted daughter June. Donated the Rockwell School to the town. Donated the house to the Bristol District Nursing Association. Donated the waterfront land called Rockwell Park.
Bristol District Nursing Assn.	1940–1973 33 years	Plaque in front foyer commemorates the donation of the house and gives it the name most Bristolians use today.
Jerome & Mary Squatrito	1973–1982 11 years	Saved the house from demolition for use as a parking lot, and did major restoration.
James & Marlo Gettys	1984–1996 12 years	Designed and executed stenciling throughout the house.
Steven A. & Debra D. Krohn	1996–present	Open to the public as bed and breakfast lodging.

The ornate doorway of the residence at 675 Hope Street at the corner of Franklin Street. Another such elegant doorway is at 224 Hope Street at the corner of Union. Photograph from 1917 *White Pine Monograph*

132 High Street at the corner of Union Street with a handsome flat head entrance with fanlight and engaged Doric columns. Another such front entrance is on the author's High Street residence. Photograph from 1917 *White Pine Monograph*

The attractive doorway and porch of 676 Hope Street. Photograph from 1917 *White Pine Monograph*

The General George DeWolf/Colonel S. P. Colt residence Linden Place front entrance. *c.* 1905 real photo postcard.

The rear entrance Colonel Colt's Linden Place residence. *c.* 1905 real photo postcard.

Front entrance of the DeWolf-Middleton estate on the Poppasquash peninsular, *c.* 1905 real photo postcard.

The Church-Manchester house doorway on Poppasquash Road. *Author's October 1997 photo*

The entrance to the residence at 328 Hope Street. Most unusual are the leaded bull's eye glass window in the door and the colored leaded glass pattern in the panel above the door. *c.* 1905 real photo postcard.

The wonderfully carved entryway and Palladium window surround of Capt. Parker Borden's 1799 home at 736 Hope Street, c. 1905 real photo postcard.

Architect and builder Russell Warren designed and built this 86 State Street (1807), Briggs-Warren-Bach house. Warren had a special affection for this house; he dwelt in it for a considerable time, *c.* 1905 real photo postcard.

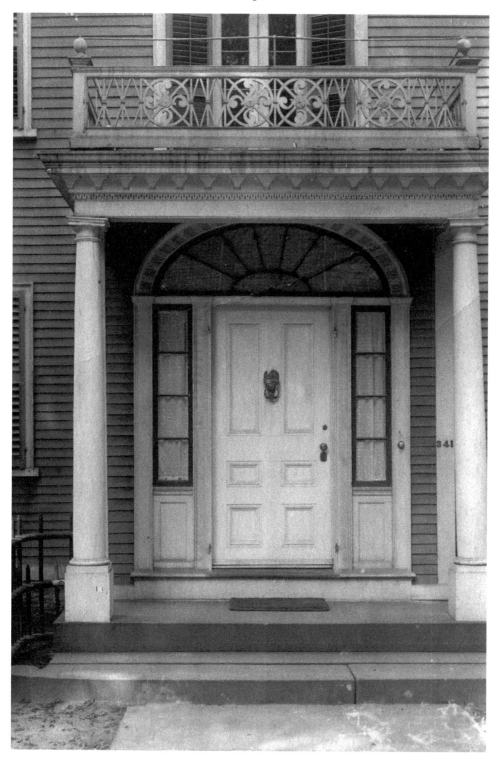

The brilliantly elegant entrance to the Four Eagles house at 341 Hope Street. Notice the delicate Chinese Chippendale railing above the shallow portico.

About the Author

Richard V. Simpson is a native Rhode Islander who has always lived within walking distance to Narragansett Bay, first in the Edgewood section of Cranston and then in Bristol, where he has lived since 1960.

A graphic designer by trade, he worked in advertising, printing, display, and textile design studios. He designed and built parade floats for Kaiser Aluminum's Bristol plant and the U.S. Navy in Newport; he painted murals for the Portsmouth Raytheon Submarine Signal Division, Kaiser Aluminum, and outdoor billboards for the Naval Supply Center. Simpson's semi-abstract oil and casein paintings, with subjects based in nature, have garnered many favorable critical reviews and are in several private Rhode Island collections.

After retiring in 1996 from a twenty-nine-year federal civil service career with the U.S. Navy Supply Center and Naval Undersea Warfare Center, he began a second career as an author of books on subjects of historical interest in Rhode Island's East Bay with his principal focus on Bristol.

Richard and his wife Irene are antique dealers doing business as *Bristol Art Exchange*; receiving their Rhode Island retail sales license in 1970.

During a 1969 Naval Supply Center inspection tour, United States Navy Secretary John H. Chafee accepts his portrait drawn by artist/author Richard V. Simpson.

Beginning in 1985, Richard acted as a contributing editor for the national monthly *Antiques & Collecting Magazine* in which eighty-five of his articles have appeared.

Bristol's famous Independence Day celebration and parade was Richard's first venture in writing a major history narrative. His 1989 *Independence Day: How the Day is Celebrated in Bristol, Rhode Island* is the singular authoritative book on the subject; his many anecdotal Fourth of July articles have appeared in the local *Bristol Phoenix* and the *Providence Journal*. His history of Bristol's Independence Day celebration is the source of a story in the July 1989 *Yankee Magazine* and July 4, 2010 issue of *Parade Magazine*.

Books by Richard V. Simpson

A History of the Italian-Roman Catholic Church in Bristol, RI (1967)
Independence Day: How the Day Is Celebrated in Bristol, RI (1989)
Old St. Mary's: Mother Church in Bristol, RI (1994)
Bristol, Rhode Island: In the Mount Hope Lands of King Philip (1996)
Portsmouth, Rhode Island, Pocasset: Ancestral Lands of the Narragansett (1997)
Tiverton and Little Compton, Rhode Island: Pocasset and Sakonnet (1997)
Tiverton and Little Compton, Rhode Island: Volume II (1998)
Bristol, Rhode Island: The Bristol Renaissance (1998)
America's Cup Yachts: The Rhode Island Connection (1999)
Building the Mosquito Fleet: U.S. Navy's First Torpedo Boats (2001)
Bristol: Montaup to Poppasquash (2002)
Bristol, Rhode Island: A Postcard History (2005)
Narragansett Bay: A Postcard History (2005)
Herreshoff Yachts: Seven Generations (2007)
Historic Bristol: Tales from an Old Rhode Island Seaport (2008)
The America's Cup: Trials and Triumphs (2010)
The Quest for the America's Cup: Sailing to Victory (2012)
Tiverton & Little Compton Rhode Island: Historic Tales of the Outer Plantations (2012)
Historic Tales of Colonial Rhode Island: Aquidneck Island and the Founding of the Ocean State (2012)
Thomas Lipton's America's Cup Campaigns (2014)

Endnotes

1. See Hugh Thomas, *The Slave Trade*.
2. Mildred B. House, an excerpt from the Narragansett Naturalist of the Audubon Society of Rhode Island, November 1963.
3. *The Herald News,* Monday, February 20, 1995.
4. Designed by Bristol architect Philemon F. Sturges, III, it was built in 1965 to house the Old Stone Bank. The designs on the building's façade are symbols representing Greek money executed by then Bristol resident artist Hugh Townley.
5. Hog Island is part of the town of Portsmouth.
6. For more on the exploits of Benjamin Church, including his days as a ranger in King Philip's War, see Simpson, *Tiverton & Little Compton, Rhode Island*, The History Press, 2012.
7. Historic and Architectural Resources of Bristol, Rhode Island, Rhode Island, Historical Preservation Commission, 1990.
8. *Ibid.*
9. For more on the HMS *Rose* see Simpson, *Bristol Montaup to Poppasquash,* Arcadia Publishing, 2002.
10. Dr. Conley suggests this story originated with Bradford's daughter who probably recalled a visit by President Washington to Bradford's Philadelphia dwelling when Bradford was a U.S. Senator.
11. Thompson, Charles O.F., *Sketches of Old Bristol*, p.119.
12. John DeWolf's 433 Hope Street residence (1789) was moved in 1915 to the lot at 443 Hope and State Streets; it is now the Rego Law Office.
13. Thompson, Charles O. F., *Sketches of Old Bristol*, p.118.
14. See Simpson, *Herreshoff Yachts*, The History Press, 2007.
15. *Ibid.*
16. *Ibid.*
17. *Ibid.*
18. Trace the Herreshoff-Brown family lineage in *John Brown's Tract* by A. L. Brown, Phoenix Publishing, Canaan, NH, 1988.
19. It is a long forgotten fact that the land on which Love Rocks at 6 Walley Street, the Sidney Herreshoff house at 125 Hope Street, and the Lobster Pot Restaurant are all built on filled land.
20. See Simpson, *Herreshoff Yachts*, The History Press, 2007.
21. Burnside Street was once called Summer Street. Refer to the Sanborn Fire Insurance Maps (1900 & 1903) at Bristol Town Hall for original street

names and house numbers. Around 1900 street numbers were changed; before 1900 the street numbers started at Bay View Avenue and ran south, after 1900, the numbers started at Ferry Road and ran north.

22. See Simpson, *Herreshoff Yachts*, The History Press, 2007.
23. See W. H. Munro, *The Story of the Mount Hope Lands*, 1881, pp. 333-334.
24. The *Bristol Phoenix*, April 7, 1877.
25. See Simpson, *Historic Bristol*, The Hotel Belvedere Saga, The History Press, 2008.
26. See Hugh Thomas, *The Slave Trade*, pp. 545, 551, and 603.
27. See *Bristol Three Hundred Years*, p. 56.
28. The Commercial Bank was chartered in 1809 and survived until 1869.
29. During the September 1960 hurricane, called Donna, John Drew and his wife Marjorie took refuge in the barn's tower.
30. Colts appear too, on every firearm made by the weapons company founded by Colonel Colt's uncle, Samuel, for whom he was named.
31. For more on the Bristol slave trade see Simpson, *Bristol: Montaup to Poppasquash*.
32. See W. H. Munro, *The Story of the Mount Hope Lands*, The Prince Charles of Lorraine.
33. See W. H. Munro, *The Story of the Mount Hope Lands*, Nor'west John DeWolf.
34. See Simpson, *Herreshoff Yachts*, The History Press, 2007, and *The America's Cup Yachts*, Arcadia Publishing, 1999.
35. See Simpson, *Historic Bristol*, The History Press, 2008.
36. A state of Brazil, located in the Northeast region of the country.
37. *The Old Stone Bank History of Rhode Island*, Volume III, 1940, Grant Takes Bristol.
38. Knowlton, Josephine Gibson, *Longfield the House on the Neck*, p.23.
39. Middleton, Alicia Hopton, *Life in Carolina and New England during the Nineteenth Century*, pp. 3-4.
40. See Simpson, *Bristol, Rhode Island: In the Mount Hope Lands of King Philip*, (1996), and *Bristol, Rhode Island: The Bristol Renaissance* (1998).
41. U.S. Representative Henry Middleton owned substantial plantations worked by slaves; Middleton partnered with DeWolfs in the trade.
42. For more on Hey Bonnie Hall, see *Bristol Three Hundred Years*, p. 55.
43. The current Andrews School building is on the footprint of Trinity Church; the Mt. Hope Diner was located between Trinity Church and the old wood frame church / theatre building.
44. This is the area along the waterfront referenced in some old texts as "the high walls."